13				
r 1				
				€

THE OIL PAINTER'S QUESTION & ANSWER BOOK

OIL PAINTER'S

QUESTION & ANSWER BOOK

HAZEL HARRISON

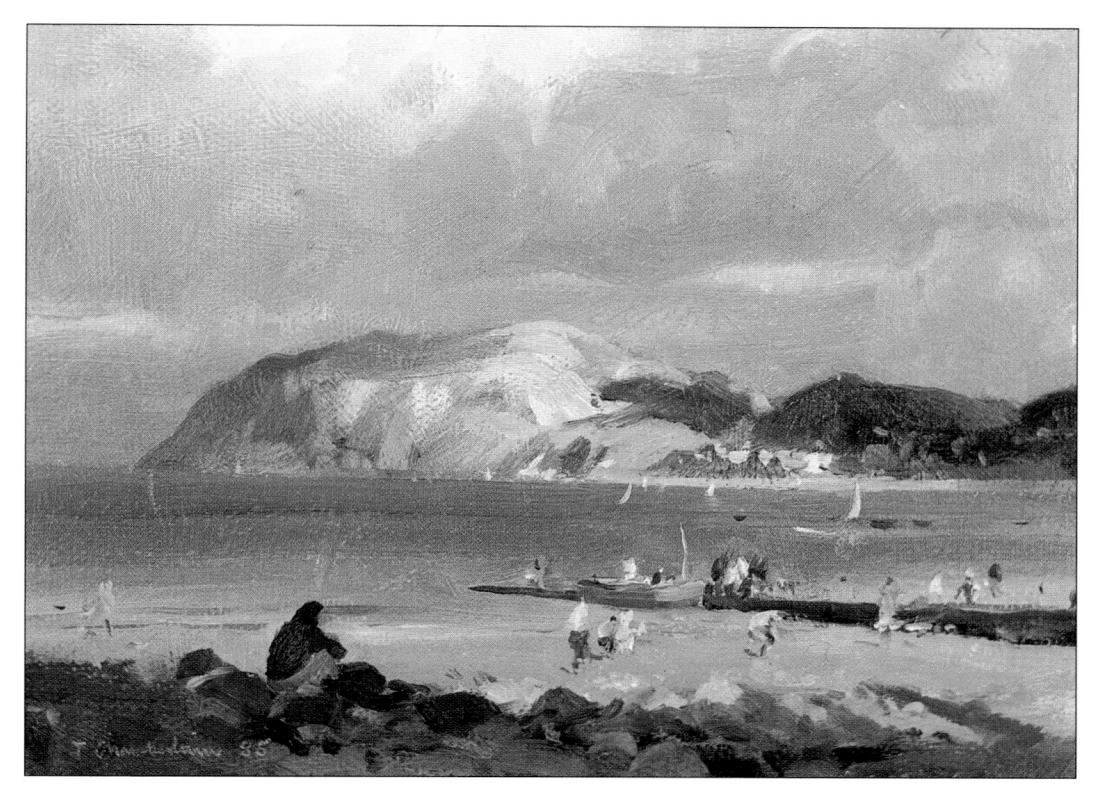

North Wales Beach by Trevor Chamberlain 6×8 in/15.2 \times 20.3cm

A Quarto Book

Copyright © 1989, 2003 Quarto Publishing plc	CONTENTS				
All rights reserved. No part of this book may be reproduced, stored in a retrieval system or	Introduction				
transmitted in any form or by any means, electronic mechanical, photocopying,	GETTING STARTED Understanding Your Medium	8			
recording or otherwise, without	Controlling the Paint 1				
the prior permission of the copyright holder.	Choosing a Size 14				
Published by Chartwell Books	Brushwork	16			
A Division of Book Sales, Inc.	Using Impasto	20			
114 Northfield Avenue Edison, New Jersey 08837	Working Outdoors	24			
USA	Techniques for Better Colors	26			
ISBN 0-7858-1741-7	Creating Texture	30			
QUAR.OCS This book was produced by Quarto Publishing plc	COLOR Making the Most of Your Palette				
The Old Brewery 6 Blundell Street	Painting Whites	36			
London N7 9BH	High Contrasts	38			
Editor Patricia Seligman	Varying Your Greens	40			
Designer Bob Gordon	Understanding Skin Tones	44			
Art Director Moira Clinch	Avoiding Mudddy Neutrals	46			
Editorial Director Carolyn King	Extending Your Range	50			
Special thanks to Gordon Bennett and Angela Gair	Making Colors Work Together	52			
Printed in Singapore by Star Standard Industries Pte Ltd					

Color and Value		PROBLEM SUBJECTS	104 Trade	
Achieving Color Harmony		Special Techniques and Tricks of the Trac		
Creating a Mood		Summer Foliage	106	
		Flowers	110	
COMPOSITION	64	Painting Light and Shade	114	
Organizing Your Picture		Defining Lines and Edges	116	
Editing Nature	66	Improving Your Figure		
Stressing a Focal Point	68	Painting	118	
Making the Foreground Work	70	Misty Landscapes	120	
Placing the Horizon		Clear Skies	122	
Keeping the Viewer Interested		Cloudy Skies	124	
Creating Drama		Winter Trees	128	
Space and Recession	82	Snow	130	
Fine-tuning Your Landscapes	86	Water	132	
Arranging a Still Life	88	Buildings	136	
Composing a Portrait	92	Metal and Glass	140	
Working From Photographs	96			
Unusual Viewpoints		Index	142	
Making a Personal Statement	100	Credits	143	

INTRODUCTION

INTRODUCTION

I have frequently heard amateur oil-painters say that they have tried watercolor or pastel but quickly given up because oils are so much easier. This is one reason for the popularity of this traditional medium, while another, it has to be admitted, is that oils have a distinct cachet - the phrase "genuine oil painting" has a similar ring to "real gold." Certainly it's nice to see ourselves standing, palette in hand before an easel, surrounded by the impedimenta of the professional artist's trade, but it would be a pity to choose this splendid medium for its glamour value alone. Artists who work mainly or entirely in oils do so because they find it's the medium that best allows them to express their feelings and ideas, providing almost unlimited scope for experimentation with new methods and techniques. Oil paint is the most versatile of all the media, and a visit to an art gallery - or just a glance through the pages of this book - will show you such a variety of different approaches and methods that you may find it hard to believe the same medium has been used.

When people say that oil paints are easy to use they are half right and half wrong. The knowledge that you can go on scraping down and overpainting more or less ad infinitum simply because the paints are opaque gives you a marvelous feeling of security. If a watercolor goes wrong too often, you can't easily save it, but an oil is different: you know you can get it right in the end if you go on trying. This is a perfectly reasonable belief - you almost certainly can get it at least a bit right, and you'll probably enjoy yourself and learn a lot in the process. But there comes a moment when you begin to feel stuck. You can see that your standard has improved you have learned to mix the right colors and put the paint on in a reasonably professional way but somehow the paintings are not absolutely right. Perhaps you haven't given enough thought to composition or brushwork? Are you using the paint wrongly in some way? You want to take a step further but don't know in which direction to move.

If you are a complete beginner, it can be bewildering even knowing how to start — which brushes should you use, what should you paint on, and which colors will you need? This book is intended to help all those who love to paint — both novices and more practiced amateurs who have begun to feel dissatisfied with their efforts

but can't quite pinpoint the faults.

The book is divided into four main sections, the first dealing with painting techniques, the second with color, the third with composition, and the final one with the subects that even professional artists find difficult, like flowers, skies, and water. In each section I have chosen a selection of amateur paintings to highlight some of the most common oil painting problems, such as overworked paint, poor brushwork, muddy colors, weak foregrounds, badly balanced or awkward shapes, wooden-looking flowers and solid-looking skies. Each amateur work appears side by side with a painting by a more experienced artist, to demonstrate how this particular painter coped with a tricky subject or interpreted it in a more exciting way. But painting is a personal matter, and these examples are not intended to show you "right" and "wrong" ways of doing things, but to suggest some ideas and in some cases give practical advice, so that you will be free to take that step forward without repeating your past mistakes. In some cases I've chosen several different interpretations of one subject so that you can see an inspiring variety of different approaches - you can learn a lot from your own mistakes, but it is often helpful to look at other people's failures and successes as well. But above all, always remember that good paintings are the result of trial and error, hard work, and constant practice, so if you feel discouraged at times, keep trying.

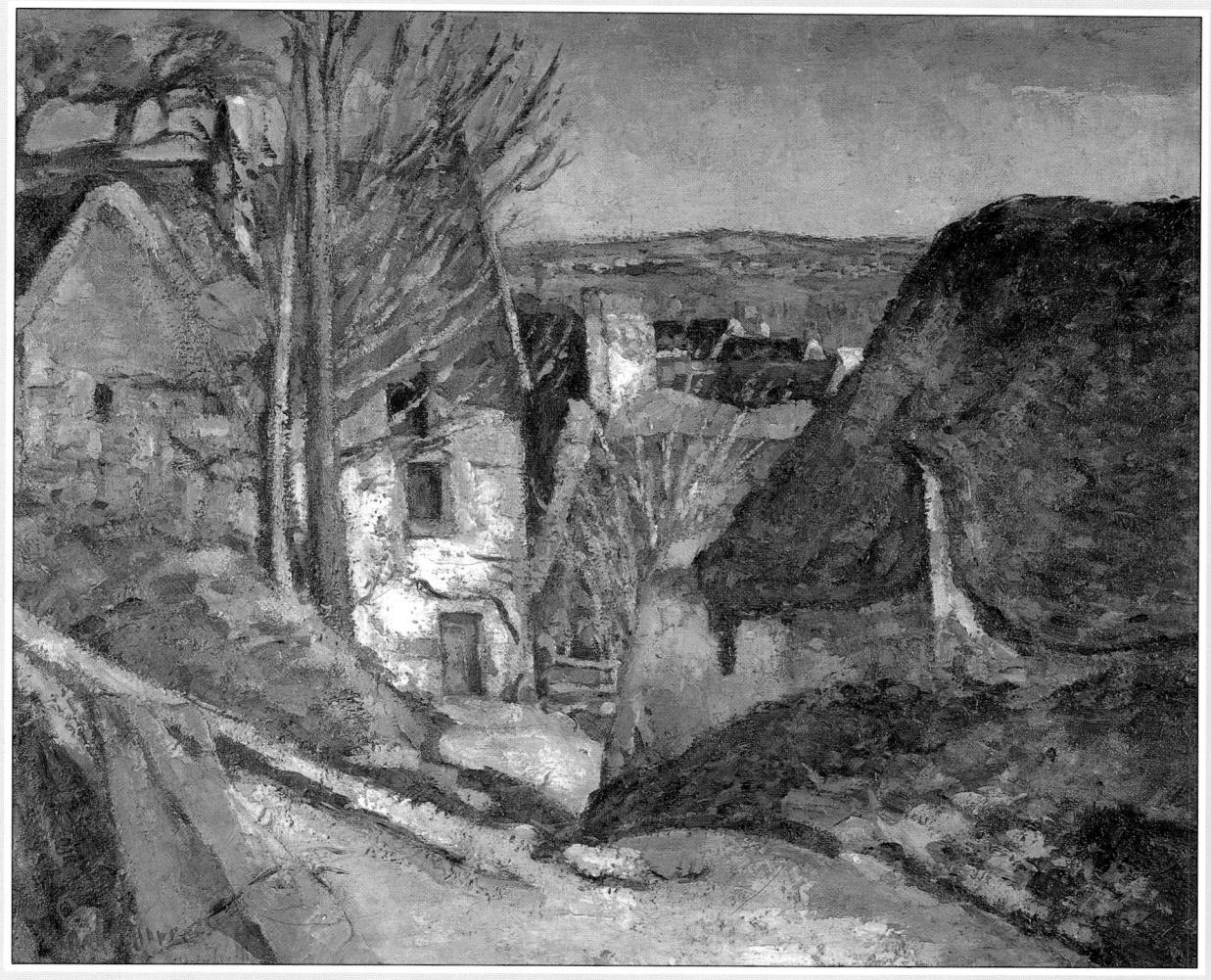

The House of the Hanged Man by Paul Cézanne, 1873 55×66 cm/ $21\frac{1}{2} \times 26$ in. Musée d'Orsay, Paris

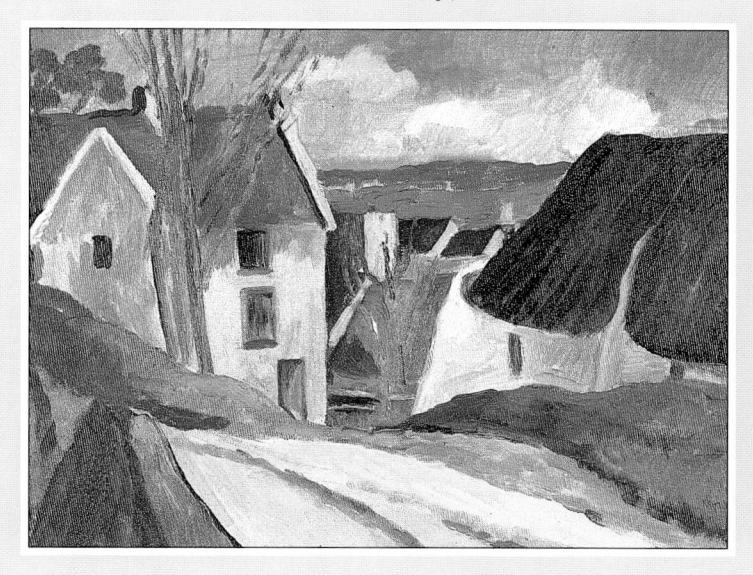

It may not seem fair to compare an amateur painting with an Old Master, but it's one of the best ways of learning how to improve your standard. The subject is the same in both paintings, but the student's version is flat and somewhat dull, with little attention given to texture or the quality of the light. Cézanne has suggested the different textures by building up the paint very thickly, particularly on the house and tree trunks, where he has dragged dry paint over earlier layers.

GETTING STARTED

Understanding Your Medium

It is no wonder that the early Renaissance painters acclaimed the newly developed oil paint as "a most beautiful invention." After the rigors of the demanding and difficult egg tempera medium, it must have seemed like manna from heaven – so much easier to use, so versatile, so colorful. By our standards, of course, it was not very easy to use in those days: there were no handy tubes or painting boards, pigments had to be laboriously ground by hand and canvases or panels made and primed before the painting could start. The first oil paintings were similar in handling to their tempera predecessors, but

gradually artists began to understand the nature of the new invention and exploit it to the utmost to produce works full of originality and excitement. They are still doing so today — oil paint has never lost its popularity, and modern paint manufacturers are constantly devoping new and better colors, mediums, and painting surfaces so that we can express ourselves freely, secure in the confidence that our paintings will not discolor or crack with age.

■ The nature of the medium There is something about the thick, buttery quality of oil paints that is immediately appealing – that is, if

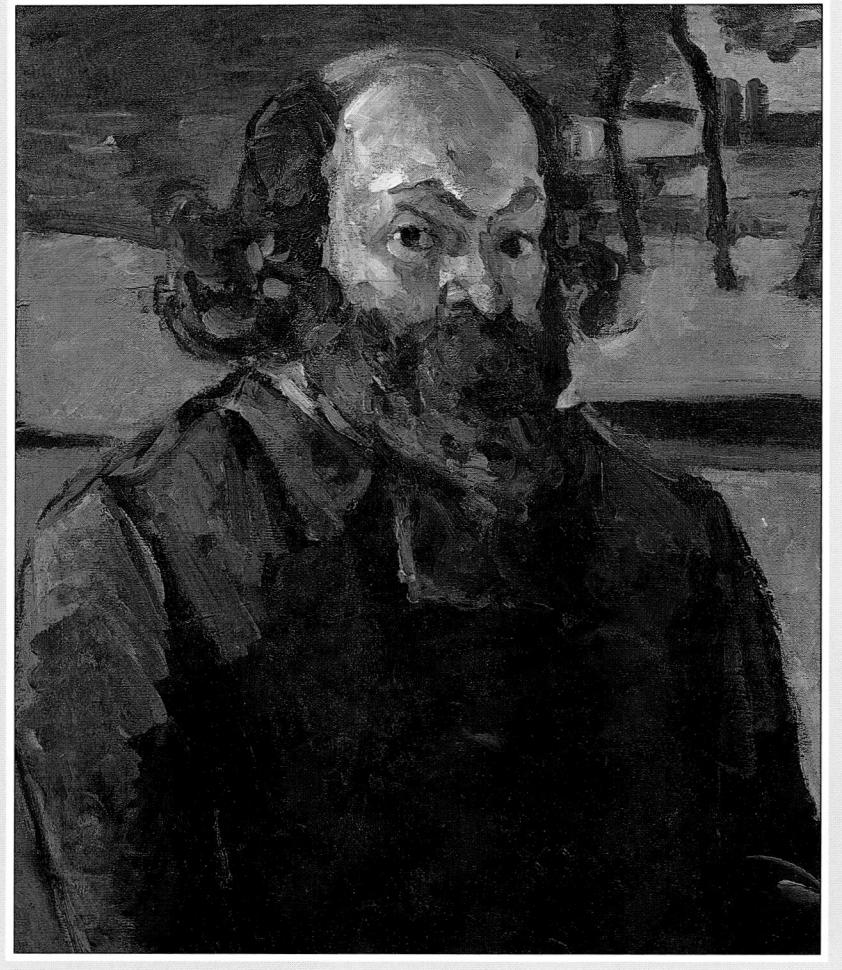

Self-portrait by Paul Cézanne, c. 1872 Musée d'Orsay, Paris

▶ Rubens painted this lovely, luminous portrait on a wooden panel consisting of four oak planks joined together. This was first given a white ground of chalk mixed with animal glue and oil and then primed with the yellowish underpainting that Rubens used in many of his pictures. He often allowed the yellow priming to show through the final layer of paint so that it became a color in its own right.

you don't mind getting your hands dirty. But their most important advantages from the novice's point of view are that they dry slowly and can be used opaquely. There isn't much you can do with an unsuccessful watercolor except throw it away and start again, but the obligingly thick consistency of oils allows you to overpaint mistakes as often as you like, changing and improving your drawing, colors, and forms until you begin to see your painting take shape in the way you envisaged. Because it dries showly, you can manipulate the paint on the canvas, moving it around to create new and interesting effects. In fact, you can use it in an almost endless variety of ways: putting it on thick with a knife; in small, delicate brushstrokes; in thin, transparent layers - even painting with a rag or blending colors together with your fingers.

■ Learning from the masters This chapter outlines some of the best-known and most useful techniques in oil painting and explains how to avoid some common problems, such as muddy

colors and poor brushwork. But bear in mind that the two best ways of learning to use paints are firstly, doing it yourself, and secondly, studying the methods of other artists at firsthand. All the great painters of the past learned from their predecessors – several of the Impressionists both used to copy the work of the Old Masters. So if you have a chance to visit art galleries, take a hard analytical look at the work of any artists you particularly admire. Most oil paintings only achieve their full effect when viewed from a distance, but if you then go up close you will see all sorts of fascinating technical details. You may notice that a color that appeared flat is actually broken up into separate brushstrokes, or that the paint is very thin in some areas and thick in others, with highlights put on with a painting knife. Although it's important to evolve your own individual methods and ways of looking at things, it would be a great pity to allow the experiments and experiences of earlier artists to go to waste.

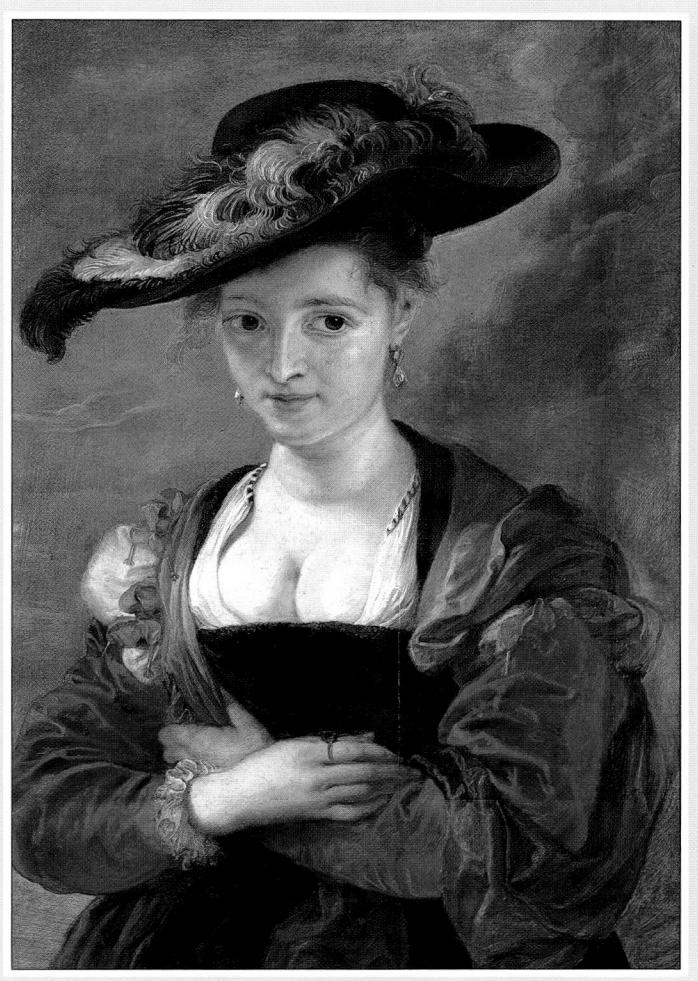

Portrait of Susannah Fourment by Peter Paul Rubens, c. 1620-25. National Gallery, London

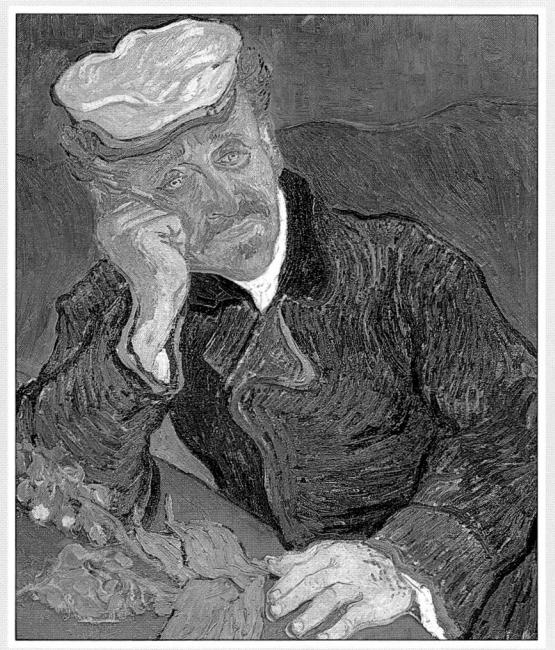

Dr Gachet by Vincent Van Gogh, 1890 Musée d'Orsay, Paris

▲Van Gogh worked very fast, painting directly onto the canvas, with no underpainting. Although the paint is thick throughout the picture, there is little overpainting — notice how you can see the bare canvas between the brushstrokes on the sleeve.

The paint has become so stirred up that I can't make it do what I want.

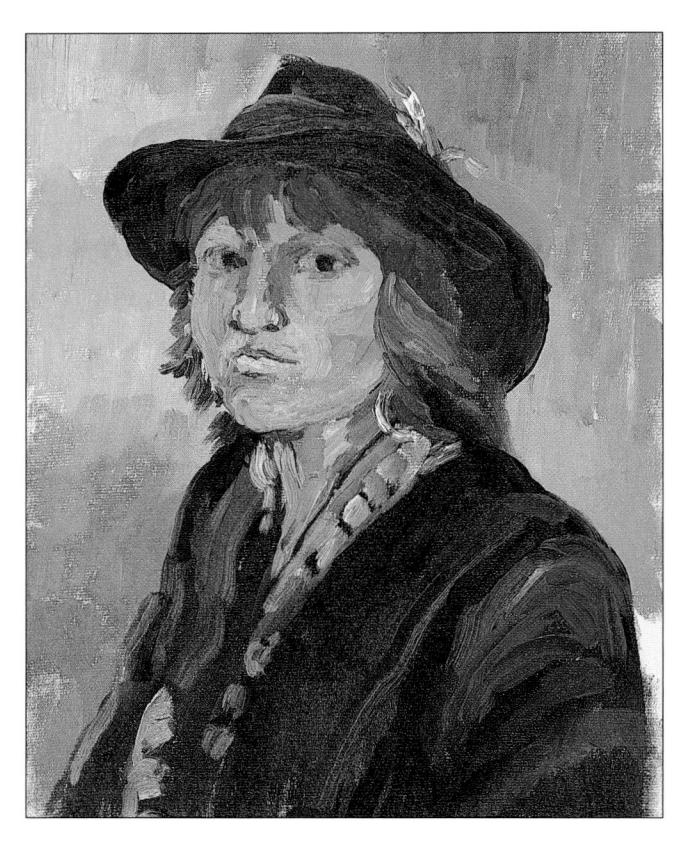

THE PROBLEM -

Churned-up paint is a very common problem. but it's quite an easy one to avoid. What the student has done here is to pile up layer upon layer of thick, wet paint so that each new brushstroke is muddied by the one below, and a stage is reached where further corrections are useless. The painter has been forced to resort to dark brown at the base of the nose and on the lips to make the brushstrokes show, and this has made the features appear leaden and crude. Oil paint has a very nice feel to it, and the temptation to put it on from the start in great juicy dollops is almost irresistible. If you like thick paint, by all means use it, but the secret lies in knowing when and where to start building it up.

- THE SOLUTION -

If the painting is beyond rescue you can, of course, scrape it all off with a palette knife and begin again, but if you master a few basic rules of painting craft you may never have to resort to such drastic measures. The golden rule in oil

painting is to work "from fat to lean." This means that in the initial stages the paint should be fairly thin, diluted with just turpentine (or other thinner). Turpentine gives the paint a very matte, dead look, so as the painting progresses, add less and less, using undiluted paint in the last stages. Often a mixture of turpentine and oil (usually linseed) in a ratio of 60% to 40% is used to dilute the paint, in which case the oil content can be increased for the later stages to make the paint thicker. This is the method used in the painting opposite, where the high, rich gloss is produced by the oil content of the final layer. By applying the paint deftly and only building it up when the likeness has been "found" in the thinner paint of the underlayers, the face has retained a lively, fresh appearance.

The paint in the darker areas or in the background is often left thin, while the main subject and the highlights are built up more solidly, giving a pleasing variety of texture. In Tom Coates's painting, the weave of the canvas is clearly visible through the paint in places, but the face itself is thickly painted.

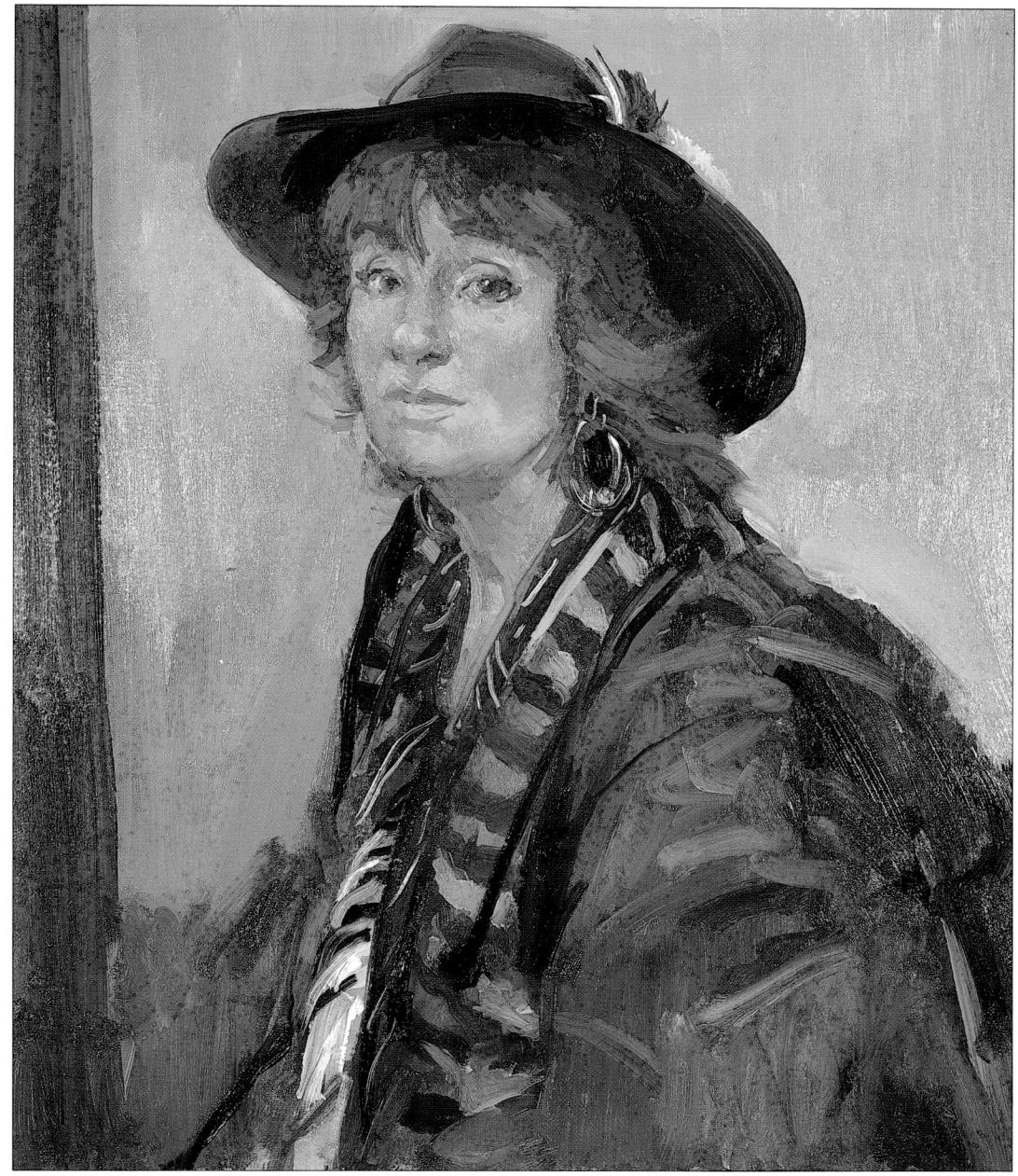

Portrait of Patti by Tom Coates. $24 \times 20 \text{ in}/61 \times 50.8 \text{cm}$

■These two photographs were taken as the portrait was being painted. The artist begins by laying down broad strokes of thinned paint (far left), indicating the cheekbone with a slash of lighter color. In the second photograph, the painting is nearing completion. The main colors of the face have been established, but the details are only hinted at.

Choosing the right surface, or support, is important in oil painting because it affects the way the paint behaves. Very smooth surfaces like hardboard don't hold the paint very well, and it tends to slither about and become difficult to handle. Use hardboard if you want to – it is inexpensive and readily available – but first sandpaper it down well and then prime it with acrylic primer, which is more absorbent than oil-based primer. You can also use the rough surface, the "wrong" side, which is very heavily textured, but this is only suitable for people who like to use their paint thick. Canvas has always been the most popular support because the weave of the fabric holds the paint well, and the texture shows through where the paint is thin, giving a pleasing surface. Art suppliers also make a variety of different painting boards, the more expensive ones being made of canvas stuck down on board. Try out as many different supports as you can until you find the one that suits you best.

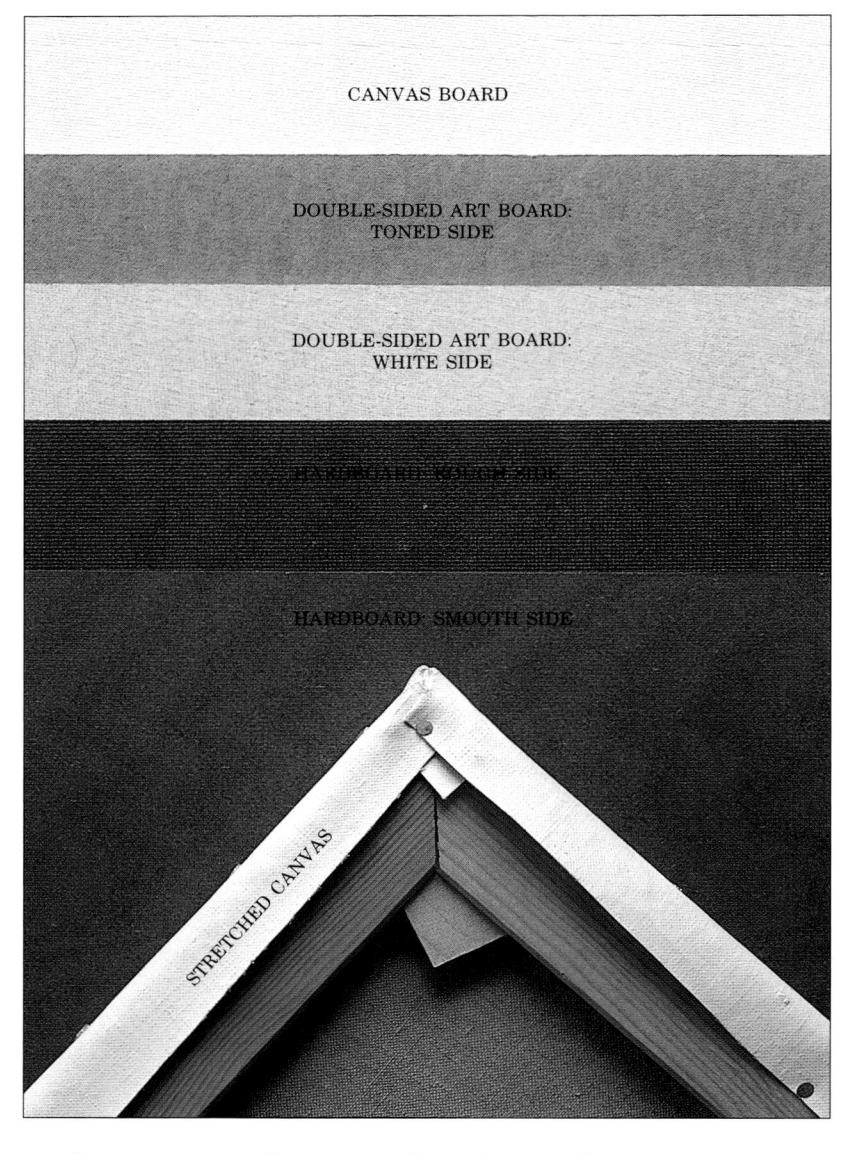

■ Start with a drawing If you plan your painting well, you won't have to make so many corrections while painting, which will help to prevent churned-up paint. So it pays to get the drawing right first. Not all subjects require a drawing or underpainting; indeed it is sometimes undesirable, but half the fun of painting a portrait is producing a likeness, so in this case it's a good idea.

You can draw on canvas or board just as you would on paper, with either an ordinary pencil, a graphite stick, or charcoal. Charcoal makes a lot of black dust which tends to muddy the paint, so it's wise to spray fixative on the drawing as soon as you're happy with it, or you can flick all over it with a rag to remove the surplus dust. Don't try to make the drawing too elaborate – it will soon be hidden by paint. Just aim at getting the proportions and the main lines right.

- Or an underpainting Some artists prefer underpaintings to drawings, because using a brush enables them to block in the main dark and light areas and provides a good "map" for the painting. The paint should be very thin and runny, almost like watercolor, so mix it with a lot of thinner such as turpentine and put it on as though you were doing a wash drawing. You can either use just one color, like a neutral brown or cool blue-gray, or you can use several colors, in which case they should relate to the ones you'll be using for the later stages.
- Correcting mistakes If your paint has become seriously clogged and you want to alter a particular area, simply scrape off the surplus paint with a palette knife and, if the knife does not remove enough of the paint, rub the rest off with a rag soaked in paint remover. If the whole painting has gone wrong, the best way of getting

The hog bristle brushes normally used for oil painting are made in a wide range of sizes and three main shapes flat, filbert, and round, All three can be used in many different ways, but as a general rule flats are the best for laying in big areas such as skies or backgrounds, while large rounds are useful for scrubbing on thinned paint for an underpainting. Small rounds are the ones to use for little touches of detail, and sharp lines can be painted with the side of a filbert.

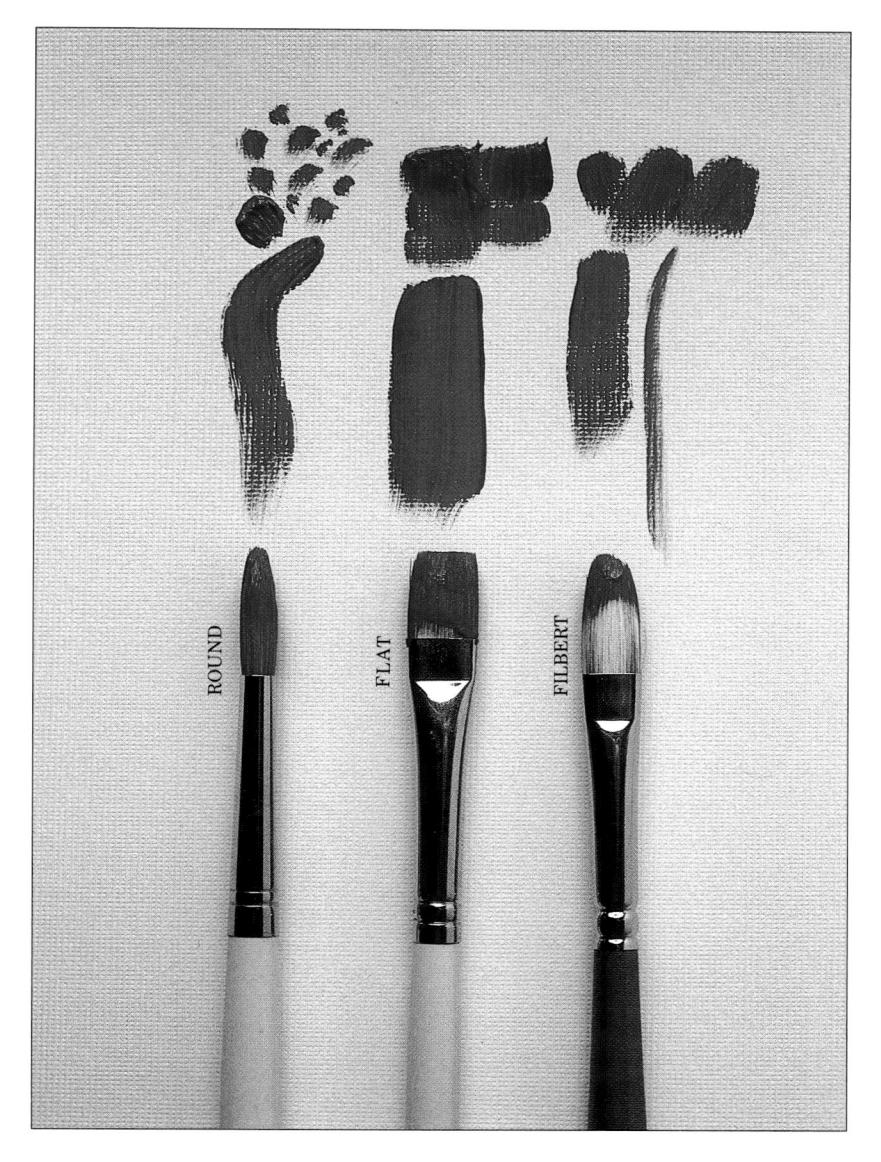

rid of the paint is by a simple method called "tonking" after its inventor Sir Henry Tonks, who taught generations of artists at the Slade School of Art in London. While the painting is still wet, lay a sheet of absorbent paper, such as newspaper or paper towel, on top, rub it gently and then peel it off. This removes the surplus paint, but leaves you with a ghost image similar to a colored underpainting.

■ Canvases and boards The kind of surface you choose for your painting is very important, since it affects the way your paint behaves. Many amateur artists paint on hardboard, which is inexpensive and easy to cut to size, but this has a very shiny, nonabsorbent surface which causes the paint to slide about and become unmanageable, taking a long time to dry. Textured surfaces like the canvases or canvascovered boards absorb more of the oil and are

pleasanter to work on as they hold the paint better. Ready stretched and primed canvases are fairly expensive, but the larger artsupply stores sell unprimed "canvas" (linen or cotton) in rolls, together with canvas stretchers. It is not difficult to stretch your own canvases, but once you have done this you must prime them before use or the oil from the paint will rot the fabric.

– $USEFUL\ TIP\ -$

When you thin oil paint with turpentine it dries fairly quickly, but underpaintings can also be done in acrylic, which dries even faster. It's perfectly safe: oil can be used on top of acrylic, but not the other way around. Some artists work in acrylic until about halfway through a painting, switching to oil for the final stages.

I thought it would be easier to start with a small canvas, but I couldn't fit the figure in.

THE PROBLEM

The scale on which you work may seem a trivial matter, but in fact it can be an important element in the success or failure of a picture. Some people who are just beginning in oils start with a huge canvas or board and then are unable to fill it, ending up with a tiny little figure lost in a great sea of background. Others, the student among them, start in a cost-conscious way by buying the smallest size, and then find the subject seeming to spread of its own accord. The picture then looks cramped and awkward, and this is what has happened here. The student has obviously begun with the head and found there wasn't room for the arms, and her attempts to fit them in have distorted the proportions.

- THE SOLUTION -

In the painting opposite the subject sits comfortably in the frame, with the arrangement of the arms introducing interesting compositional lines. The difference in size between these two can-

vases is pronounced: the student's small one is only 14 in (35.5cm) in height, whereas David Curtis's is nearly four times that. When painting landscapes, he works on a fairly small scale, but he likes a large size for figure work in order to do justice to the subject. Unless you are a natural miniaturist, it's hard to paint the small details of features with freedom if the face area is so small that you find you have to resort to tiny brushes. Getting the feel of size Painting is similar to handwriting; everyone has a size that feels comfortable for them, and it is difficult to increase or decrease it. But the only way to find out which size suits your subject and way of working is by trial and error. You won't want to waste expensive canvases and boards, so it's a good idea to start by working on oil sketching paper tacked to a drawing board. This paper is sold in large sheets, so you can either use the whole area or mask off some of it with tape if you find your painting wants to be smaller.

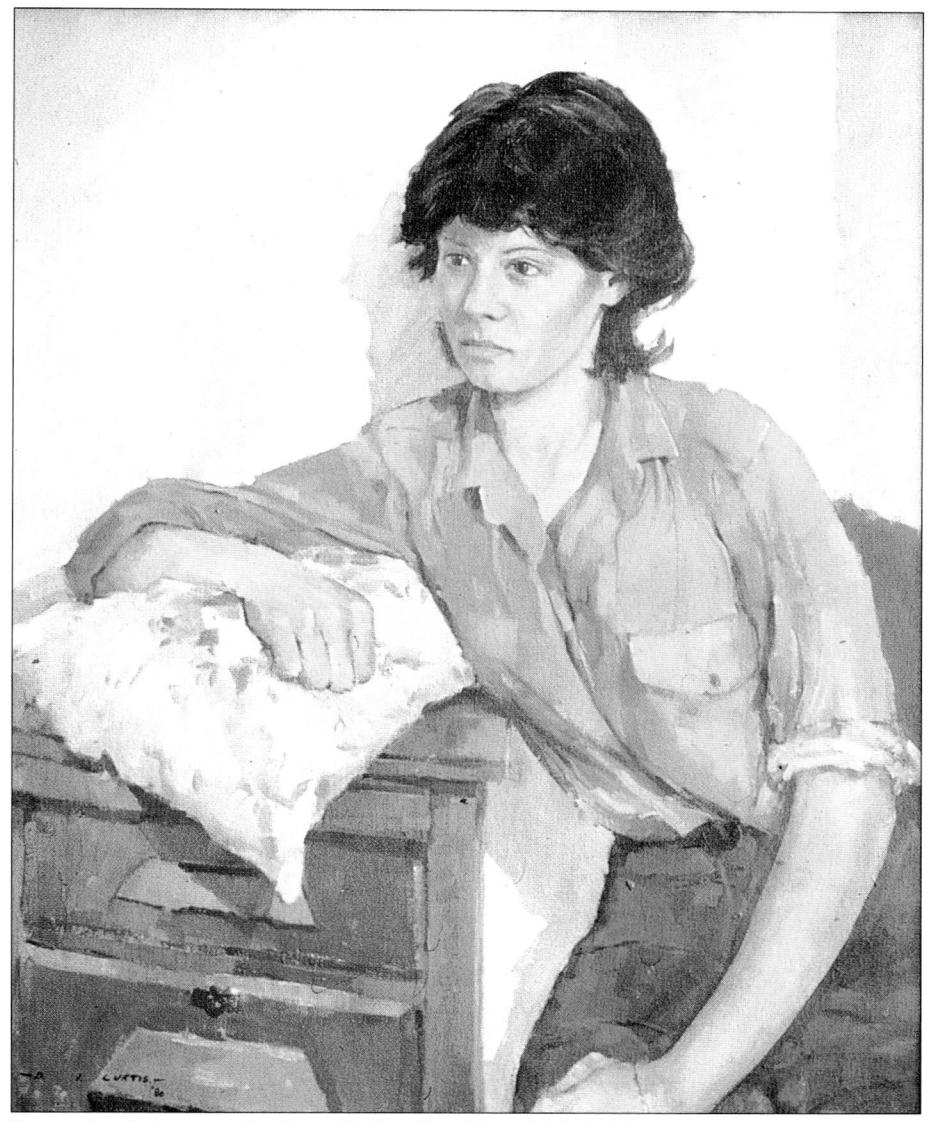

Portrait of Jeanette by David Curtis. $40 \times 30 \text{ in}/101.6 \times 76.2 \text{cm}$

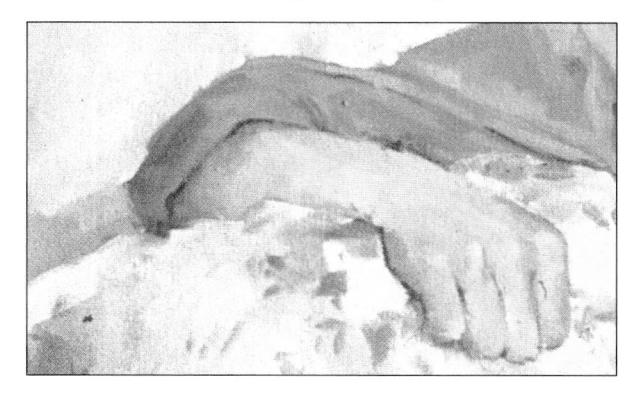

The space between the elbow and the left side of the canvas prevents the arm from looking cramped, as it does in the student's painting.

The deliberate cropping of the left hand makes a pleasing shape at the bottom edge of the canvas.

How can I make my paintings less monotonous?

The rocks look the same as the sea.

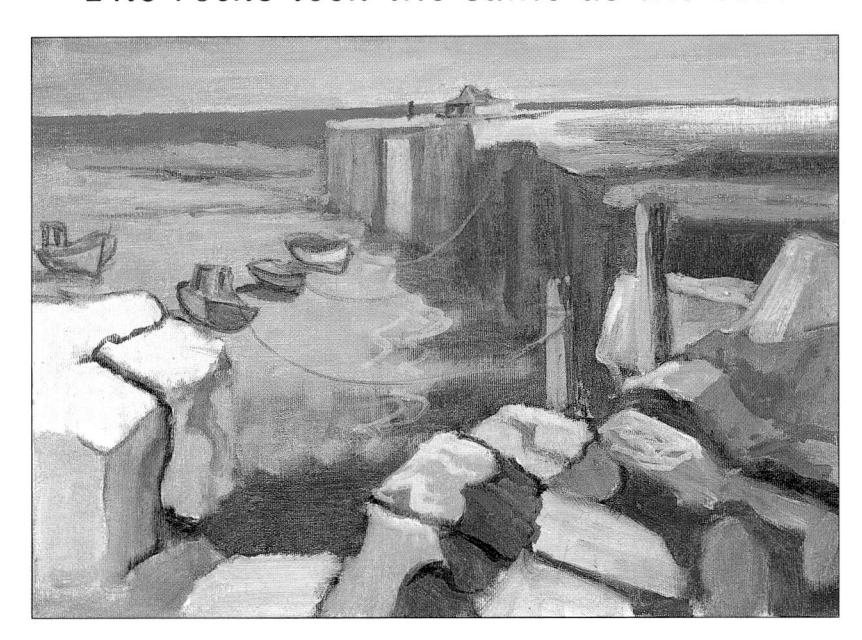

THE PROBLEM

All paintings share one thing in common – they are flat surfaces on which paint is laid to imitate something imaginary or seen in nature. Color plays a vital part in the process of arriving at a two-dimensional equivalent of a three-dimensional subject, but the way the paint is put on is just as important. Not only do different kinds of brushstrokes help to define forms, suggesting the different textures of objects in a way that color alone cannot do, they also give the finished painting a pleasing texture, or paint surface. The student has treated rocks, sea, and boats as though they were all made of the same substance: it is the monotony of the brushwork that has turned a potentially exciting subject into a dull picture with an unpleasing paint texture.

- THE SOLUTION -

When oil paint was first invented, it was used fairly smoothly, and painters took pride in producing works in which no brushstroke was visible. But it was not long before great artists, notably Titian in the 16th century and Rembrandt in the 17th, began to exploit the possibilities of the paint itself, and the marks made by the brush became an integral part of the work. The French Impressionists took this even further, and in Monet's work, the paint surface virtually became the subject.

- Unity and variety In the painting opposite the brushwork is lively and varied. In the foreground, flat, juicy strokes map out the volume of the rocks. Vertical slashes represent pieces of timber, and the gentle swell of the water is carefully observed with strong, intuitive strokes from all directions. Notice how slight is the difference in color and value between the rocks and the timber - their forms and textures have been created largely by the way they have been "drawn" with the brush. But there is unity in the variety: although individual brushstrokes may go in different directions, each area of the painting has been treated with the same approach. Imagine what the effect would be if the artist had decided to paint the sea in little pointillist dots - it would look as though two completely different paintings had been cobbled together.
- Brushes When planning a painting, always look at the subject in terms of paint surface as well as color and value, and experiment with different brushes to get the feel of the various marks they make. You may find that one particular shape of brush suits your style of work Cézanne favored square-ended brushes for his diagonal, brick-like strokes, while Monet created his shimmering effects of light with small dabs of color applied with pointed brushes. (Turn to page 13 for illustrations of different shapes.)

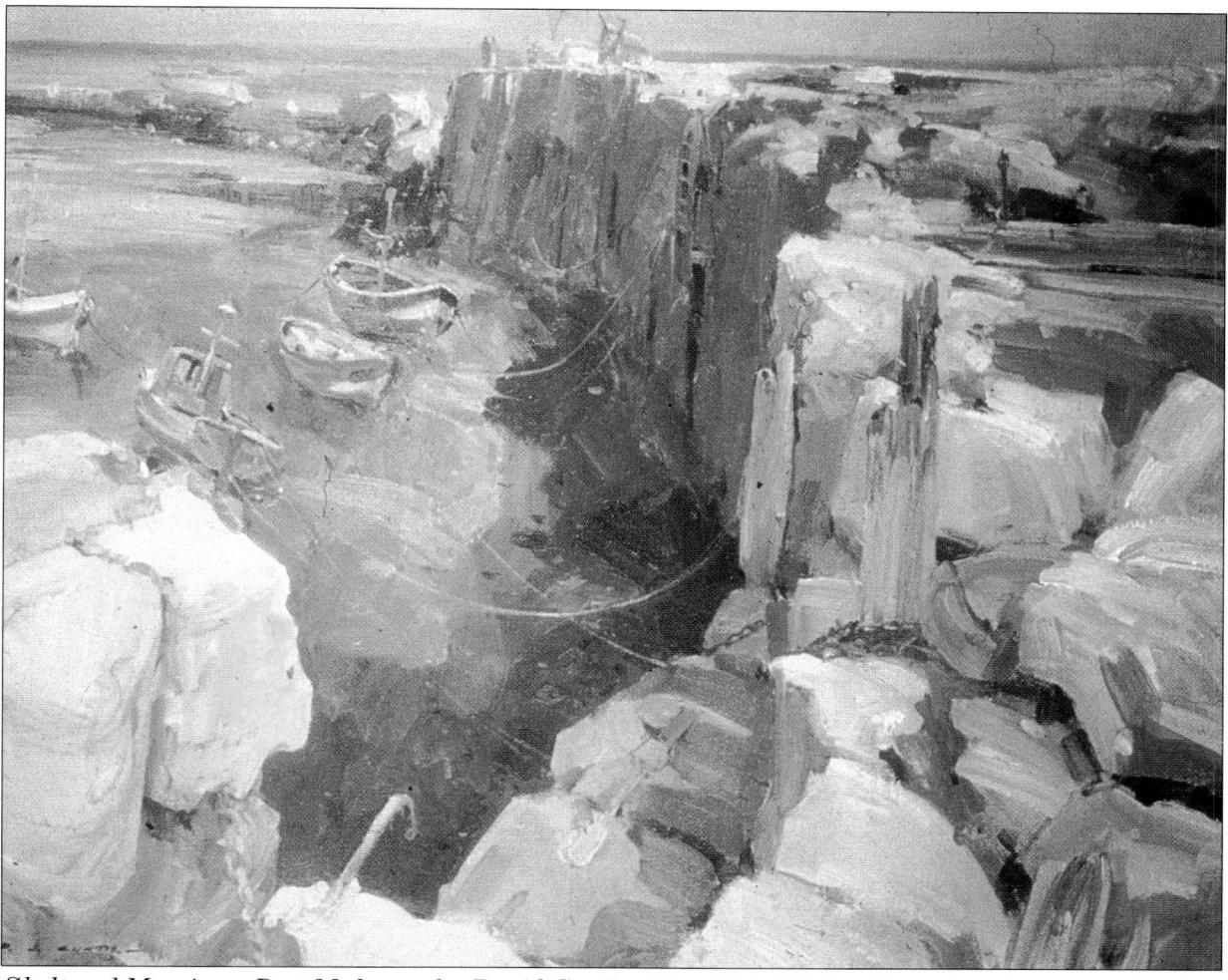

Sheltered Moorings, Port Mulgrave by David Curtis. 20×24 in/50.8 \times 61cm

■David Curtis achieves his varied and exciting effects with just one type of brush, a filbert-shaped bristle in a number of different sizes. He finds this shape the most versatile, because it can be used flat for broad areas and on its side for crisp, clear lines. The choice of brushes is a very personal one, and you probably won't find out which kind you like best until you have worn out a few.

North Norfolk Beach by Peter Burman. $30 \times 24 \text{ in}/76.2 \times 50.8 \text{cm}$

Although this subject – a boat hurtling through water - is an exciting one, it could have looked dull and static if it had been treated in a fussy, overrealistic way. There is the minimum of detail here, but the artist makes his brush speak volumes. The boat itself is sketched in with just one or two strokes, and the sky and foreground are suggested very broadly. The real subject of the painting is movement, and the rapid, expressive brushstrokes convey a marvelous feeling of urgency and excitement.

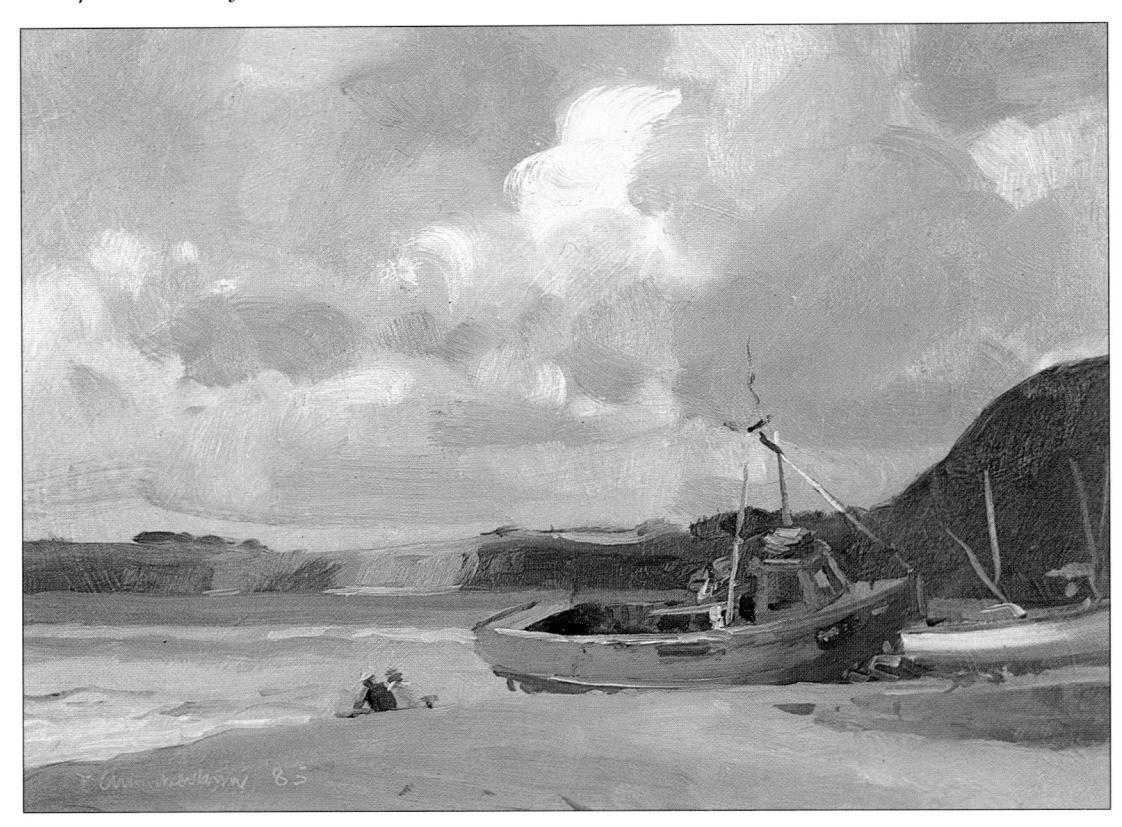

South Devon Coast by Trevor Chamberlain. 6×8 in/15.2 \times 20.3cm

Beginners often make the mistake of putting on the paint with uniform, flat strokes, but this can make the painting less expressive. Look at the way the artist uses different brushstrokes for each part of the painting, and how

descriptive they are. This is because they follow the shapes of the objects instead of going against them. The lovely, swirling strokes he uses for the sky make us almost able to feel the movement of the clouds as they form and reform.

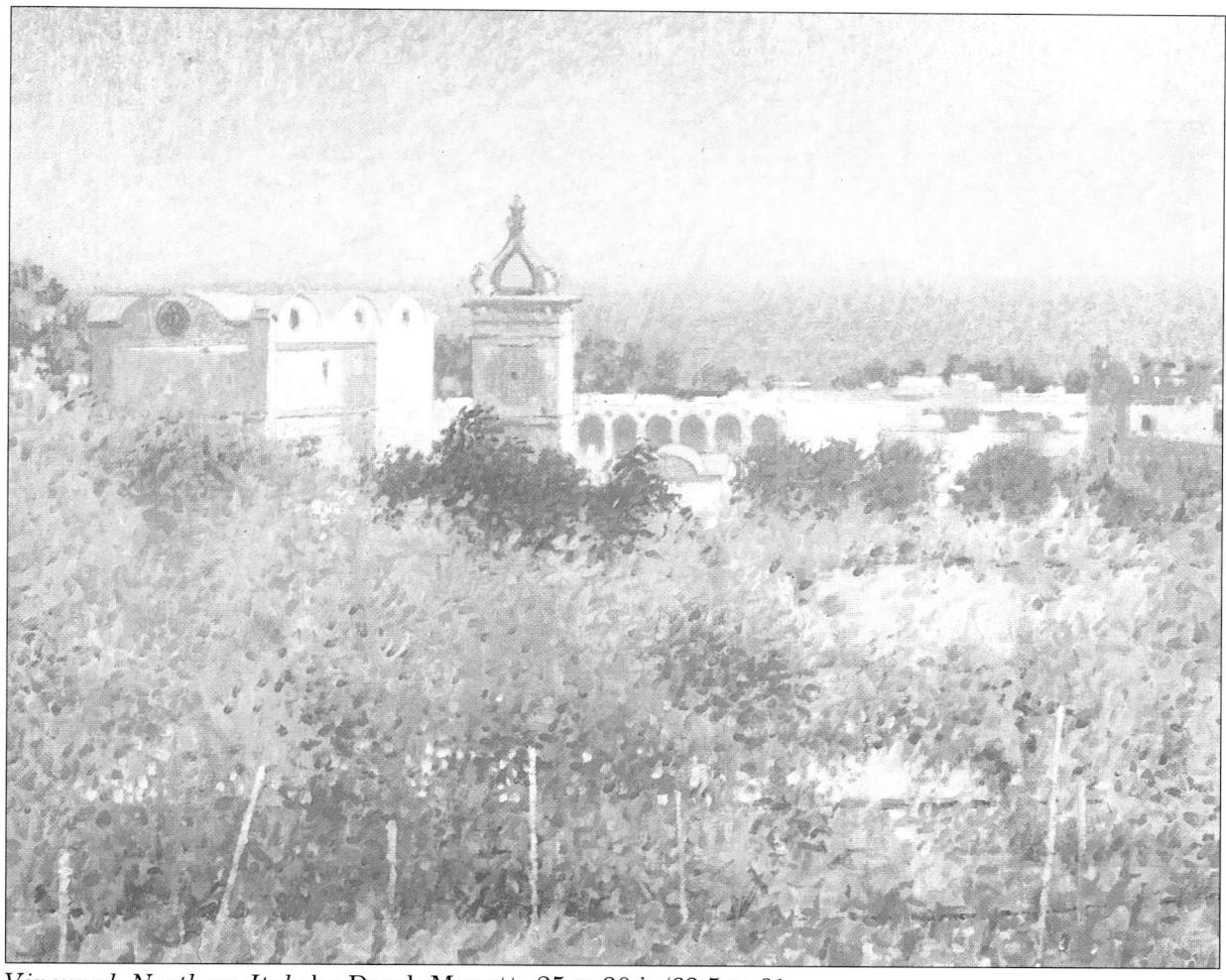

Vineyard, Northern Italy by Derek Mynott. $25 \times 30 \text{ in}/63.5 \times 61 \text{cm}$

This picture could not be more unlike the others shown on these pages. Here the effect is of stillness, not movement, and the artist has created the impression of misty, shimmering light by carefully building up tiny, delicate brushstrokes in a precisely controlled range

of values and colors. Notice how he has used the same method throughout the painting: at first glance the sky seems flat, but look more closely and you will see that it too is composed of myriad little dabs, merging gently into the distant hills.

I like the idea of using really thick paint, as Van Gogh did, but my attempts look crude.

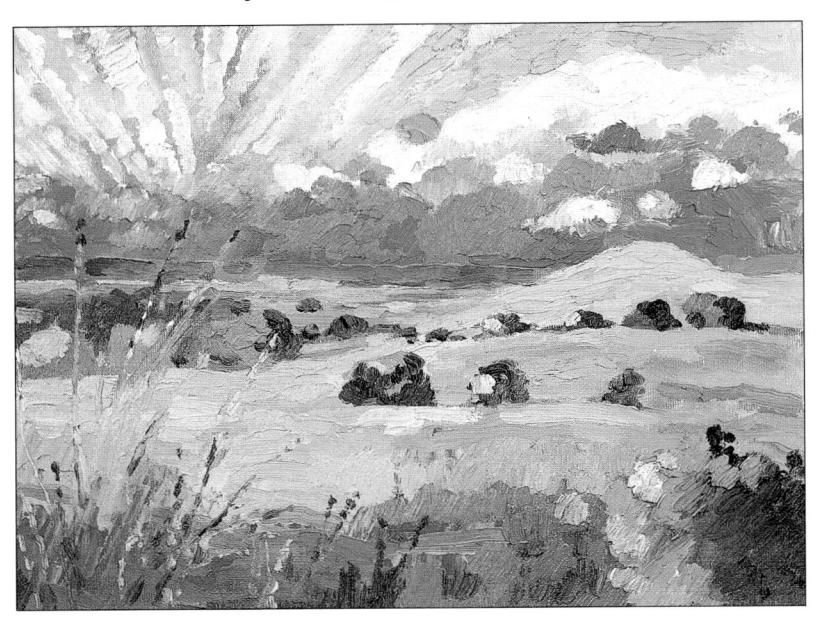

THE PROBLEM

As any admirer of Van Gogh knows - and the student here is clearly among them - using really solid paint can create a marvelous feeling of energy, spontaneity, and excitement, and it's a splendid way of exploiting the buttery consistency of oil paint to the full. If used well, impastos (the technical term for paint applied very thickly) can be both expressive and attractive. The paint stands away from the canvas in ridges, giving an effect akin to relief sculpture, and the marks of the brush or painting knife make a lively textured pattern on the surface of the canvas. But piling up more and more paint does not always give this effect - impasto paintings can go sadly wrong, and look messy and untidy. The student has made a good try: there is plenty of energy in the picture, and parts of it work well, but the brushwork is rather crude, particularly in the foreground, where uncertainty and indecision have led to muddled overworking.

THE SOLUTION -

The same view, painted by Brian Bennett (opposite) shows a more controlled use of impasto. The paint used for the dramatic sky is applied with a painting knife, flattening the impasto. The distant hills are left as a thin layer of paint, but in the foreground, the wind-blown grass, applied with the edge of the knife, is allowed to stand out. By this method – using

stronger detail in the foreground than in the background – the artist has introduced a convincing feeling of recession in the painting. But this is not the only way of doing things: as the student has noted, Van Gogh used his paint uniformly thick. He would sometimes squeeze it on straight from the tube and then "sculpt" it with a brush into short strokes or swirling curves. Rembrandt built up his paintings from thin to thick, laying on final impasted highlights with a palette knife. This is the commonest approach, and most artists who exploit the solidity and opacity of oil paints include painting knives in their equipment, using them as occasion demands.

■ Knife painting An ordinary straight-bladed palette knife is the tool you use for cleaning your palette and sometimes for mixing paint. You can use it for putting paint onto canvas, but it's a clumsy method as palette knives are not designed for painting. Painting knives are purpose-made; they have delicate, flexible blades and cranked handles, and come in a variety of shapes and sizes. Although the marks they make are different to brushmarks because the flat surface of the blade "squeezes" the paint onto the surface, they are capable of extremely subtle and varied effects. Brian Bennett's landscape shows these very well - small, light touches from the point of a triangular blade give a lively sparkle to clouds and foliage, while fine lines, such as

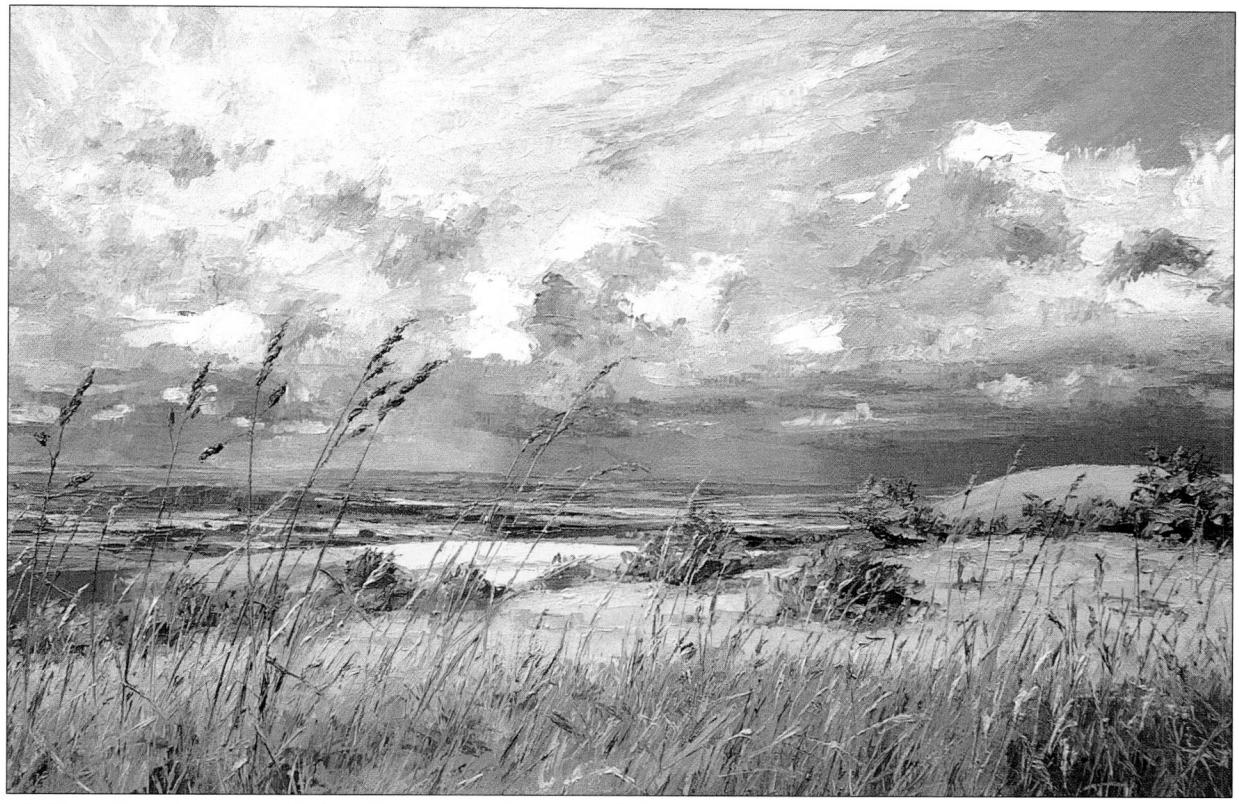

Chiltern Landscape by Brian Bennett. $30 \times 20 \text{ in}/76.2 \times 50.8 \text{cm}$

▶ Paint is flicked on with the edge of the knife, giving a sharper, clearer line than is possible with a brush. The thickness of the paint makes the effect even more pronounced, as the knife strokes stand out in fine ridges.

those of the blades of grass in the foreground, are touched on with the side of the blade. On these pages you can see another artist's approach to knife painting, together with some of the many effects you can achieve, but if you experiment on your own with different knives you'll evolve your own methods.

■ Mediums As you've no doubt discovered, oil paint is far from cheap, and impasto painting can make a large and unwelcome hole in your budget. The solution to this problem is to mix the paint with a bulking medium specially made for impasto work, which will thicken it without changing its color. Most paint manufacturers have their own brand, so ask in your local art

supply shop if you're not sure what to buy. If you don't use a medium you can only make the paint really solid by adding white, which means that you can only put on the paler colors thickly. The medium lets you make all the colors thick, even the dark but vivid ones such as the crimsons and the deep blues and greens, which are somewhat thin and transparent on their own. You'll be amazed at how little actual paint you need. The other great advantage of the impasto medium is that the paint will remain just as you put it on, retaining the marks of the knife or brush, which is what impasto painting is all about. Sadly for Van Gogh, it was not invented until long after his lifetime.

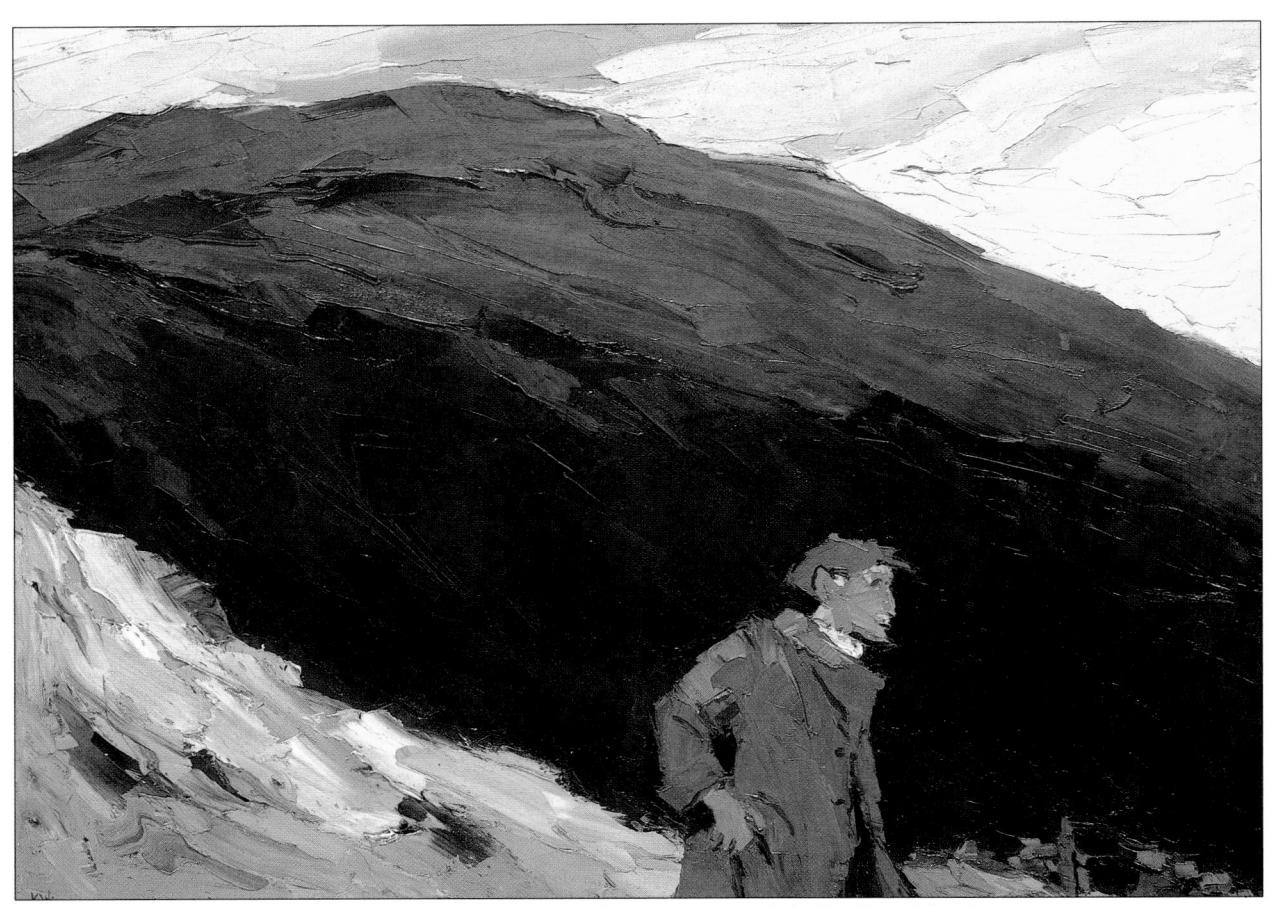

Dafydd Williams on the Mountain by Kyffin Williams. 36×48 in/91.5 \times 121.9cm

Here the artist has worked entirely with painting knives. This technique gives a much harsher effect than impasto applied with a brush, and the pattern of angular slabs and ridges of paint gives additional feeling and drama to the somber subject matter.

Painting knives are made in a wide range of shapes and sizes to enable you to vary your effects. The large, straight ones are ideal for sweeping the paint onto the surface, while the small, pearshaped ones, which can can be used very precisely, are perfect for little touches such as flecks of light on foliage.

The artist using a painting knife constantly scrapes off and then re-lays paint until the desired effect is achieved. It's an exciting technique, but it's wise to restrict the number of colors you use until you have the feel of it, since the paint will quickly lose its freshness if overworked.

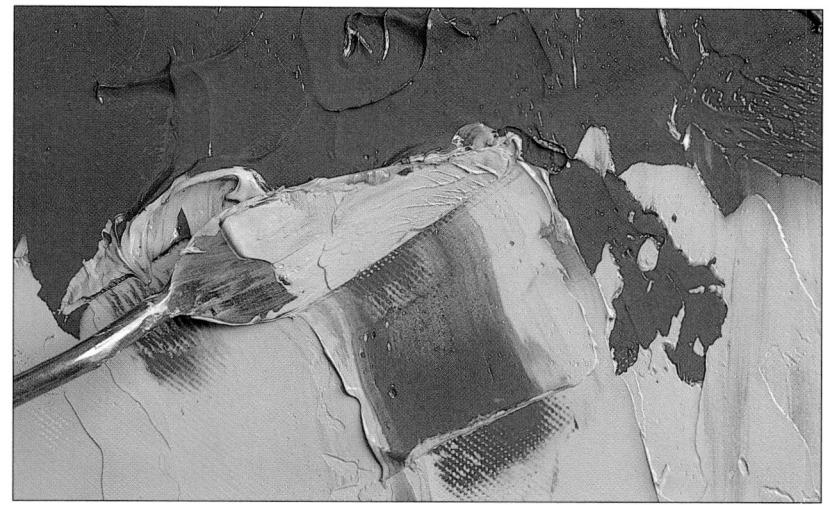

▶ If you compare this demonstration with the palette-knife one you will see two entirely different effects. In both cases the paint was very thick, because it was bulked out with impasto medium, but these swirls and curves could only be made with a brush. The knife "squeezes" the paint onto the surface, giving much more angular marks.

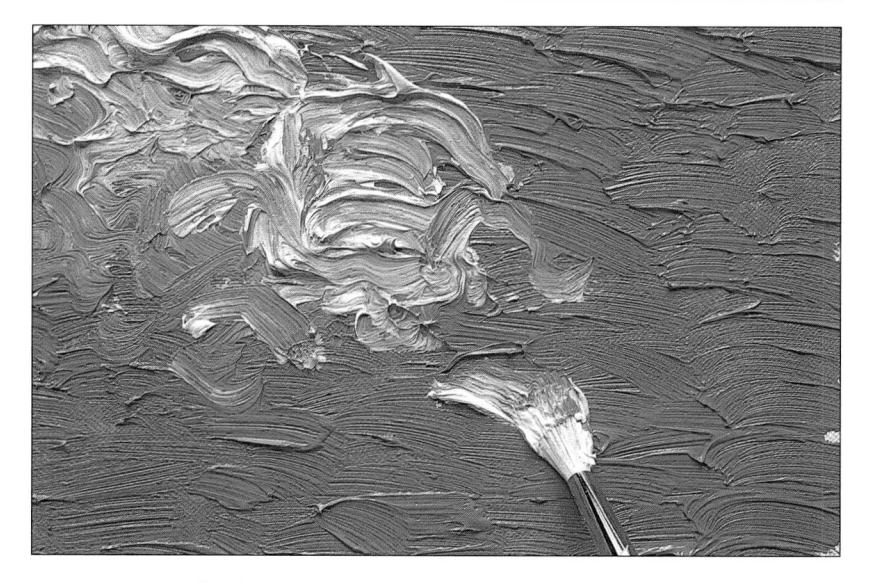

I intended to do a quick outdoor sketch, but I have overworked it.

THE PROBLEM

Painting outdoors presents a different kind of challenge to that of an indoor setup such as a stilllife or portrait. For a start, there are the purely physical problems - you may be too hot or too cold; your easel may blow over, or the sun may shine so brightly on your work that you can't see what you're doing. But more crucial is the fact that you have very little control over the subject beyond that of choosing the view you intend to commit to canvas. You can't control the lighting – if the sun wants to go in or come out, it will - and you can't ask a tree to move over a little so that it catches the light better. The student's picture looks as though it was begun on a dull day, when the colors were muted and the contrasts small, and altered with increasing desperation when the sun emerged to transform the whole scene. As he has rightly observed, he has overworked it, causeing the muddy colors and heavy look of the painting.

- THE SOLUTION -

In contrast, David Curtis's painting opposite looks fresh and spontaneous. You can see how quickly and deftly he has observed the scene and applied patches of color to canvas. The paint is touched in lightly so that it retains its freshness, whereas the student has made the mistake of working each new brushstroke somewhat heavily into the color beneath.

- Keeping up with nature If you are working in a changeable climate, the odds are that your chosen view will not remain the same for long. and even in sunny lands the direction of the shadows will alter as the day wears on. Painters who regularly work outdoors often take two or three canvases or boards so that they can start work on another sketch when the light changes, returning to the first on another day. If your subject is a complex one that requires an underdrawing, such as buildings, or boats in a harbor, do the drawing and painting on separate occasions so that when you begin to paint you won't have to make corrections and waste valuable time. When you do begin to paint, work as fast as you can without rushing.
- Working alla prima This term describes the kind of painting that is completed rapidly and freely in one session. It is unlike the classic building up method described earlier in that the minimum of underdrawing is done, and the paint is put on thickly and opaquely from the start. No painting medium is needed, though a little oil can be used to make the paint more manageable. Each brushstroke and patch of color is more or less the final one, but as the colors are applied wet-into-wet instead of being left to dry between layers they will blend together in places on the canvas, an effect much prized by the Impressionists. The technique is the perfect one for recording quick impressions.

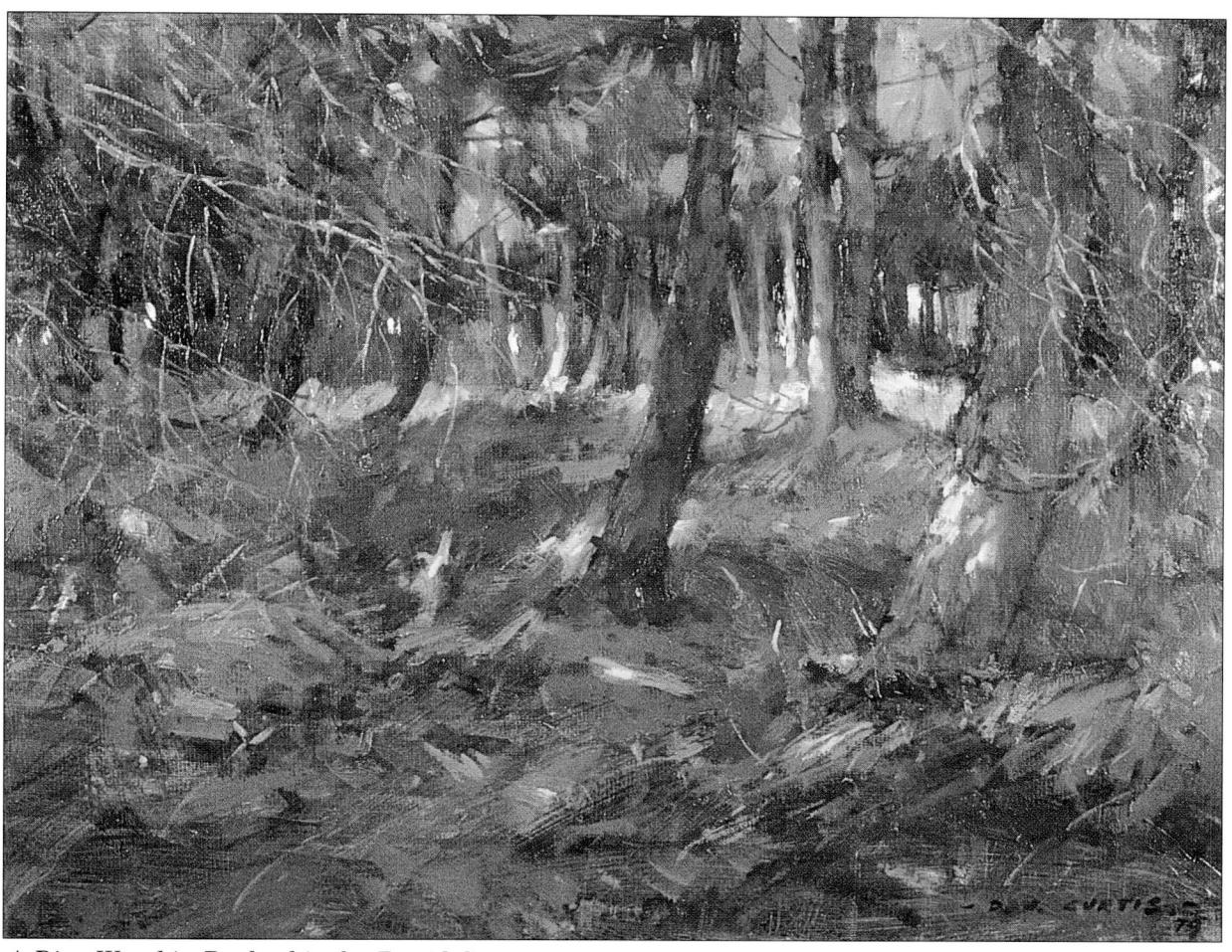

A Pine Wood in Derbyshire by David Curtis. 18 imes 14 in/45.7 imes 35.6cm

The secret of painting *alla prima* is to avoid overworking. If you want to make changes, it's often better to scrape down the offending area with a palette knife. Here the paint looks bright and fresh because it has been applied lightly and swiftly, without muddying earlier layers.

How do I make grays and browns lively? They are flat and dull in my painting.

THE PROBLEM

The gentle grays, blues and ochers of a winter scene like this, with its stone-built houses and bare tree trunks, are among the loveliest in nature but, as the student has discovered, they present a considerable challenge to the artist. If you paint them too flat, covering the canvas with areas of even color, they look both drab and unrealistic. But if you try to introduce bright colors, such as patches of vivid green foliage or brightly painted doors, the subtle colors suffer by contrast. In the student's painting, all the surfaces look lifeless because there is little variation in any one area of color, but in reality every patch of "brown" or "gray" is a complex combination of colors.

– THE SOLUTION -

In the painting opposite the artist uses a novel approach to color. He begins with an ocher underpainting, and on top of this he puts down large, bold patches of color, slightly exaggerating the natural hues. You will see that the green

tree in the foreground is made up from a number of different shades of green, and also blue. He leaves the underpainting uncovered in places, which helps to unify the picture, and then completes the process of tying the various areas together by reasserting the original drawing with a black line. There is a lot going on in the painting, but the forms and textures of the buildings and the way the light falls on them are suggested rather than described literally.

■ Using broken color There are several different ways of making colors appear brighter or more interesting, and they are all variations on the idea of optically mixing the paint on the canvas. Gordon Bennett's painting relies for its effect on the use of broken color, a technique in which strokes of paint are applied alongside each other with no blending, giving a mosaic-like effect. This is a method that needs planning — it won't be successful if you put on a random hodgepodge of unrelated hues. Start by working within a small color range, mixing several versions of each color on your palette before

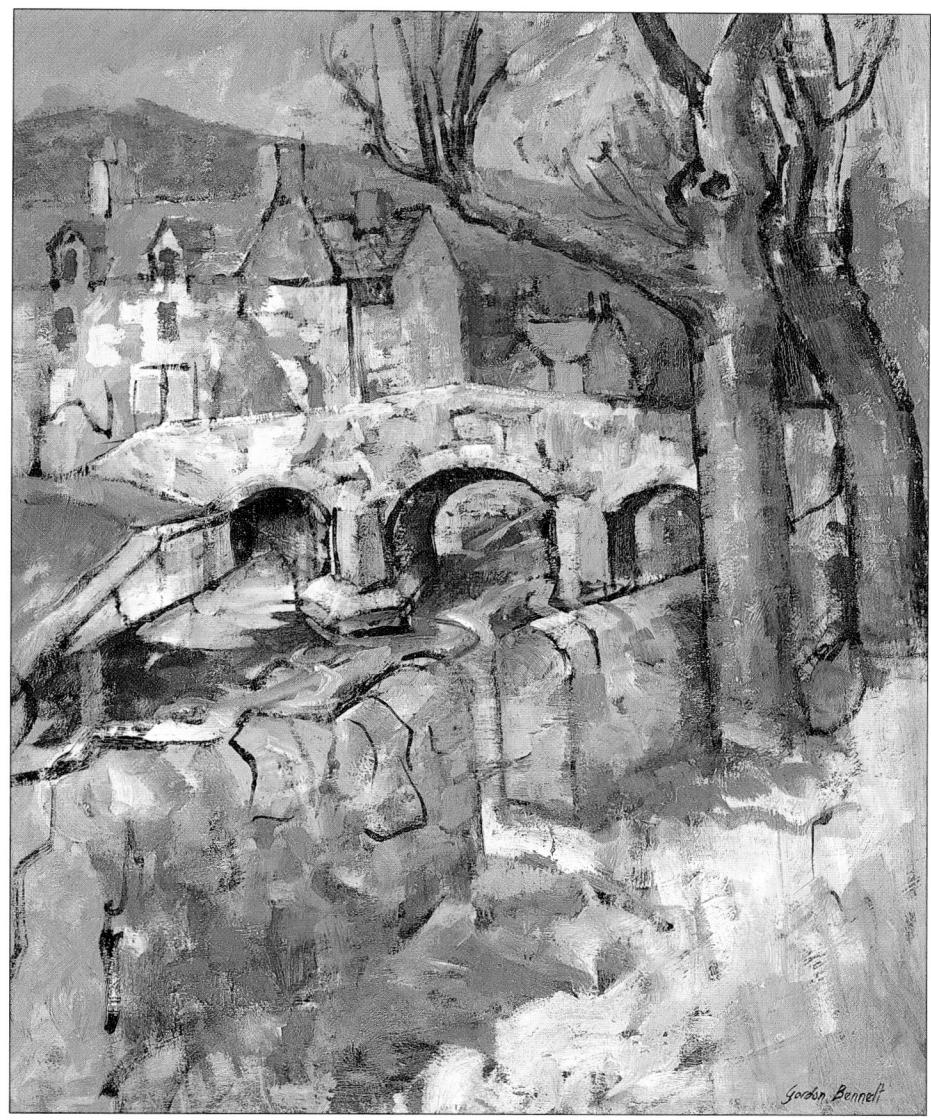

The Bridge at Baslow by Gordon Bennett. $30 \times 24 \text{ in}/76.2 \times 61 \text{cm}$

Separate patches of color are applied, varied but close in value. The shape of the brushmarks suggests stonework.

Blues repeated from the stonework help to give unity to the painting. Patches of the warm yellow ground are allowed to show through.

Lighter blue-gray and curved brushstrokes suggest the shape of the wall and the fall of light.

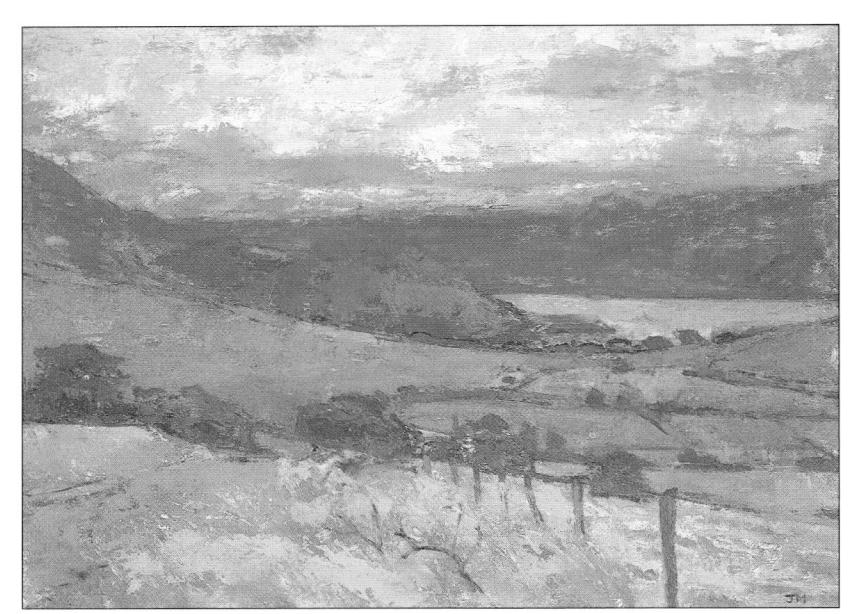

■Paradoxically, a large area of flat color seldom looks really vivid because the lack of contrast reduces its vitality; it is usually best to break it up in some way. The artist has used the technique of scumbling (see page 30) to give extra punch to his predominantly quiet color scheme. He applies the paint unevenly and rather dry, so that both the warm ocher of the tinted ground and earlier layers of lighter paint show through in places.

Ullswater by Jack Millar. 21×17 in/53.3 \times 43.2cm

putting any down on canvas. Keep them close together in value; a wall or sky will fail to read as a flat surface if you juxtapose light and very dark brushstrokes. You may find it helpful to work on a tinted ground or an underpainting, as otherwise you will find distracting little patches of white appearing wherever your brushstrokes don't meet. And finally, make sure you keep your brushes clean or each new patch of color will mix with the one before, and you will lose the very effect that you are aiming to achieve.

■ Optical mixing The English artist John Constable discovered that he could make the greens of foliage or grass look brighter and more vibrant by using several different greens close together. The French Impressionists took the method even further, capturing effects of shimmering sunlight by means of small strokes of pure color. When little dots or dabs of primary colors, such as red and yellow, are placed next to each other and viewed from a distance, they mix in the eye of the viewer, and are perceived as orange, but a lovely, luminous, shimmering orange totally unlike one pre-mixed on the palette. The technique is a time-consuming one, so try it out initially on a small scale, keeping the brushstrokes small and the colors of similar value – a dark red and a pale yellow will simply remain themselves.

■ Glazing This, although very different from broken color methods, is another way of mixing paint on the canvas. Glazing involves building up color by laying successive veils of thin, transparent paint, which gives a depth and

richness reminiscent of stained glass. It is one of the oldest techniques in oil painting: the vivid, glowing blues and reds of the robes in early Italian paintings of madonnas or saints were achieved in this way. Until our own times, glazing was a slow and laborious technique, as the paint had to be thinned with slow-drying oil and then left to dry before the next layer was put on. Because of this, during the 19th century artists largely abandoned the method. It is now coming into its own again, and manufacturers of artists' paints have brought out special fast-drying glazing mediums, at least one of which is alkyd-based, and an excellent alternative to oil.

Glazing is often combined with other techniques in a painting, being particularly effective for enlivening an area of dull color or for giving additional richness to a dark one, such as the shadow on the side of a face. Not all the layers of paint have to be thin, indeed very exciting effects can be achieved by applying a glaze over a thick impasto, where the new color modifies the underlying one. Rembrandt used it in this way, sometimes laying a glaze directly over an underpainting in the darker areas, but building up the highlights in thick paint and applying further glazes on top. The possibilities of the technique are endless, so experiment with it in your own way. But don't try to thin the paint with either linseed oil or turpentine, because the oil makes a sloppy mixture that tends to dribble down the canvas, and turpentine gives the paint a dull, matte quality that would defeat the purpose of the exercise.

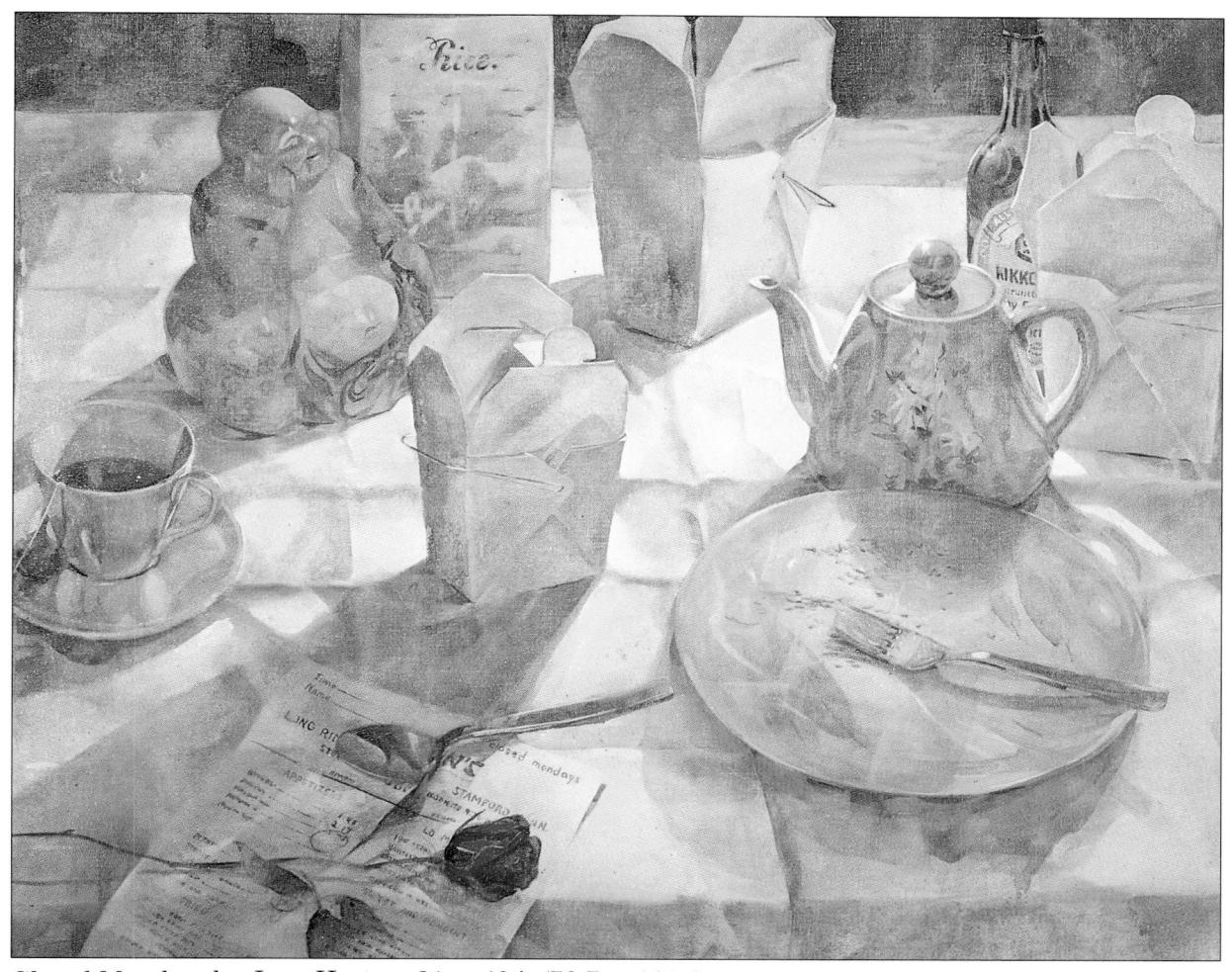

Closed Mondays by Joan Heston. $31 \times 40 \text{ in}/78.7 \times 101.6 \text{cm}$

▲ It's hard to believe that this subtle and delicate painting is an oil. Joan Heston works entirely in glazes, building up an intricate web of colors by laying a series of thin layers one over another. As you can see, she keeps to a small value range, but uses a wide range of pale but clear colors.

This artist loves to capture the transitory effects of sunlight and shade, and here he uses the technique of optical mixing to give his colors extra brilliance. He puts down small dabs of pure color straight onto the canvas so that the whole painting seems to be alive with moving, everchanging light.

Picnic in Wales by Arthur Maderson. 38×32 in/96.5 \times 81.3cm

I liked the textures of the old wood and the whitewashed wall but I've failed to capture them.

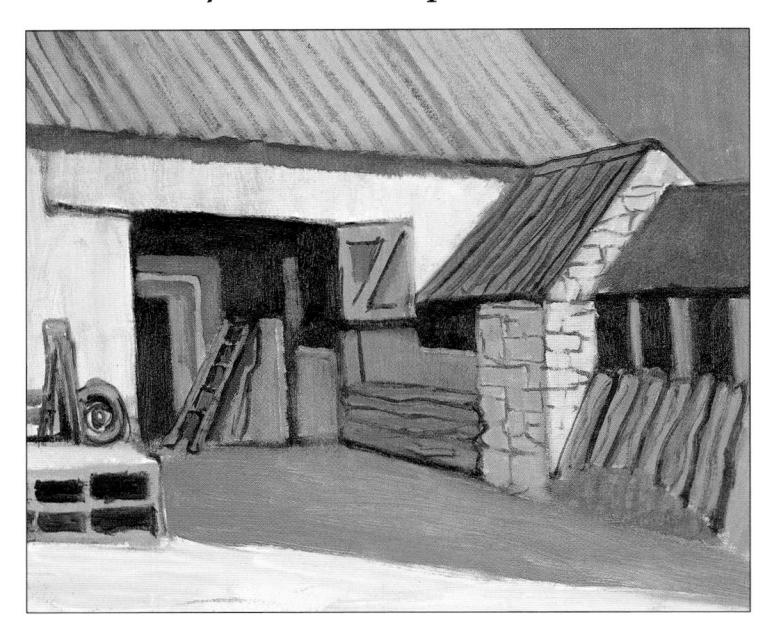

THE PROBLEM

Oil paint is such a versatile medium that a particular technique can be found for virtually any subject. The paint can be used thin and transparent to suggest water, applied in thick, opaque wedges to imitate rocks or bricks, or in small dots to give an impression of shimmering light and color. It can be applied with knives, with a great variety of different brushes, or even with rags or fingers. But artists sometimes only arrive at a particular technique after years of experience and experimenting, so it is hardly surprising that the student has failed to find a suitable way to suggest texture. It's just a case of not having enough knowledge of the medium to exploit it to its best advantage. In his picture, the walls and roofs have been painted as though they were flat; there is little color variation within each area, and the dark lines outlining the pieces of timber are both too regular and too strident. Nevertheless, it's a good start, and could be used as an underpainting over which the texture is applied.

- THE SOLUTION -

Anyone who has ever been to a carpentry class will know that when you are hammering in a nail you must let the hammer do the work, allowing it to fall rather than pushing it, so that its own weight does the job for you. In the painting opposite, the artist has let his brushes

do the work in very much the same way; each brushstroke follows the direction of the old planks in the roofs and barn door so that shapes and forms are suggested rather than described literally. He has also used the technique of applying paint that is only partially mixed on the palette, so that each brushstroke contains several different hues. In old buildings there are always irregularities of surface that are perceived as very subtle variations in color and value; no one area of color is completely flat. Partial mixing is an excellent method for creating textures like these, or indeed wherever you want to avoid flat color. Inexperienced oil painters find it alarming because they feel - and are sometimes told - that they must mix each color thoroughly. The trick is to start with a range of suitable colors on the palette, keeping the values close to one another, and then pick up a little of each, preferably with a square-ended bristle brush, which gives the paint a more effectively streaky look than a round or soft one. If you are not happy with the effect, simply scrape it off and try again.

■ Scumbling This is a variation on the theme of partially mixed paint, but in this case the mixing is done on the canvas by roughly scrubbing opaque paint over a dry layer below so that some of the first color shows through. The idea is to put the color on unevenly — usually with a circular motion, though it can also be

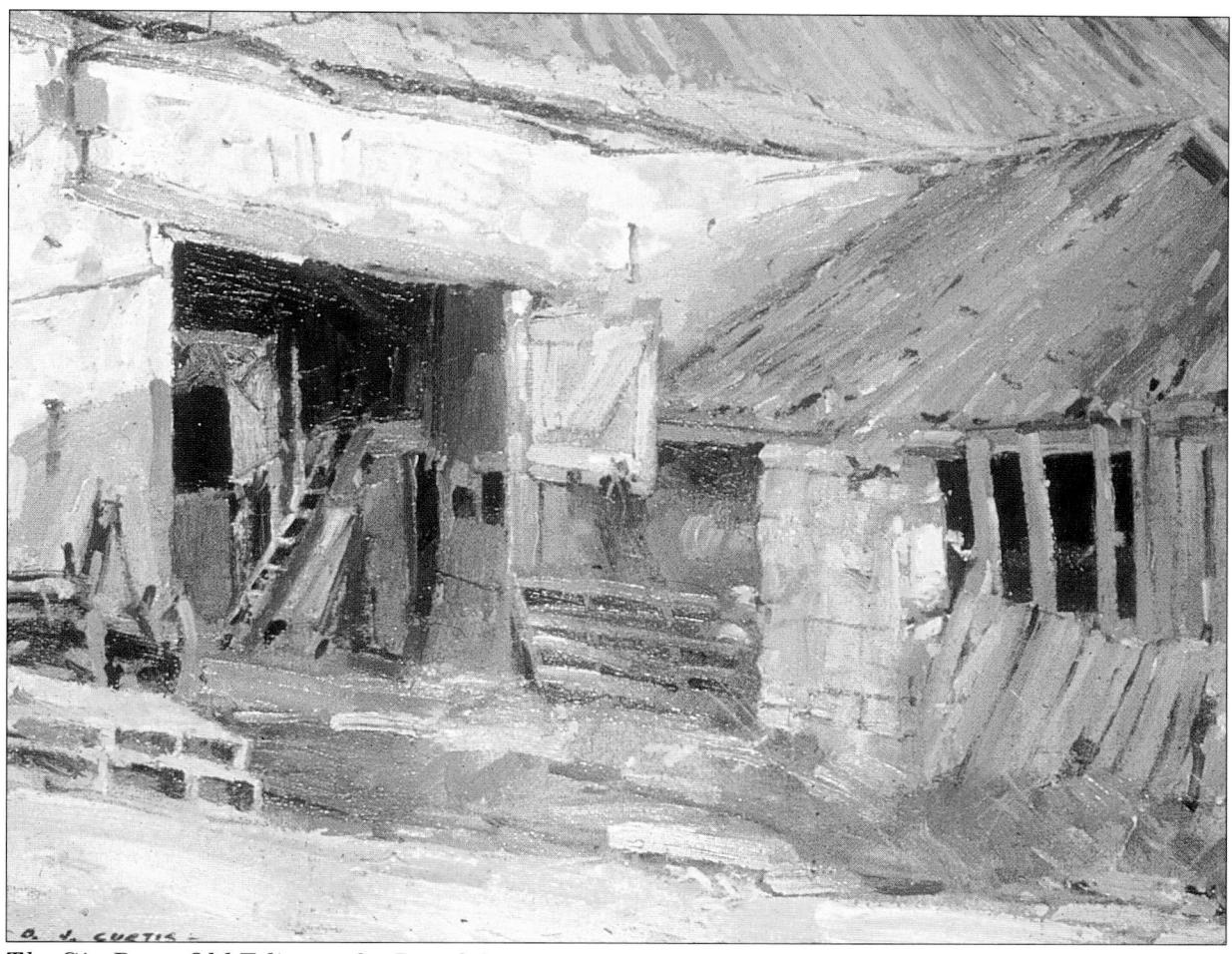

The Gin Race, Old Edington by David Curtis, 10×12 in/25.4 \times 30.5cm

▶ To create the effect of the colorful lichen-covered roof, the artist begins by applying a thin layer of orange-brown. Over this he paints a thicker, more opaque layer of dull green, using uneven brushstrokes that allow some of the original color to show through.

dabbed on with a brush or rag, or even smudged on with the fingers – so that it produces a lively, irregular texture, with the underlayer visible in places. Just the technique for old, peeling, whitewashed walls.

■ Staining The trouble with scumbling is that you must wait for the first layer of color to dry before you start, but staining the canvas with the color you want to show through the scumble cuts down the waiting time. Staining is done by applying a layer of much-thinned color all over the canvas with a rag, sponge or broad brush (you can use acrylic if you have it, since this dries even faster than oil thinned with turpentine). The stain can be applied evenly for a smooth, flat, finish, or unevenly so that the brushmarks show. Rubens made much use of a warm, yellow-brown stain applied in long, diagonal strokes, and this striated underpainting was deliberately left uncovered in places to form an integral part of the finished painting.

■ Sgraffito When your primary concern is creating texture you can do a lot of scraping down and repainting — this won't hurt the painting; it will probably improve it. Sgraffito, another useful texture-making technique is, indeed, based on scraping away paint. Rembrandt, who invented many of the oilpainter's tricks of the trade, used to scribble into

thick impastos with a sharp instrument in order to "draw" individual locks of hair or an intricate pattern of lace. The technique is still very much a part of the artist's repertoire. If you scrape into dry paint with the point of a knife you will expose the white surface of the canvas, while if you use a blunter instrument, such as the handle of the brush, to scrape into wet paint, you will reveal the layer of color below and create little raised ridges at each side of a trough, which can be perfect for imitating weathered wood. Almost anything can be used for this technique, and each implement gives a different effect, so experiment with different ones, such as a steel comb, a flat blade, a knitting needle, or anything else that comes to hand. Some artists even rub off a top layer of paint by sandpapering it. If you try this, make sure it really is dry.

■ Frottage This technique, which was pioneered by the Expressionist painter Max Ernst, is particularly suitable for rough textures like pebbled beaches or weathered rocks. The idea is simple: you lay a piece of non-absorbent paper on an area of opaque, wet paint, rub it lightly and then pull it away. The paper will remove some of the paint, leaving a rough, mottled surface behind, but it is a somewhat unpredictable technique, so it is wise to experiment with it before using it in an actual painting.

Interesting textures and color combinations can be gained by scumbling, since the lower layer of color shows through the upper one in an irregular way. The lower layer of paint must be allowed to dry first, and the scumbled paint should not be too oily. The idea is to get a rather rough, free effect by scrubbing or dabbing the paint on with a brush, a rag, or even your fingers.

▶ You can never be absolutely sure how the *frottage* technique is going to turn out, but the result is always interesting. When doing this demonstration, I found that crumpling up the paper and dabbing it onto thick, wet paint gave a good texture to the beach area.

▼ The sgraffito technique is an easy and versatile one. Here the artist imitates the grain of wood by scratching into wet paint to reveal a darker, dry color below. You could take this idea further, using the side of the knife to scrape off a larger area of the top layer to give a broken-color effect. You can also make fine white lines by scratching into dry paint to reveal the canvas. Any sharp, pointed implement can be used, depending on how thin you want the lines to be.

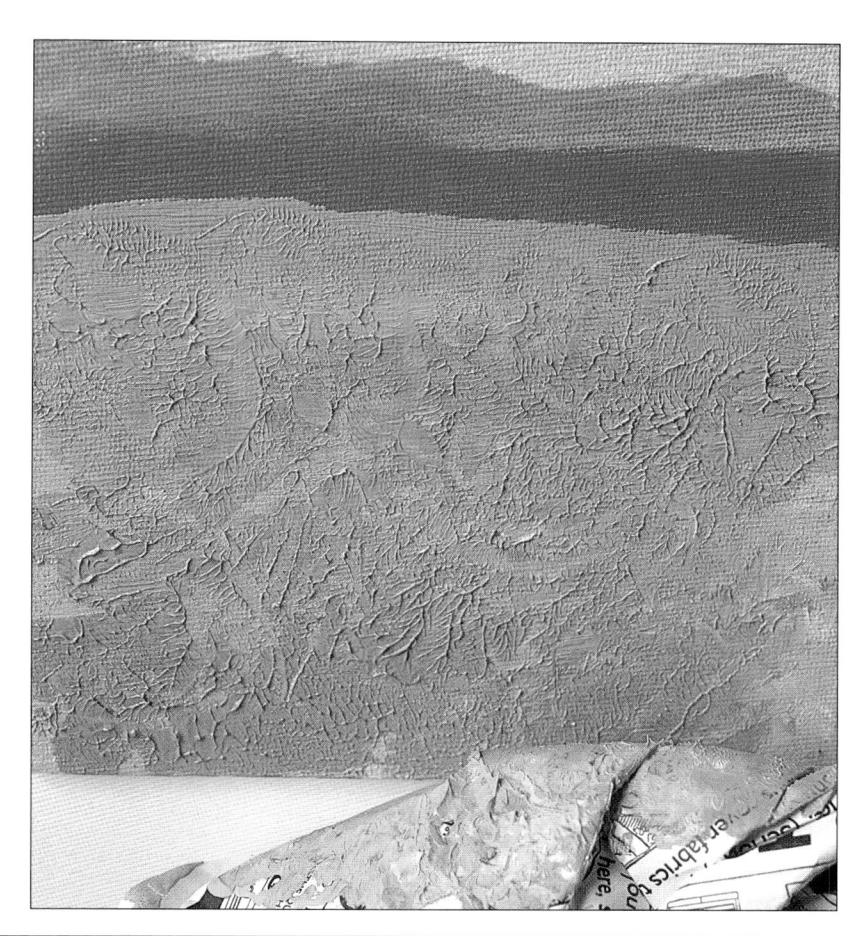

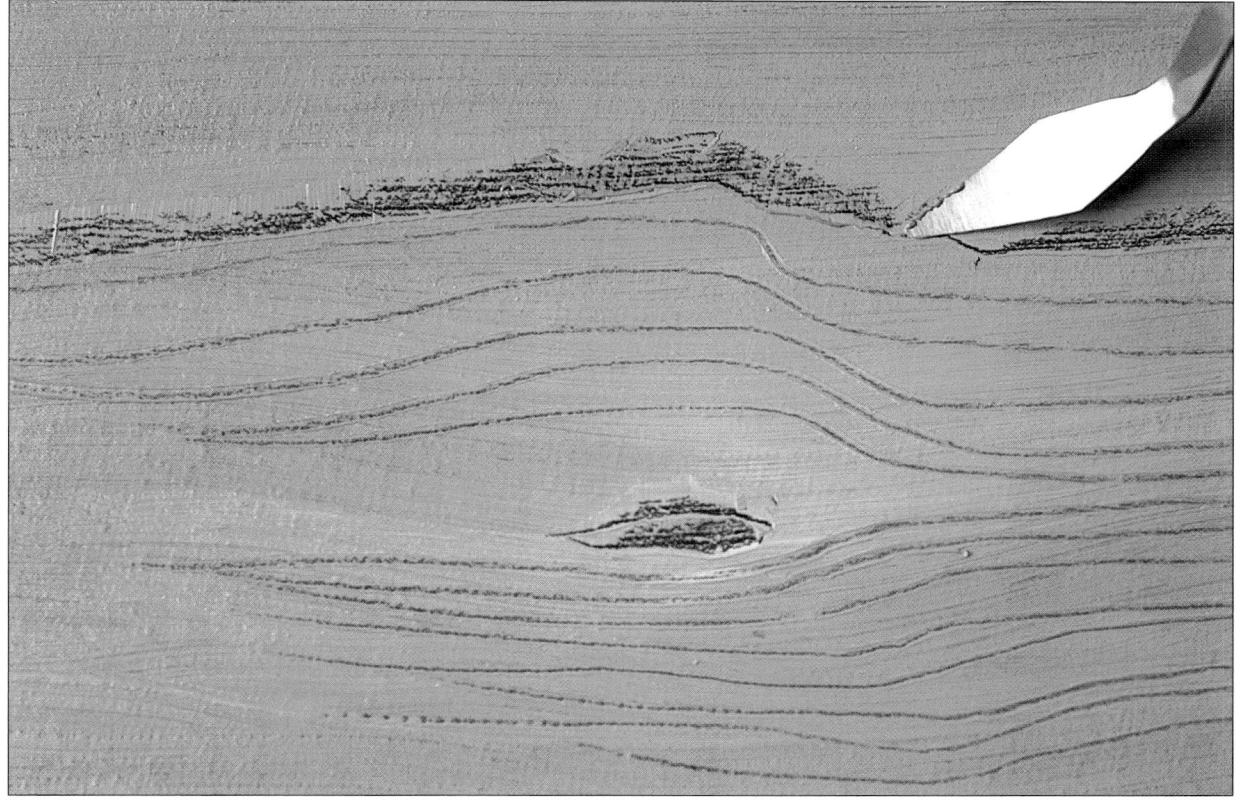

COLOR

Making the Most of Your Palette

You don't have to know all the complex theories of color that appear in "how to paint" books to be a good painter, but there are some things it is helpful to know, mainly because it saves the slow and sometimes discouraging process of learning through trial and error. For instance, we all know that blue and yellow make green, but it could take you a whole painting's worth of time to figure out which blues and yellows are the best choice to mix a particular green.

This chapter doesn't tell you everything there is to know about color, because painting is about expressing your own ideas and feelings, not someone else's, and part of the fun is finding out the best ways of doing this. But it does provide you with some useful and interesting basic knowledge that should help you avoid some common pitfalls. In addition, there are plenty of inspiring examples of how other artists set about

things — how they match their colors to their subjects, use complementary colors to make both seem brighter, balance the lights and darks, use certain combinations to create a somber or happy mood, or create serene, harmonious pictures by using a restricted range of colors.

methodsing colors If you have never used oil paints before, obviously the first and most important thing you have to decide is which tubes of paint to buy, so let's look at a suitable range of "starter" colors. It is best to limit yourself to the really essential ones to begin with — you can always add more as you need them, but you don't want a paint box full of tubes you'll never use. All colors are mixed with white, so you must have a large tube of titanium white, not flake white. Add to this two reds (alizarin crimson and cadmium red); three yellows (cad-

Mount Zion by David Graham. $24 \times 29 \text{ in}/61 \times 73.7 \text{cm}$

Still Life with Pomegranates by Joyce Haddon. $10 \times 12 \text{ in}/25.4 \times 30.4 \text{cm}$

Bright colors can be made to appear even more vivid by contrasting them with neutral or dark ones. In this delightfully simple still life, the artist has boldly devoted some two-thirds of the painting to the almost black background, so that the colors of the fruit sing out like a fire in the night.

▶ A painting is unlikely to be successful unless it has an overall unity of color, and this picture derives its atmosphere of peace and serenity from the way the colors have been chosen and controlled. The patches of light yellow sunlight provide the "key," and all the other colors - darker yellows, warm mauves, and red-golds - are orchestrated around them.

Experimenting with colour is one of the most exciting aspects of painting. The light, bright, "high-key" colors in this landscape may not be exactly as they were in reality, but they convey a powerful impression of sunshine and heat.

mium, lemon, and yellow ocher); two blues blue); one brown (raw umber); one green (viridian), and one black (ivory black). That's eleven colors, which is plenty. Some artists would rule out the black, but it's marvelous in mixtures.

Later on you will certainly want to extend your range, and your choice of extras will depend on your subject matter. On page 51 there are some suggestions for indispensable flower colors, but if you are committed to landscape you are more likely to want extra greens and browns. Whatever you choose, until you are sure a color is suited to your needs, buy small tubes rather than fullsized ones. And whatever you do, don't fall for colors with names like "flesh tint" - the only way to make flesh look real is by mixing.

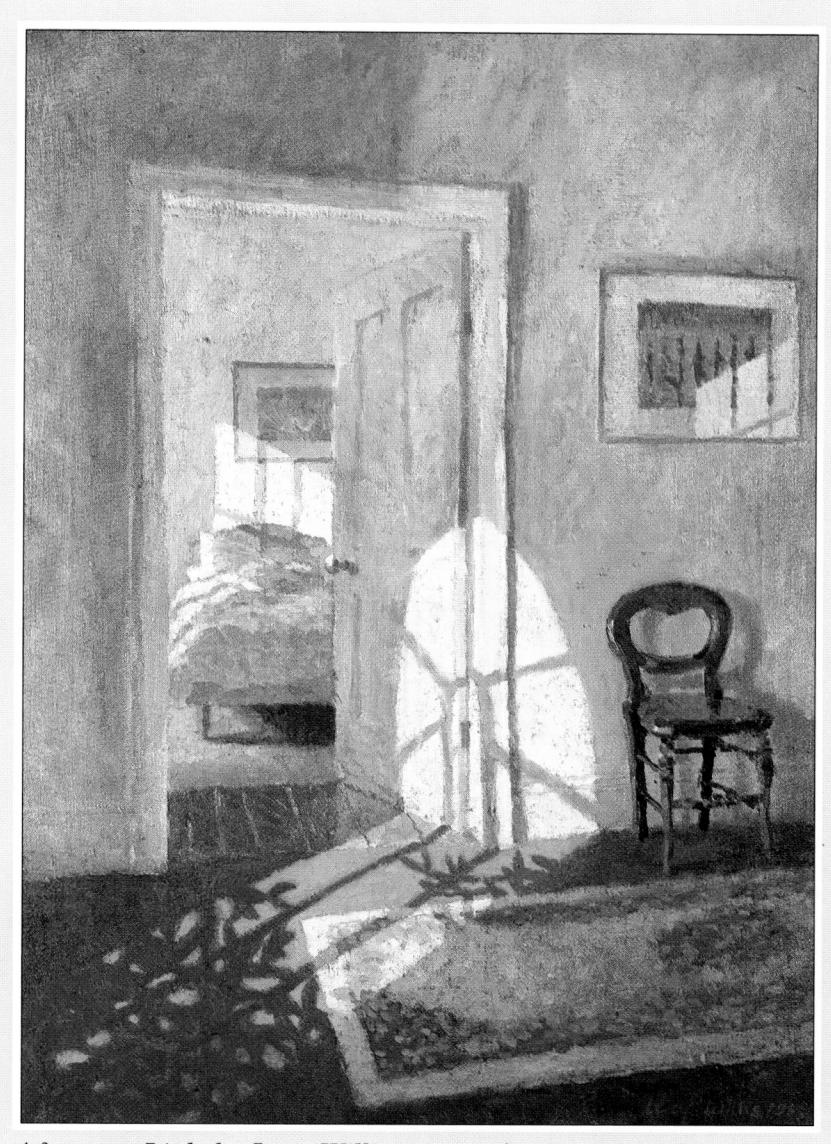

Afternoon Light by Lucy Willis. $28 \times 19\frac{1}{2}$ in/71.1 × 49.5cm

How do I get color into the whites without losing the whiteness?

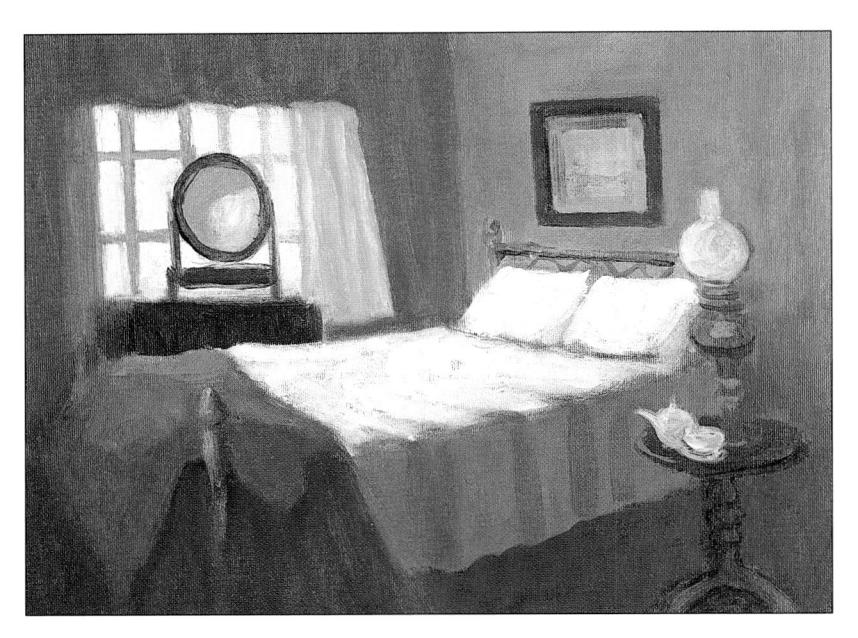

THE PROBLEM

Painting a picture in which all the elements have the same or a very similar color presents an exciting challenge to an artist. This is because the differences in color and value are created entirely by the degree and quality of the light that falls on each object or plane. White, like black, has no actual color of its own, but unlike black it reflects the colors of its surroundings, so that it is almost never really white but a composite of many other colors. White snow, for example, has blue shadows on a sunny day because it reflects the blue of the sky, and the creases and folds of a white garment seen under artificial light can be greenish, yellowish, or even a warm, orange-brown. Beginners often refuse to believe the evidence of their own eyes; they know the shirt is white, so it must be painted white. This is what has happened here. The student has made a good attempt, but has leaned too heavily on slabs of white paint straight out of the tube for the highlights, adding timid touches of color in the shadows but failing to make the most of them.

THE SOLUTION -

As is so often the case in painting, it's partly a question of observation and partly one of "going one better" than nature. You can afford to exaggerate a little if you know what you are doing, and you will find that you can paint fairly bright blue or green shadows on a white object so long as they relate to other colors in the painting and to the prevailing light. In the painting opposite all the whites are warm, with both highlights and shadows tinged with yellows and greens – sometimes quite a strong yellow. It is a glowing, inviting scene, with a summer sun streaming in through the window, and the artist has made the most of the golden color scheme by stepping up the shadows on the shaded side of the bed and echoing them in the brass lamp and bedhead as well as in the gold mount of the picture on the wall. The same yellows shine through the loosely applied bluish-greens on the darker window wall. This painting makes an interesting comparison with Winter Light on page 47. In both paintings the theme is light and how it affects local colors.

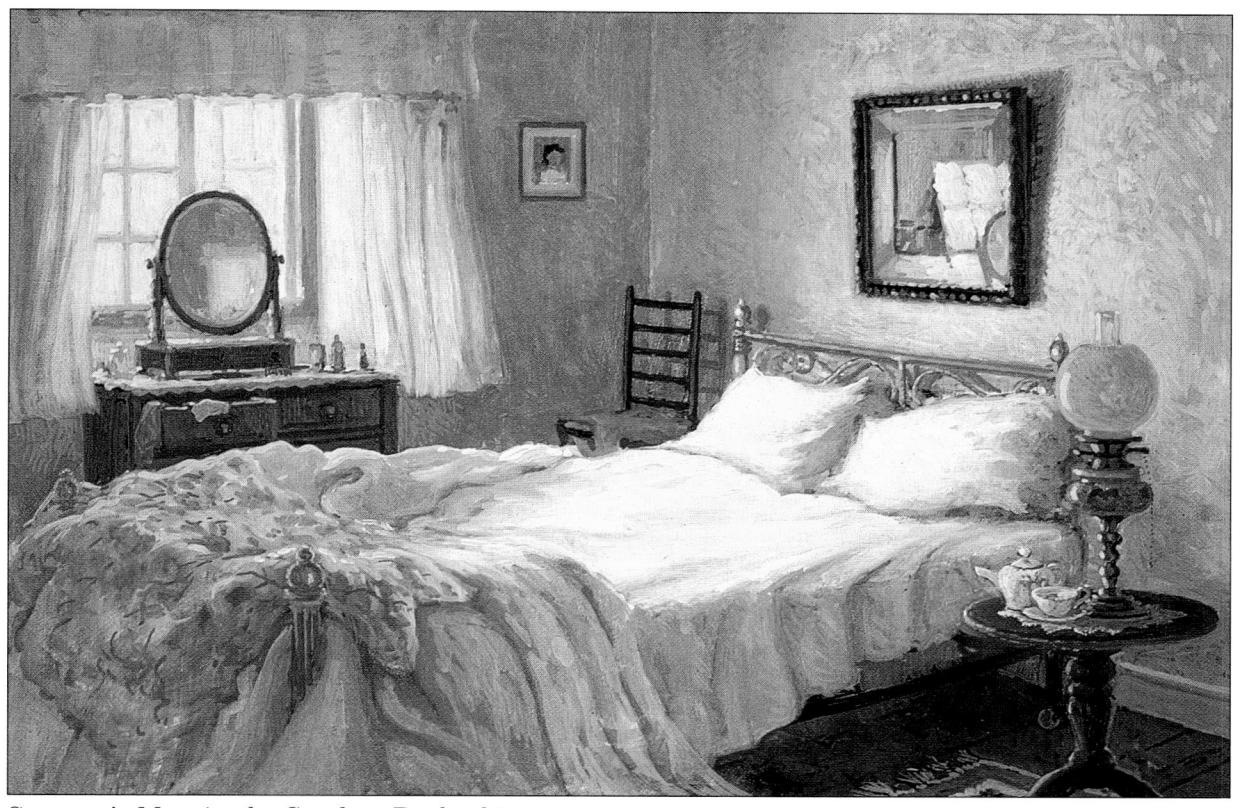

Summer's Morning by Stephen Darbyshire. $6 \times 8 \text{ in}/15.2 \times 20.3 \text{cm}$

◀A warm glow is given to the whites by working on a pretinted yellow-pink ground. It's a good idea to start by coloring the surface when you are painting whites, and a warm shade, such as a beige or yellow ocher, will prevent the colors from becoming cold and gray.

I used black for the shadows, but the painting lacks depth.

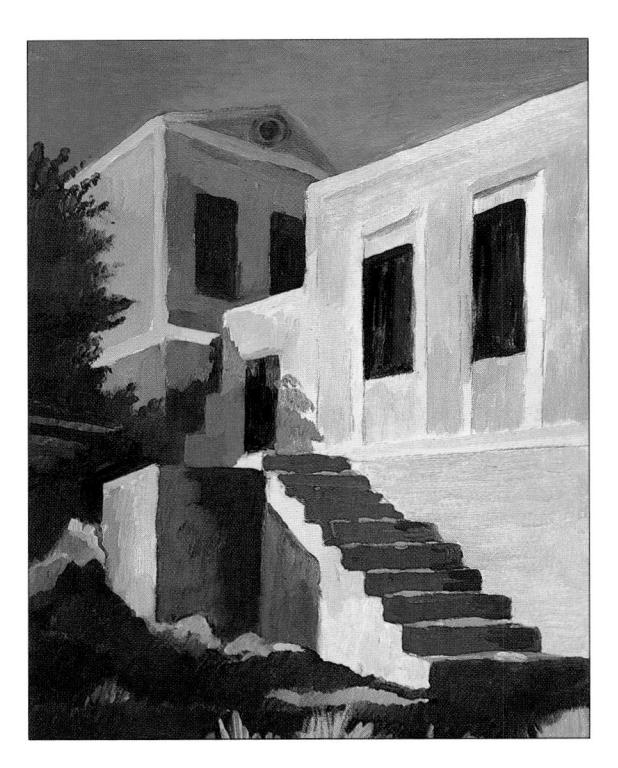

THE PROBLEM

Subjects with particularly strong value contrasts, all bright highlights and deep shadows, are apt to make beginners lose their heads. It's perfectly understandable – the shadows look just about as dark as they could be, and black is the darkest color in the paintbox, so on it goes. But the student's painting demonstrates that it just doesn't work, and this is because black oil paint has a very curious property. On the palette it looks rich and shiny, but if you put it on canvas neat it dries to an unpleasant matte purplish gray which no amount of oil or varnish can redeem and which doesn't look nearly as black as pure Prussian blue, indigo, or violet.

- THE SOLUTION

It is now time to explode a myth. For decades it has been received wisdom that black should never be used, and people are often heard saying that "the Impressionists never used black." In fact, black is a marvelously useful color, and although some of the Impressionists did avoid it, it was much employed by Renoir, who described it as "the queen of colors." But he also pointed out that it should only be used in mixtures, "as in nature," and this is the crux of the matter. On

its own, black destroys a painting, but when mixed with other colors it is superb – for light ones as well as dark – and few artists would be without it. For instance, a particularly vibrant olive green can be made by mixing ivory black and cadmium yellow, and mixed with reds and blues it forms a basis for a whole range of lively deep browns and purples. In the painting opposite, the artist has avoided using black for the shadows, searching for the visible browns, blues, and violets. Then, by contrasting them with warm, glowing yellows, he has really managed to make them "sing."

■ Judging the darkness Because every color is modified by the light that falls on it, and there is always some light, even in shadows, colors are seldom as dark as they seem. If you have a black object with you — a camera case or pocketbook — hold it up close to you and in line with the "blackest" part of your subject, shut one eye, and you will immediately see the difference in value. Then look hard at your dark area and try to analyze the different colors in it; dark shades are just as varied as light ones, and you'll probably notice a range of deep blues, browns, and violets. Always try to relate the dark parts of the painting to the light, bright ones.

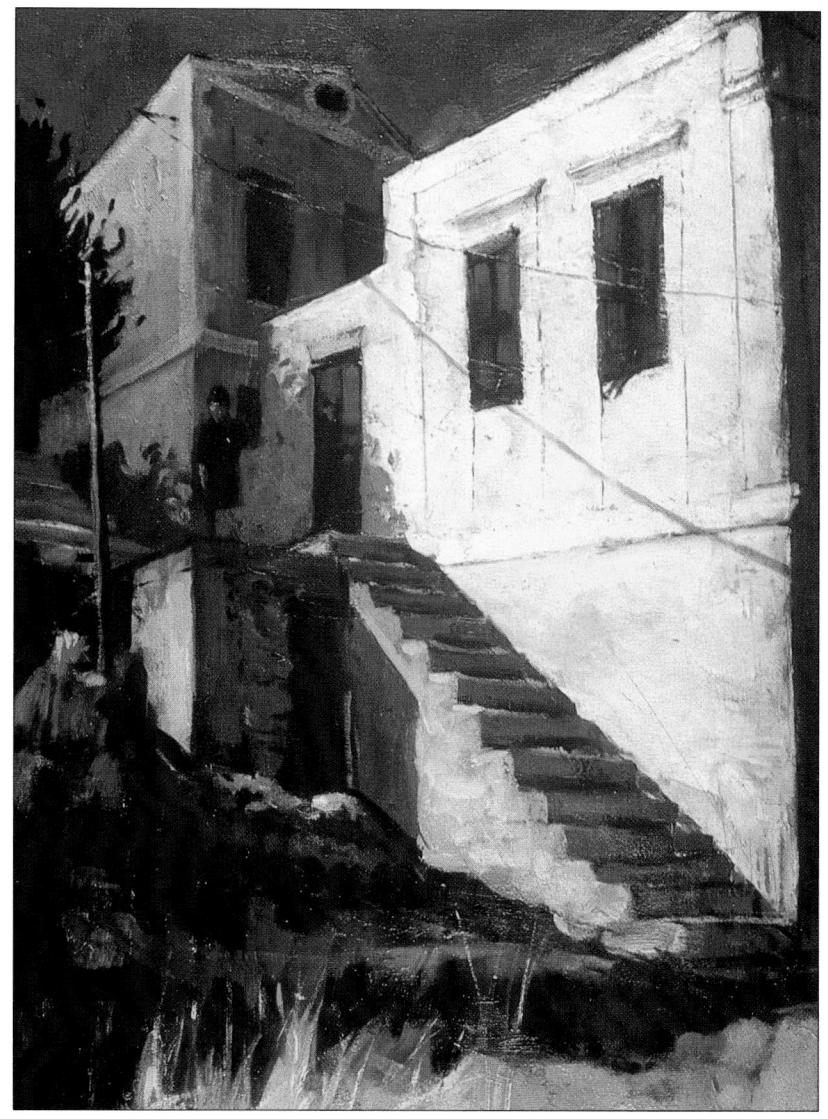

Chorio Houses, Symi by Paul Millichip. 36×24 in/91.4 \times 61cm

■The colors of the shadows are deep and strong, but nowhere has unmixed black been used. Notice how the artist has enlivened the dark area here as well as giving unity to the picture by repeating the intense blue of the sky.

My greens look somewhat dead and dull; how can I make them more vibrant?

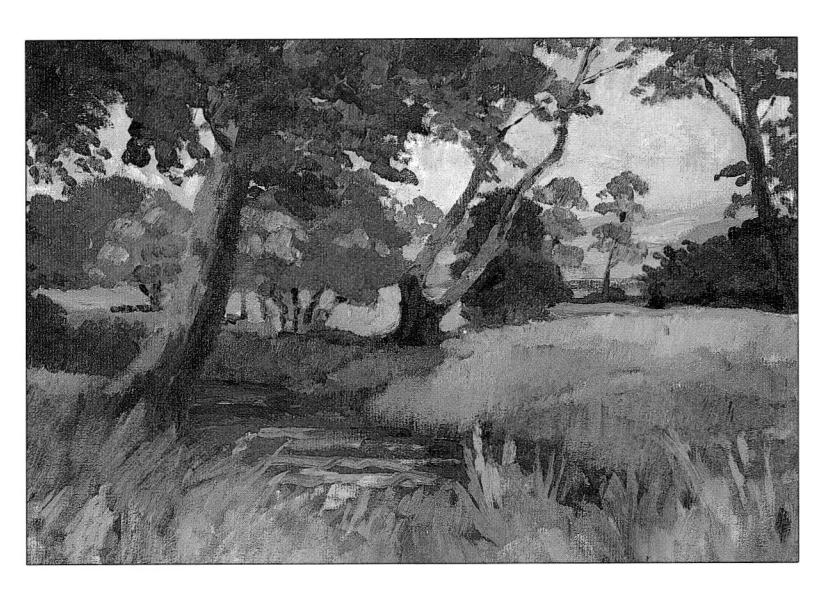

THE PROBLEM

The very greenness of summer trees and grass tends to blind you to the fact that there are really quite a lot of other colors among the greens, and that plants and trees vary considerably in their greenery. Some verge on the blue; others are almost yellow, particularly where the sun strikes them. The shadows on a warm, olive-green tree are often brownish, even red in places, while those on cool, blue-green foliage can be almost pure blue or violet. The values have been controlled fairly well in the student's painting, but the colors are monotonous because the same green – probably sap green – has been used everywhere and there is little variation within each area of grass or foliage.

- THE SOLUTION -

In the painting opposite, a wide range of colors has been used for each part of the picture, and the value contrasts are equally marked, giving a lively impression of light and shade. Although it is the quintessential green summer landscape, the sunlit areas of "green" are actually yellow, with traces of pink and deep blue. Different greens have been mixed for individual plants and trees. On the edge of the lake a yellow-green is used for the flag irises, while a deep blue-green is considered more appropriate for the foliage above them.

■ Making notes Working outdoors directly from the subject is the best way of learning to

recognize the vast range of colors in nature's "palette"; Turner made endless on-the-spot sketches which he carefully filed and used for reference for later studio paintings. You need not make elaborate sketches; a few rapid dabs of paint or a quick pencil drawing combined with written color notes can teach you a great deal about the relationship of one color to another, and will act as a memory-jogger when you're painting at home. If you have no equipment with you, try to "paint in your mind," looking at each tree or bush with an analytical eye, and thinking about which color mixtures you could use. As I write this, I can see that the sunstruck leaves of the tree outside my window are almost white in places and yellow in others, while the shadows are a beautiful purplish-blue.

■ Ready-mixed greens But although observation is the greater part of the battle, it is not the whole of it. You may be able to see that all the greens are different, but how do you know which tube colors or mixtures are the best ones to represent them? There are several excellent tube greens to choose from and, although all artists have their personal choices, there are two which are found in most paintboxes — viridian (a dark, cool blue-green) and cadmium green (a lovely rich, warm one). Sap green, even brighter and considerably darker, is also much used by landscape painters, and so is terre verte, a dark, dull green which you can use straight from the tube for shadow areas. Viridian, which has

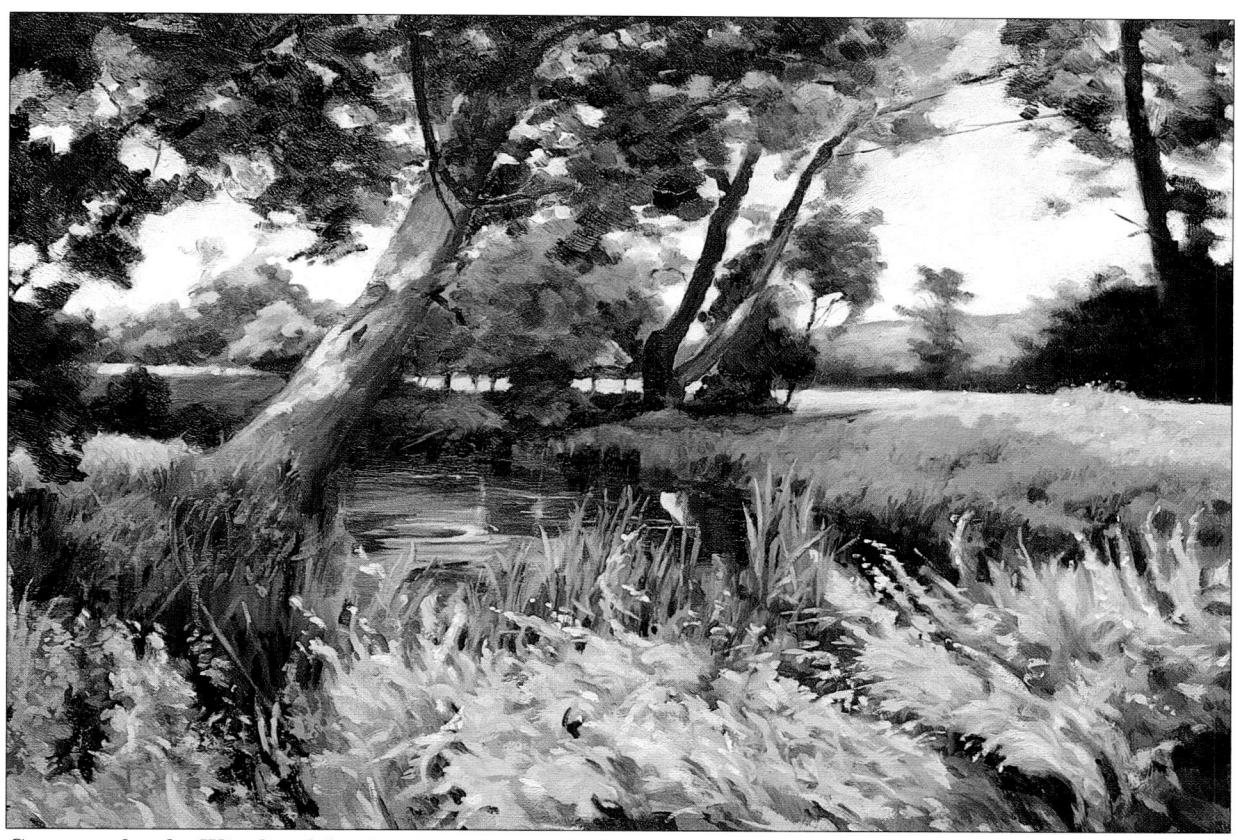

Summer by the Windrush by Roy Herrick

If you compare these two details, one from the student's painting (above left) and the other from the professional's, you will see a startling contrast. The student has tried

to vary the greens, but has been much too timid about it, whereas in Roy Herrick's painting there is a wide range of greens, yellows, and a nearblue.

rather an unnatural look when pure, is best for mixtures, but you can give a nice sparkle to a painting with small touches of neat cadmium green. All the tube greens can, of course, be modified as needed by the addition of yellows, blues, browns, or even reds and purples.

■ Blue and yellow makes green Of course it is not strictly necessary to own any tubes of green at all, since an almost infinite range of lovely greens can be made by mixing blues and yellows, or yellows and black. Tube greens are a convenience, but mixing your own greens is both enjoyable and instructive. The chart shows just some of the greens that can be made from different combinations of three blues (ultramarine, phthalocyanine blue, and cerulean blue), three yellows (cadmium yellow, lemon yellow and yellow ochre), and black. Many of these mixtures are subtler and more interesting than

ready-mixed tube colors – notice, for example, the rich olive green produced by mixing black with yellow.

■ The problem of white Greens, like any other colors in oil painting, can be lightened by the addition of white, but you will produce more interesting colors by lightening with yellow and darkening with blue or red. You need to be extra careful with greens, since adding white can change them in a way you might not have expected. The vellows and vellower greens are not affected - they remain the same color but a lighter hue – but try adding white to either terre verte or viridian and you'll find you have a color that is more like a pale blue than a green. This happens to some other colors too: on a later page we look at the way various reds react with white. Mix in white sparingly, and if you don't like the color, try another mixture.

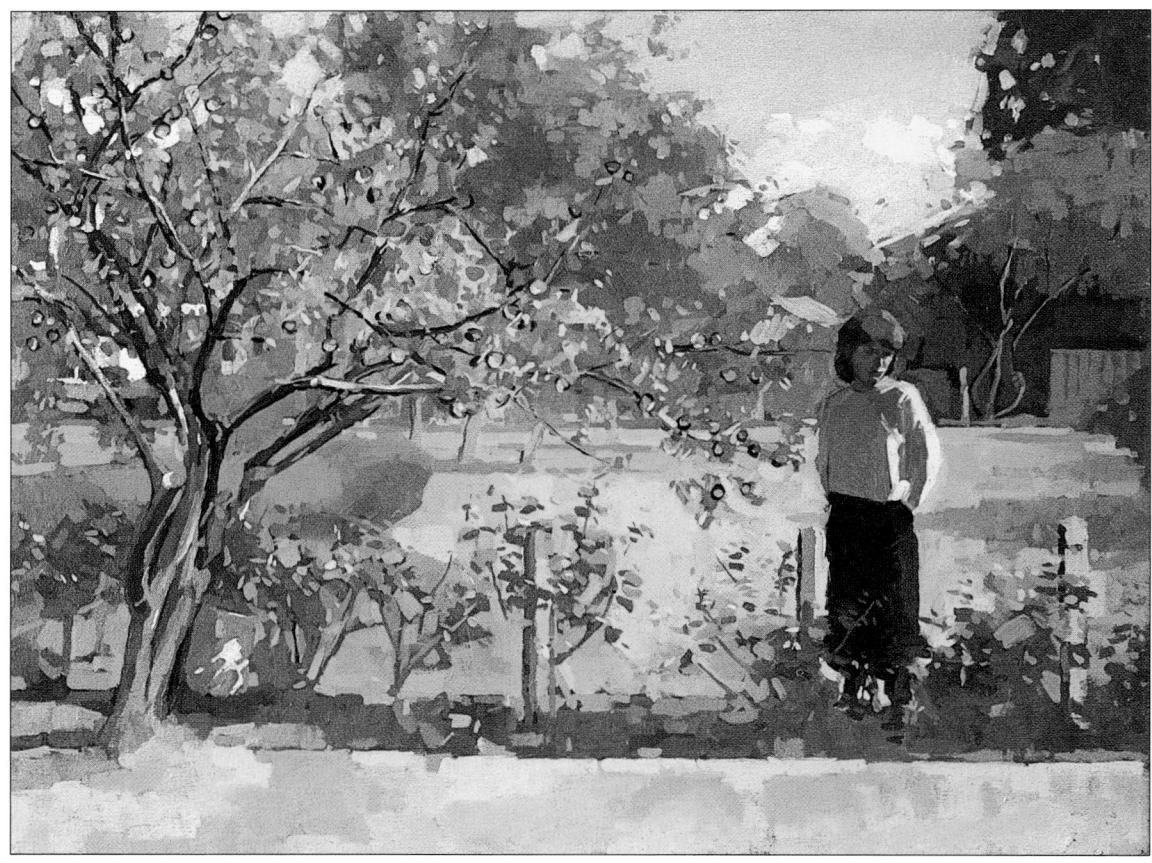

The Apple Tree by Geoff Hunphreys. 24×18 in/61 \times 45.7cm

There is a wide variety of different greens in this painting, from rich, bright yellowish ones in the foreground to several shades of blue-green in the background. But notice how the artist has united the colors and values by repeating the dark, cool greens of the more distant trees in the shadows on the lawn.

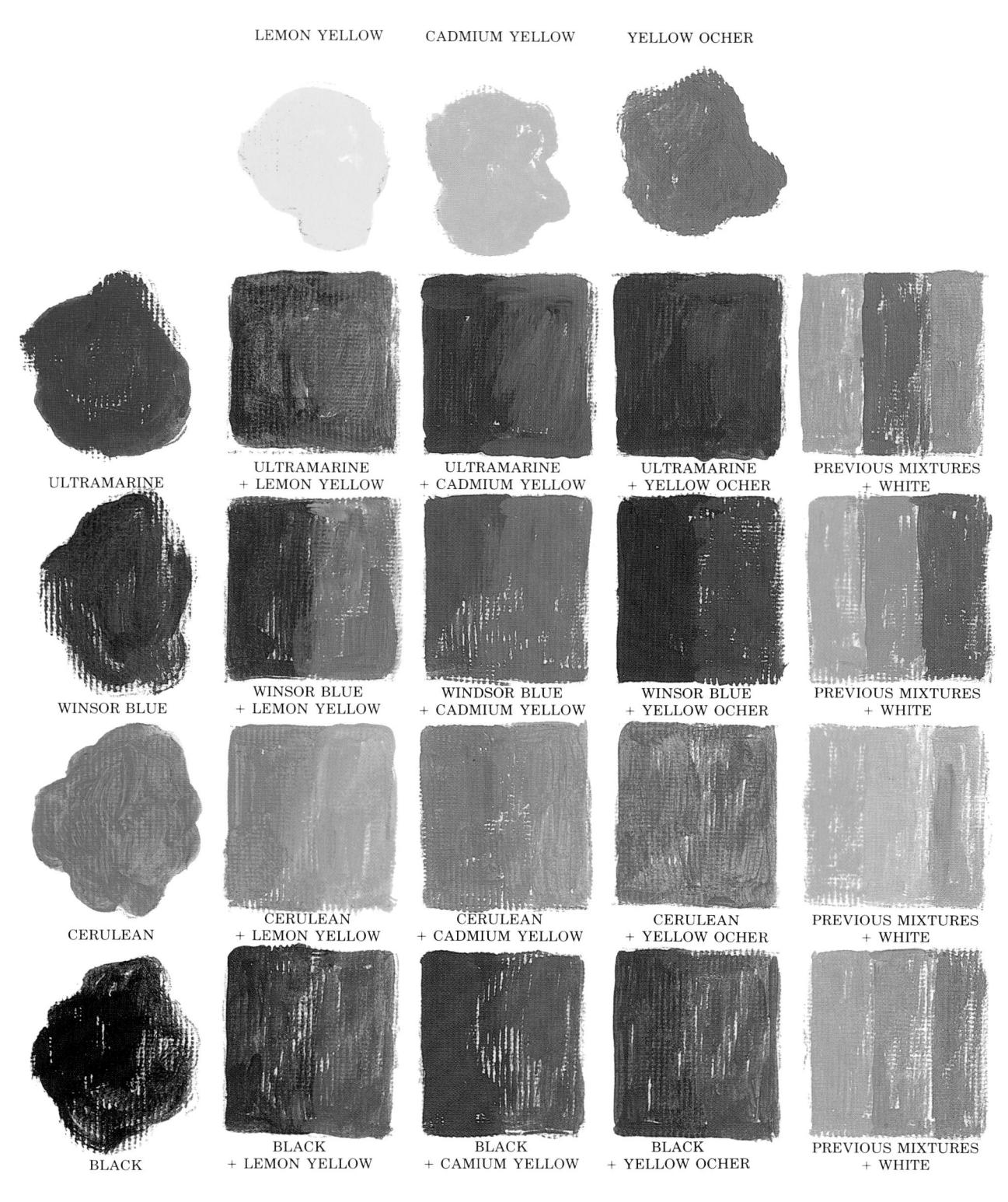

Mixing greens There are so many ways of mixing greens that it is only possible to show a few of them here. The important thing to remember is that some blues and yellows are cooler than others, so if you want a cool blue-green, start with Winsor (phthalocyanine) blue or Prussian blue.

I'm not too dissatisfied with this as a likeness, but the skin looks very patchy.

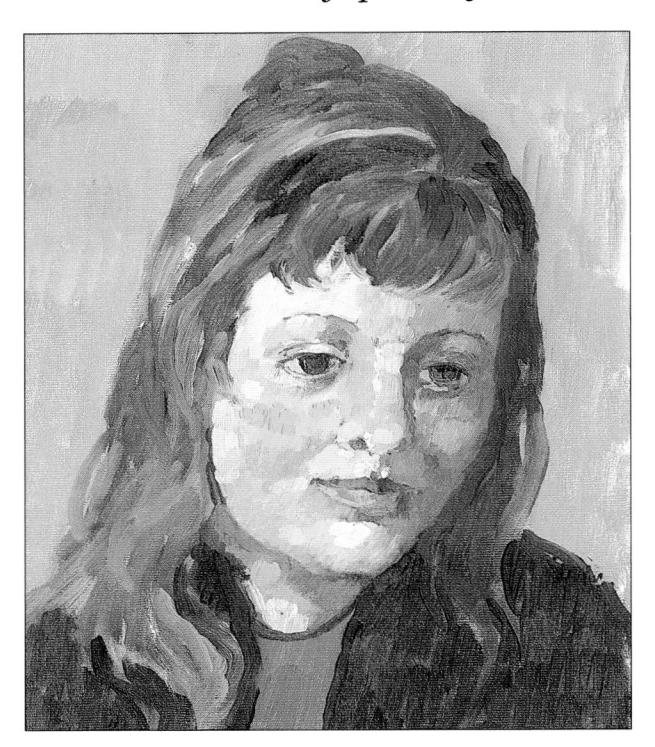

- THE PROBLEM

Painting skin can be a confusing business because skin types – and therefore their colors – vary so widely from person to person. Most beginners make one of two basic mistakes: the first is to go all out for an overall color, ignoring the variety within the face, and the second is to become so obsessed with the range of colors in each area that the face loses its homogeneity. The student has made the second mistake, and in an attempt to get all the colors in, has overstated them, so that the structure of the face has become lost in an unblended patchwork of reds, pinks, yellows, and blue-greens. Even so, it is an excellent attempt, and shows careful observation of color.

THE SOLUTION -

The first step is to assess the type of skin color. Ask yourself whether the face is more red than pink, or a warm ivory color, or perhaps a pale bluish white? The best way of making this kind of assessment is to half-close your eyes, which blurs the colors and values so that you can see the face as a whole without the distraction of red lips or dark eyebrows. This base mid-tone color

can be applied as a flat wash underpainting, which will act as a guide for later colors. Then think about the type of skin: is it rough and weathered, or clear and soft? In Pamela Kay's portrait opposite the youth of the sitter is proclaimed in every brushstroke: the forms are rounded and smooth, and the colors gently blended to give the skin an almost translucent quality. The student's painting, on the other hand, gives no real idea of the sitter as a person with a particular type of skin and coloring.

■ Mixing flesh colors No one can really prescribe a list of the best colors for painting skin — as we have seen, all skins are different — but for a subject like this one, you could not go far wrong with yellow ochre, alizarin crimson, and perhaps a touch of cadmium red, modified by burnt umber, Payne's gray, cobalt blue and, of course, white. Don't begin by mixing just one color and putting it down on the canvas in the fond hope that the others will match it, but mix a good range of darks, lights, and mid-tones on the palette first. This will give you a good basis on which to work, and you can make improvements as you proceed, brightening some colors and darkening others as needed.

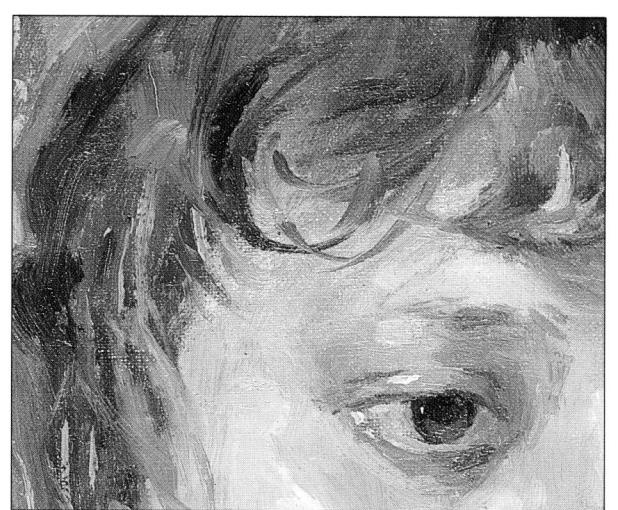

Our skins all change with time, but that of children and young people is very fine and soft. The artist has suggested this translucent quality by using pale blue for the delicate indentation at the temple.

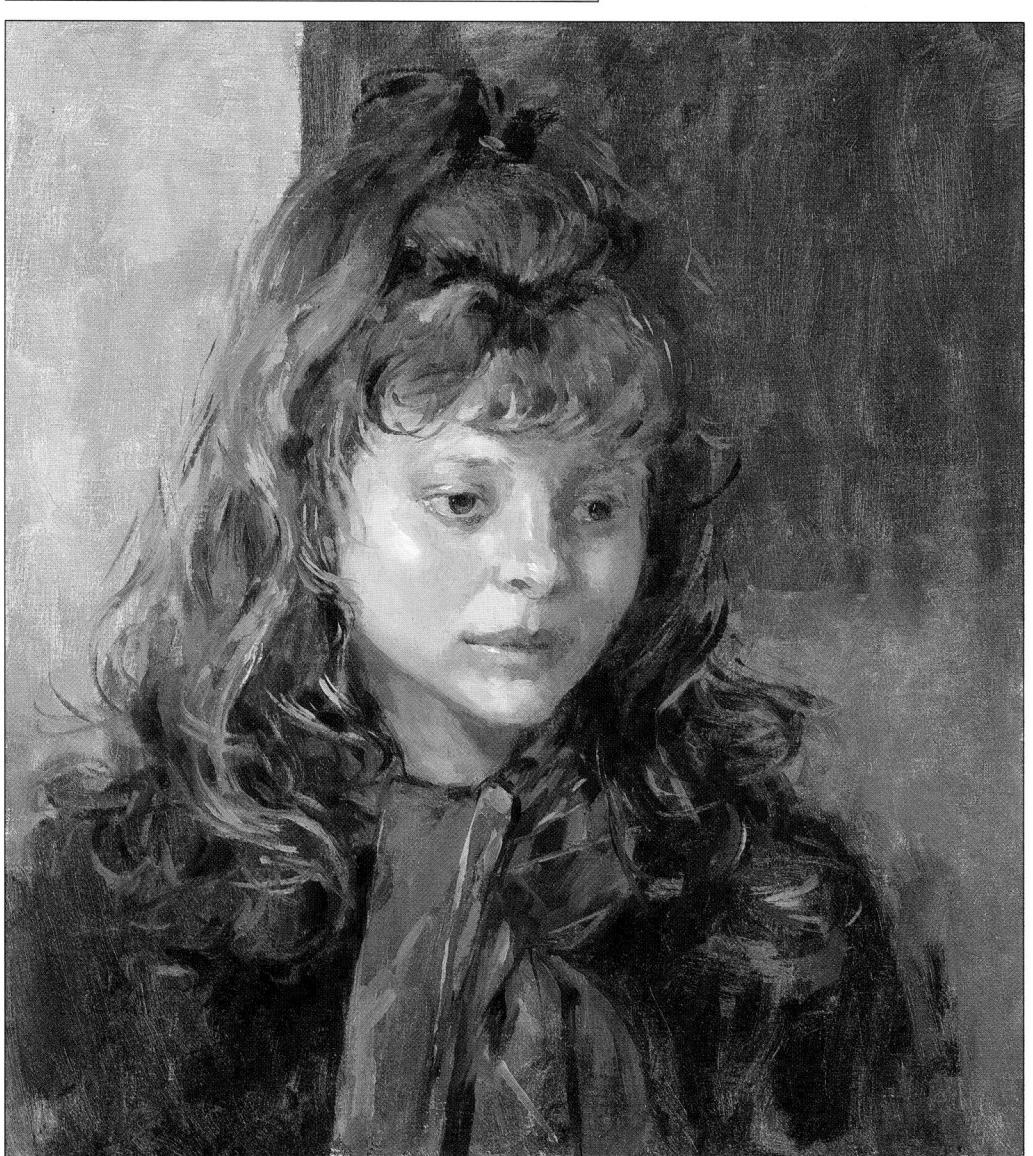

 $Portrait\ of\ Emma$ by Pamela Kay. 14 \times 12 in/35.5 \times 30.4cm

How can I make my neutral colors look more interesting?

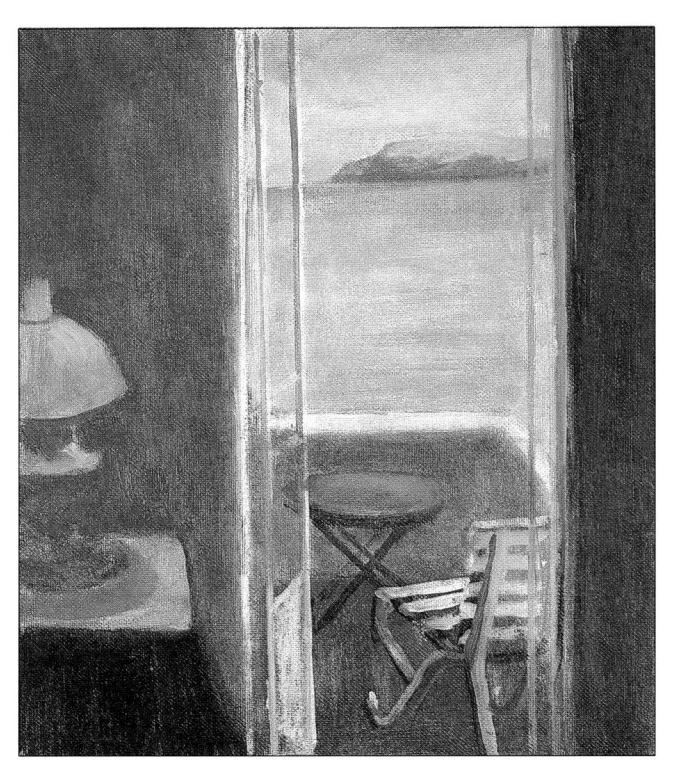

THE PROBLEM

The definition my dictionary gives of the word neutral is "dull, but harmonizing with most other colors." And herein lies the problem. Many inexperienced painters think of these colors in the same way – as unimportant, not worth the effort of thinking about. After all, they are just a foil for the "real" colors, so surely any old mixture of brown, black, and white will do. Actually, of course, neutrals are just as important as bright colors, and they are quite a lot harder to mix as there is an almost infinite number of different combinations to choose from. You can get a good vibrant red out of a tube, but achieving a dark, warm gray-brown that doesn't look like mud requires careful thought. A further complication is that no color exists in a vacuum, each one being affected - sometimes drastically changed - by those surrounding it. You may mix up a promising-looking blue-gray on your palette but find that it looks much too bright or too blue when it's on the canvas because all the other colors are relatively muted. In this painting the student has evidently taken fright at the sheer difficulty of dealing with a color scheme that is almost all "neutral," and has understandably sought safety in muddy gray.

THE SOLUTION -

The second part of my dictionary definition is true, at least as far as it goes - neutrals do harmonize with most other colors. But they have their own characters too - they can be warm or cool, dark or light; they can veer toward green, yellow or red, or they can be just plain gray. In Winter Light (opposite) the colors are predominantly cool, as befits the subject. Yet on closer inspection you can see there are warmer areas – the sky and its reflection in the sea, and the light from the lamp. Here, hints of yellow, pink, and mauve enliven the painting. Seen in a context of bright hues, all these colors could be described as neutral, but there is no mud, and the range and variety of blue-grays, green-grays, and yellowbrowns is certainly remarkable.

■ Mixing neutrals All artists have their own ideas about mixing neutrals. Some have a set of formulas for cool or warm neutrals, while others make a more intuitive mixture from the colors that happen to be on the palette, which is a good way of achieving consistency of color. It is not really possible to provide a set of recipes for neutrals, because it's such a vast range, but the charts on the following pages provide some useful suggestions.

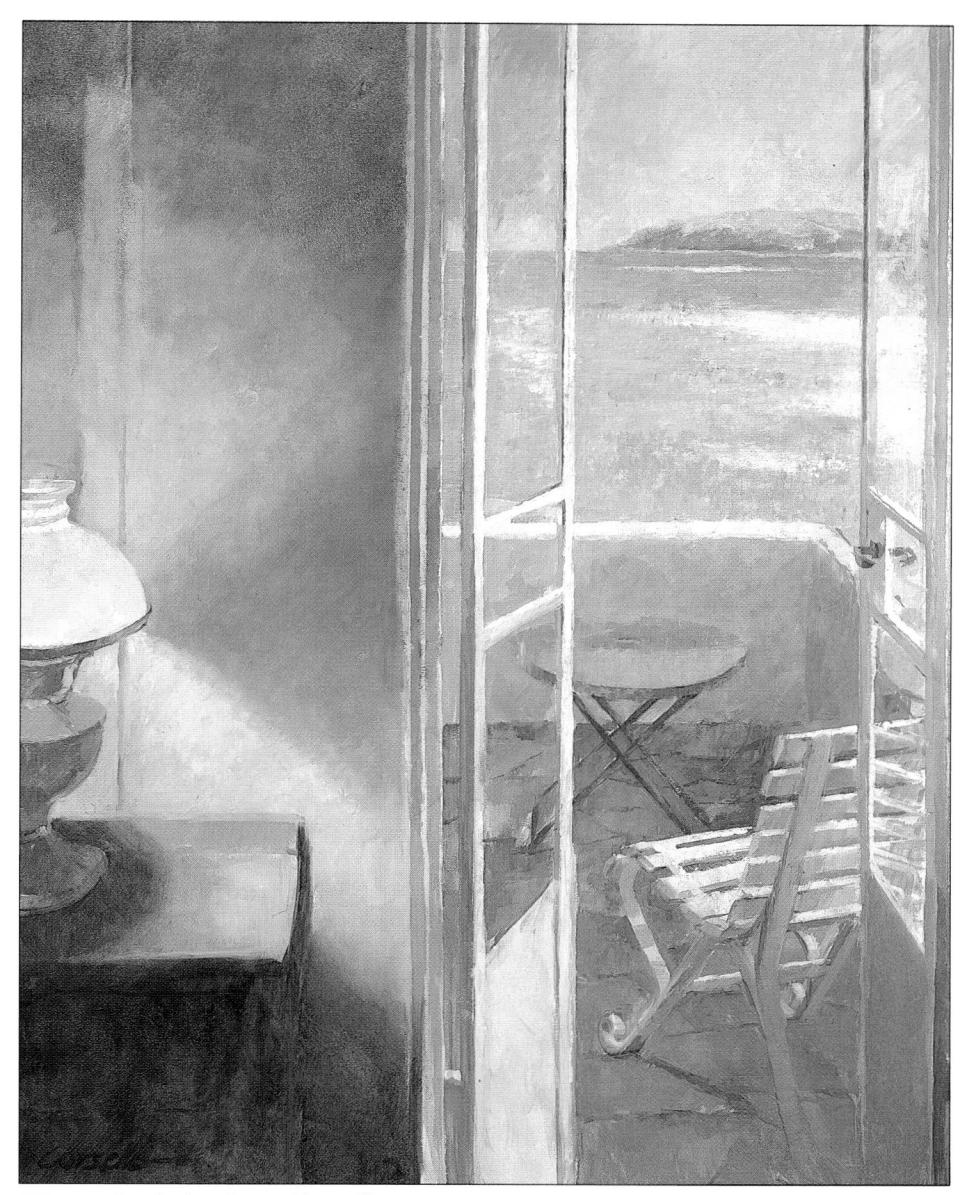

Winter Light by Jane Corsellis. $38 \times 32 \text{ in}/96.5 \times 81.3 \text{cm}$

■The green-grays, violetgrays, and ochers are all carefully related so that the painting has a strength and unity. Notice that no area of color is completely flat. The pale patch of wall behind the lamp has touches of yellow and mauve in it, and the broken brushwork enhances the effect of light.

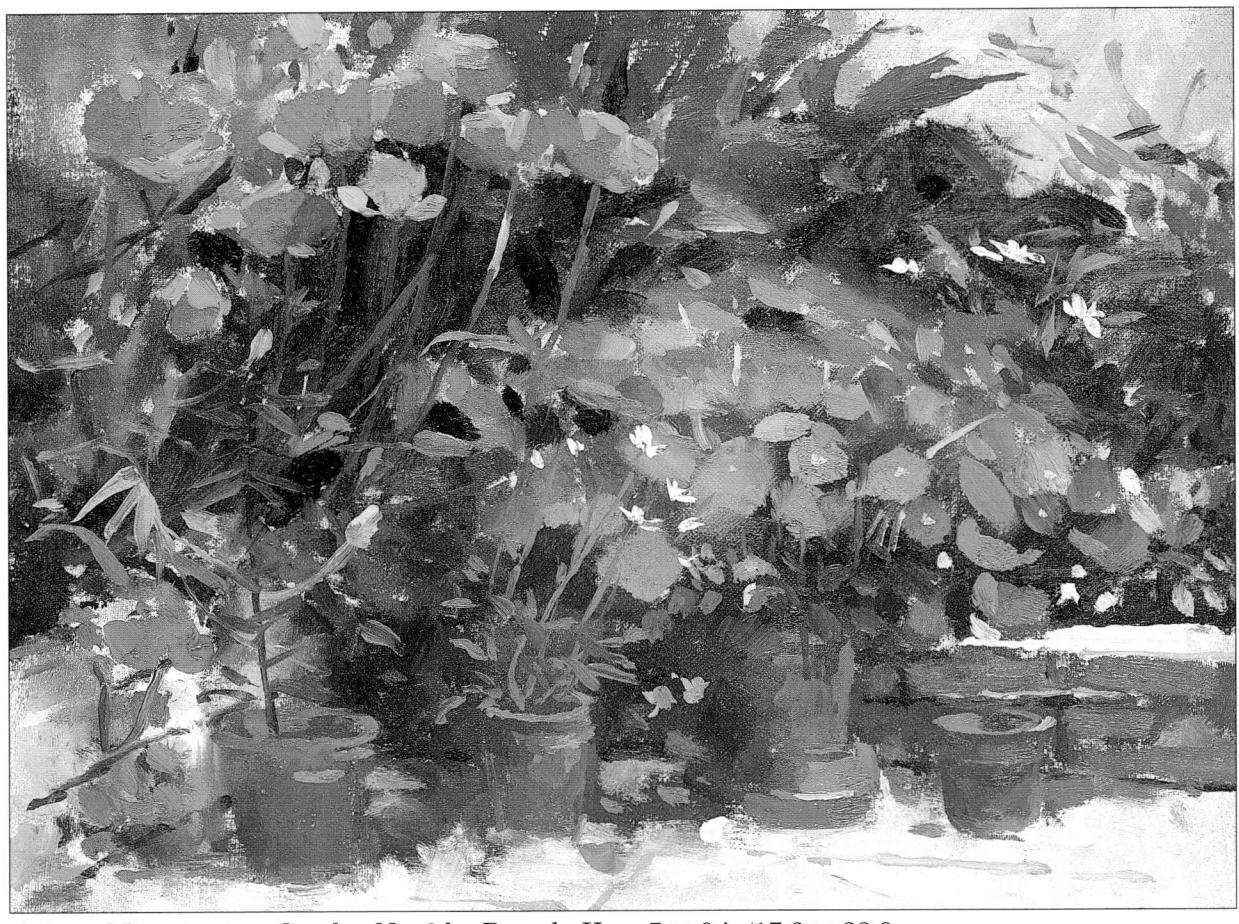

 $Oriental \, Poppies \, in \, a \, Garden \, No. \, 2$ by Pamela Kay. 7 \times 9 in/17.8 \times 22.9cm

A mistake inexperienced painters often make is to mix neutrals from a random combination of any colors that happen to be on hand, but these "non-colors" are every bit as important as the bright ones. Look at the variety of

hues the artist uses here: each area of cool blue-gray, dark greenish brown or warm yellow-brown is carefully planned to provide the best background for the brilliant reds and mauves of the flowers.

COLORS MIXED IN DIFFERENT PROPORTIONS, ALL WITH WHITE ADDED

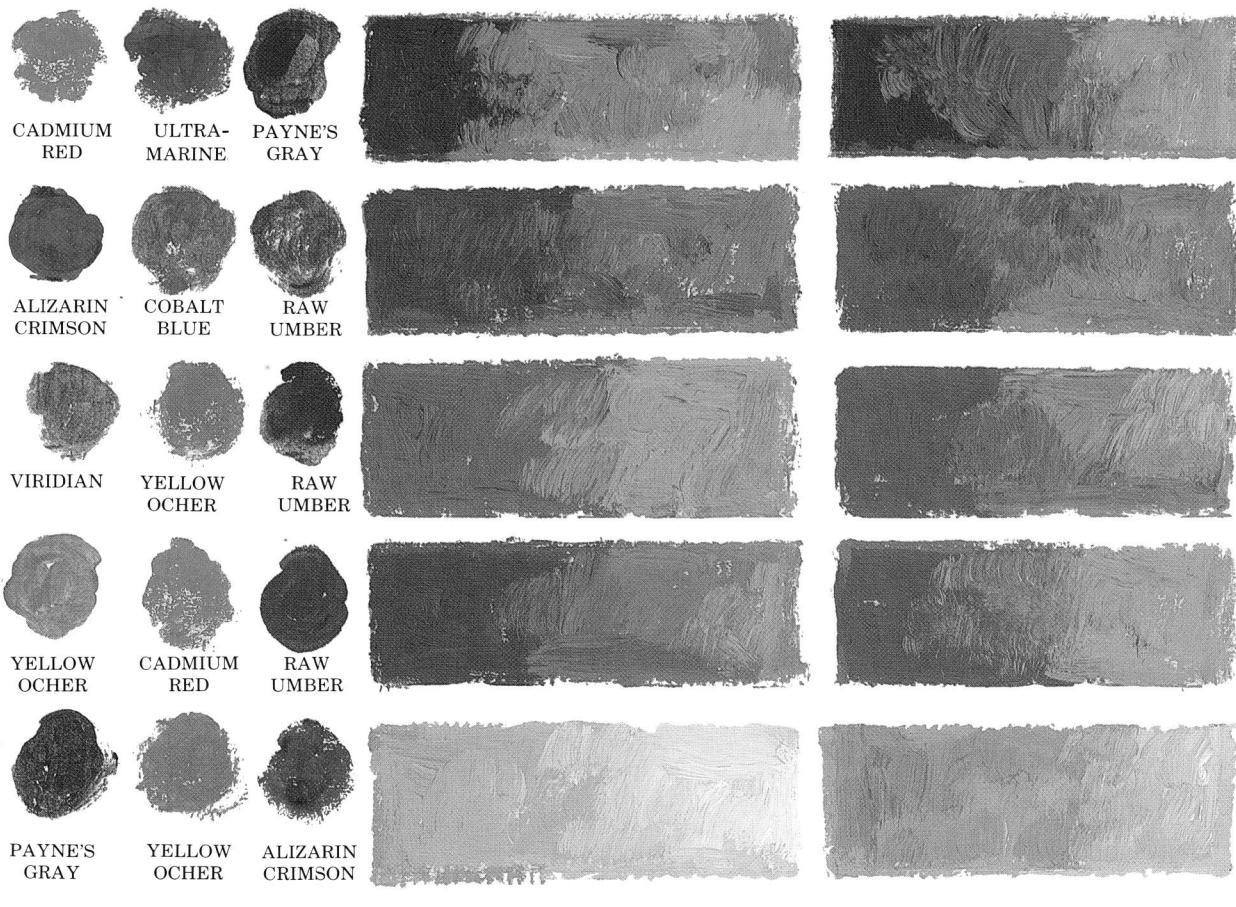

▲ Making a chart The best way to establish a regular set of good neutrals is to carry out your own experiments along the lines indicated on this chart, making a note of each satisfactory mixture.

▼Complementary colors
Most neutrals are mixed from
three or more different
pigments, so it may seem
surprising that when you
combine two of the colors
opposite one another on the

color wheel, such as red and green, the result is also a neutral. Here we show some of the subtle hues you can produce by this simple method.

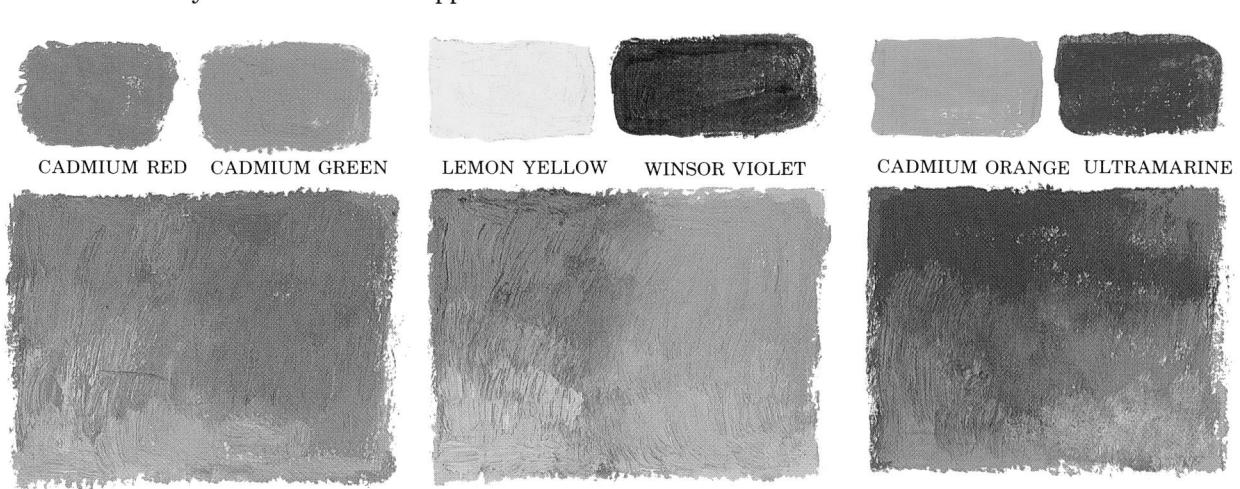

I'm disappointed with this flower painting. How can I make the colors look more vivid?

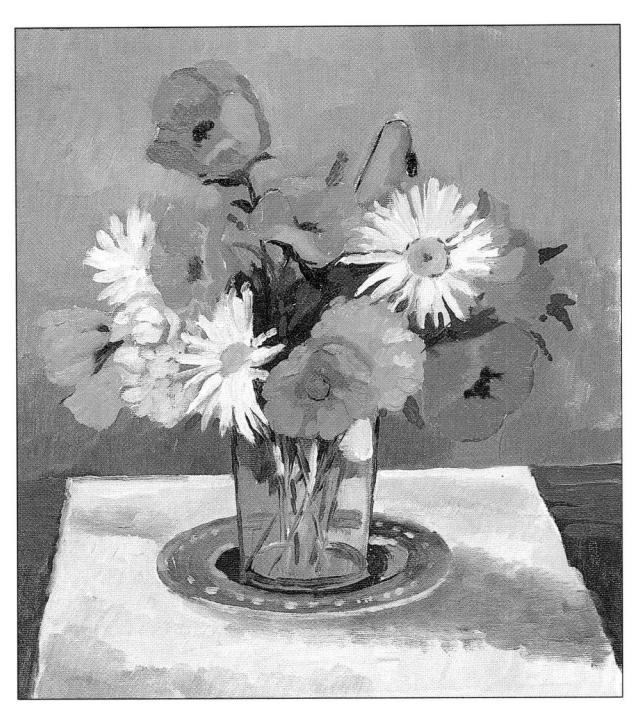

THE PROBLEM -

Flowers are an irresistible subject – how could those bright, glowing colors fail to appeal to any artist? But it's those very colors that often bring about the downfall of novice painters, and there are two main causes of failure. One is not appreciating the fact that flowers are by no means the same color all over and the other is simply not knowing which colors to use. This painting is an example of both: the student has produced dull, muddy pinks and mauves by using mixtures based on alizarin crimson, and the flowers are robbed of both color and form by the flat, uniform treatment.

THE SOLUTION -

The best way to show flowers in all their glory is to save the bright colors for the highlights, and make "less say more" by means of contrast. In Pamela Kay's painting opposite, you'll notice a lot of different colors and values, most noticeable in the red poppy on the right, which varies from a deep crimson scarlet, passing through various shades of pink. Before you even begin to mix your paint, look very hard at your subject, focusing on a particular flower. Then ask yourelf how much of this really is bright pink or

mauve. If you can't see much variation it may be because you haven't got the lighting right, so try moving the flowers around so that the light from a window catches them. And don't forget about the background. Look at the way Pamela Kay has broken up the background, contrasting the central flowers with a dark, warm brown, so that they look brighter and more delicate.

■ The mixing problem Some colors, such as blues and yellows, mix very well together and don't lose their brilliance in the process, but odd things can happen to the reds. For example, alizarin crimson and ultra-marine, which should by rights make a good purple, actually produce a dull, murky one and cadmium red loses its splendid vivacity as soon as white is added. So if you intend to go in for flower painting, you must extend your palette and buy at least two extra colors. You'll certainly need a good purple, and you won't capture those lovely pinks and mauves without one of the rose or rose madder colors, and perhaps a magenta. But be careful, as some of these pigments fade over time, so always choose one that has the word "permanent" on the label. If you feel really extravagant, invest in a small tube of vermilion, the most intense of all the reds - but very, very expensive.

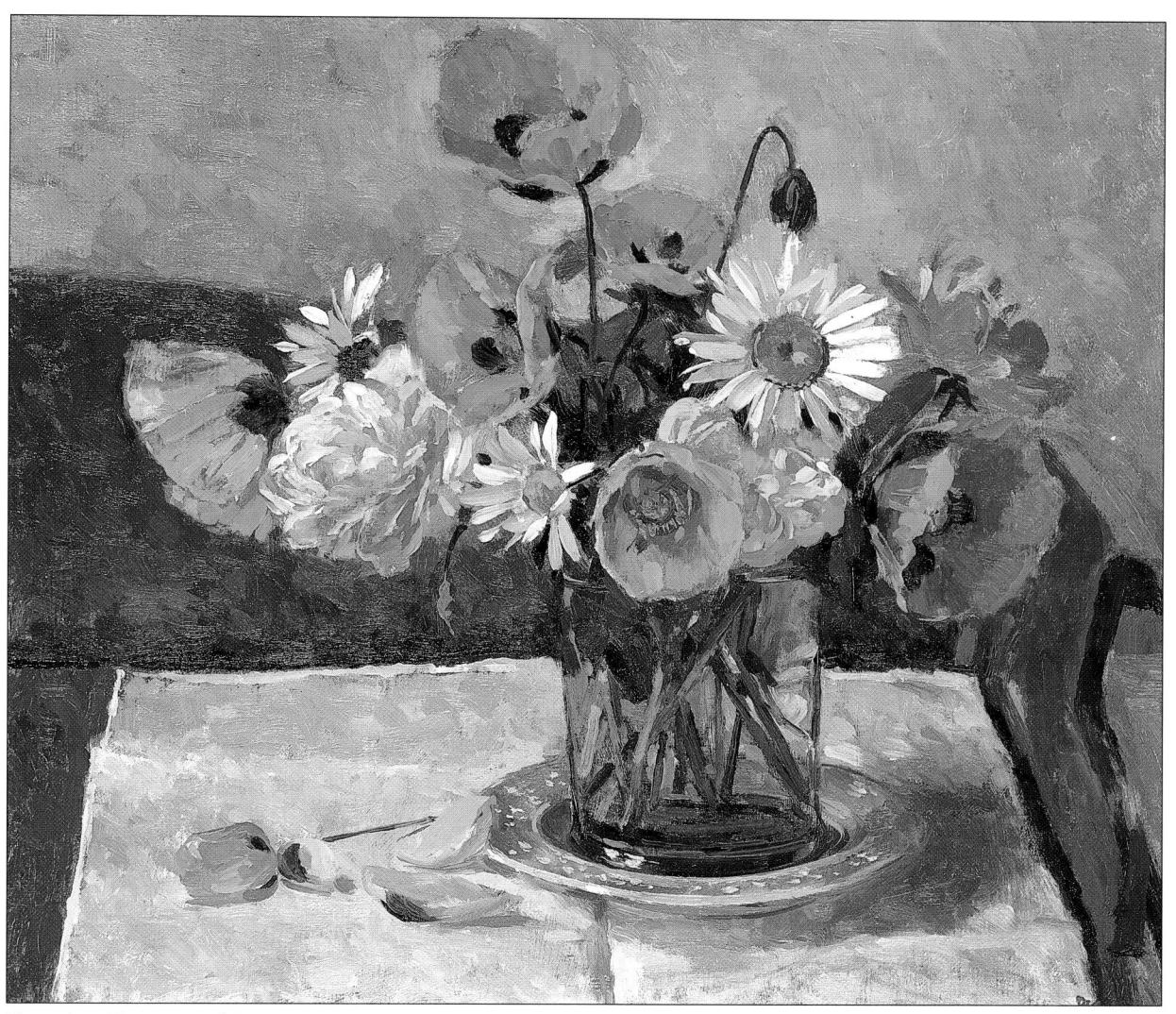

Poppies, Roses and Daisies by Pamela Kay. $13 \times 14 \text{ in}/33 \times 35.6 \text{cm}$

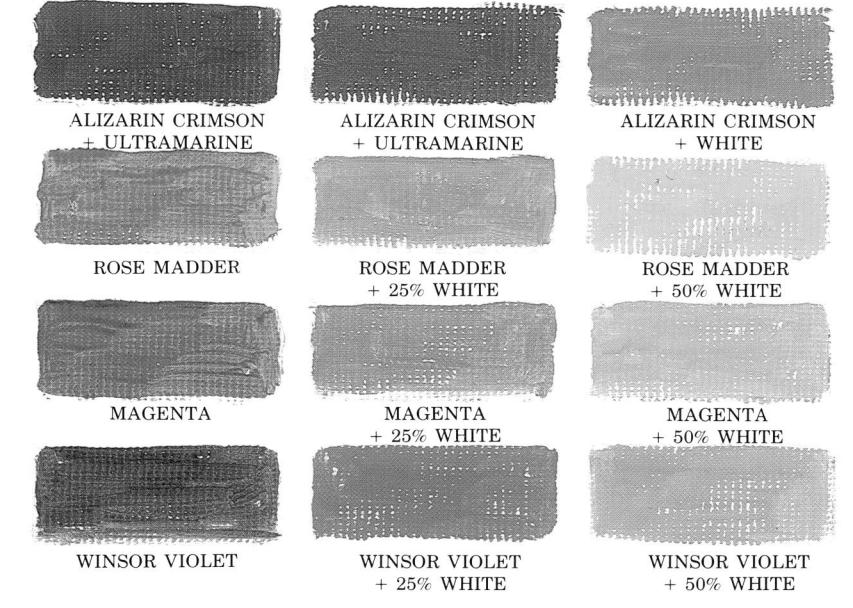

◆Special colors Here you can see the somewhat murky color produced by mixing alizarin crimson with blue or white. Rose madder and white produce a brighter, purer pink, and brilliant purples and mauves cannot be mixed. Anyone who intends to go in for flower painting will find the three colors shown in the lower part of the chart a useful addition to the palette.

Iwanted to emphasize the shadows, but now I think the color is too bright.

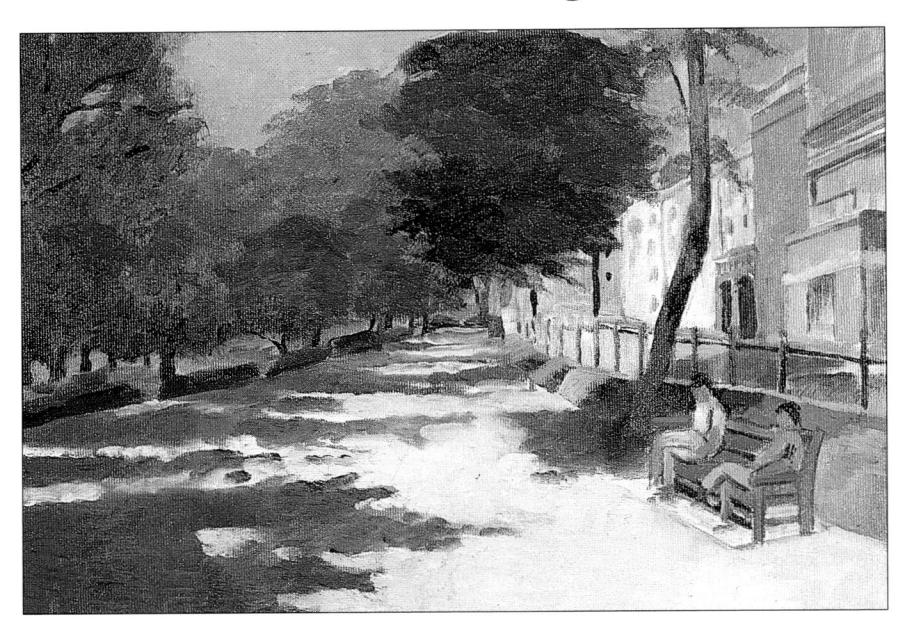

THE PROBLEM

The student has taken an intelligent and painterly approach to her subject, and has very nearly hit the mark. She has seen how strong shadows in the foreground can be used to create color and pattern interest, and has painted them boldly. But the blue-violet she has chosen is much stronger than the other colors, and because she has not repeated it anywhere else, the picture lacks cohesion. It is true that shadows are often very colorful, and even when they are not, there is no reason why you should paint exactly what you see. But if you are going to exaggerate one color you sometimes have to do the same with the others or they will not relate to one another. The painting would have worked very well if the sky had been a stronger, warmer blue, with perhaps some touches of blue in the trees to tie them to their shadows on the sidewalk.

- THE SOLUTION -

When you are planning out a color scheme for a painting, it's vital to realize that no color exists in isolation: our perception of every hue we look at is radically affected by the context in which we see it. Most people have noticed how an orange or red can really shout out when surrounded by somber colors, but can lose its identity when juxtaposed with other bright

colors. But playing off vivid colors against duller hues does not always give the effect you want, as we can see from the student's over-bright shadows. William Bowyer has taken the opposite approach in *The Terrace, Richmond* opposite, and stepped up all the colors so that their intensity matches that of the shadows.

■ Complementary colors There are some bright colors that actually enhance one another, and these are called the complementaries. Each of the three primary colors (red, blue, and vellow) has its complementary (green, orange, and violet respectively), which appears opposite to it on the color wheel. When these colors are juxtaposed, they set up a kind of vibration, and both appear brighter. The reason that the painting opposite works so well is that two pairs of complementaries have been used: violet shadows on yellow in the foreground, and red and green in the background (the delivery truck and the foliage). Notice too how the yellow of the sidewalk is not a flat color, but has small amounts of the violet mixed in with it to strengthen the relationship. It is possible to over-use complementary colors, but they are a marvelously useful tool in painting. A large area of green, for example, can be given extra sparkle by the addition of a small touch of red, and a little green on the shaded side of a red object brings out the color in the same way.

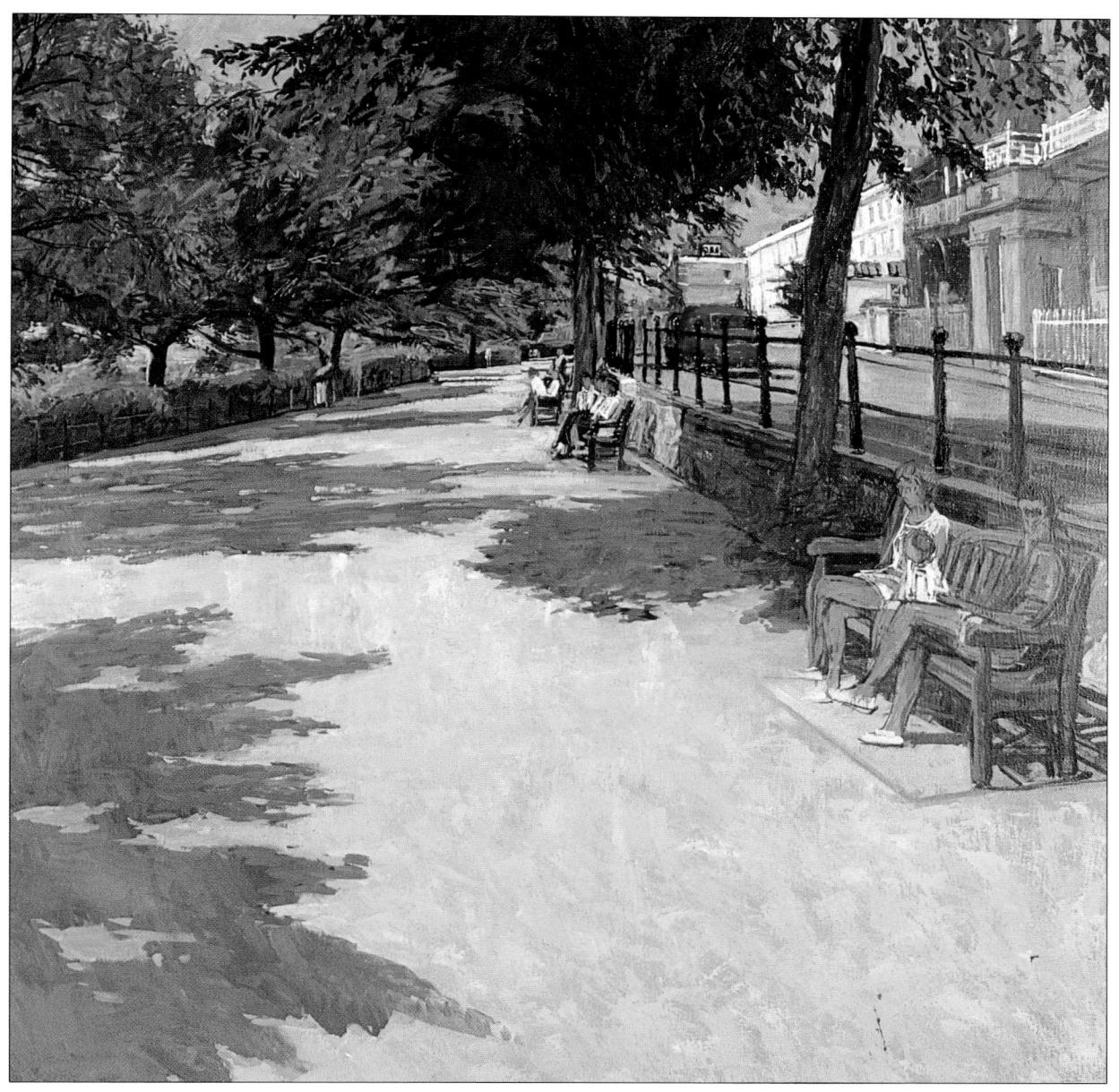

The Terrace, Richmond by William Bowyer R.A. 40 in/101.6cm square

■As well as heightening the color scheme by using complementaries, the artist has made sure that the painting has an overall unity by repeating colors. The bluegreen of the man's shirt (left), a slightly deeper and greener color than the sky, can be seen again in the background foliage (far left).

My painting looks a little weak and flat. What have I done wrong?

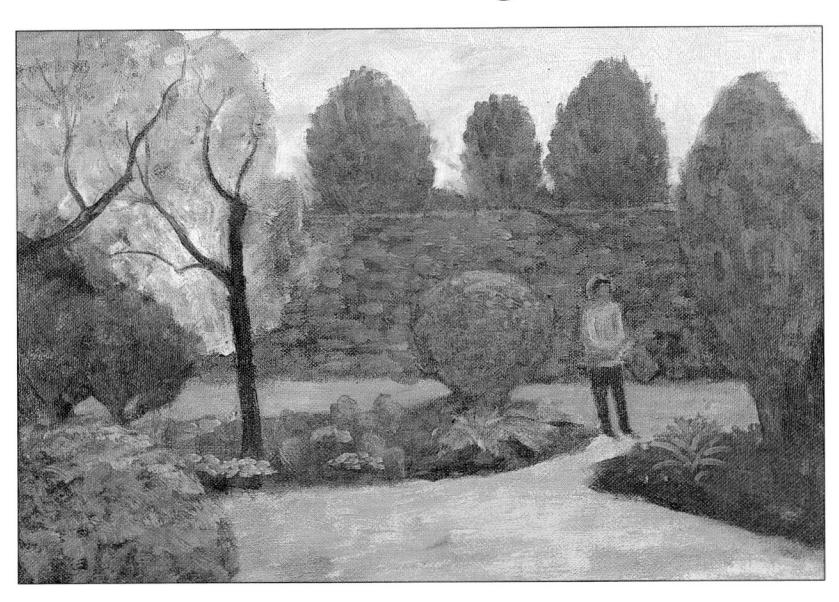

THE PROBLEM

Colors have two main properties, intensity (or saturation) and value (or tone). The intensity of a color is its degree of yellowness, redness, or blueness, and value is its lightness or darkness judged on a "gray" scale with white at one end and black at the other. Both are equally important in painting. It goes without saying that a picture painted entirely in shades of one color will probably look monotonous, but it isn't always appreciated that lack of value contrast can have the same effect. The word "monotonous", after all, means "all in one tone." The student has concentrated on the color and forgotten about the values; if we were to take a black-and-white photograph of the picture all we would see is gray. A successful painting will always say something in pictorial terms even in a monochrome reproduction, because it has contrast.

THE SOLUTION -

In the 18th and early 19th centuries, the fashionable academic painters were taught to build their paintings on an elaborate value foundation. All the modeling of form was done in monochrome, and the color was put on only in the final stages, like the frosting on a cake. The method was largely abandoned when the Impressionists began to revolutionize painting methods. But it isn't a bad idea to plan your values in advance by making small sketches with a soft pencil or ink and water so that you can locate

the main masses of light and dark.

- Getting the balance right Some colors are by nature very much lighter in value than others, for example yellow can never be anywhere near as dark as crimson. So it stands to reason that if you use a variety of colors you are bound to have some value contrast, but you may need to reorganize your light and dark areas so that they have more impact or make a better pattern. It's a sound rule in painting that shapes should be varied but not too dissimilar, so try to offset large dark areas against smaller ones, even if you have to invent in places. Margaret Green's The Bonfire (opposite) shows a lively variation in color and value. Although painted mainly in browns and greens, extra interest is provided by the inclusion of the curl of smoke and the figure carrying the watering pot. Notice also the way the round bush in the center is balanced by the taller one on the right.
- Choose a value key Avoid dividing your picture into equal areas of light and dark; decide first whether your painting is to be predominantly light, dark, or "middle of the road." Margaret Green's is a mid-tone picture, and the lightest and brightest accents (the white sweater and the watering pot) are very small. The darkest values are the boughs of the trees. Measured on the "gray" scale, these would seem fairly light, but in the context of the other values they are dark enough to stand out and provide a pleasing pattern.

■The strongest contrasts of value and color are in the center of the painting. But the figure of the girl in her white sweater needs a balance, and this is provided by the area on the left, where the branches stand out clearly against the smoke from the bonfire.

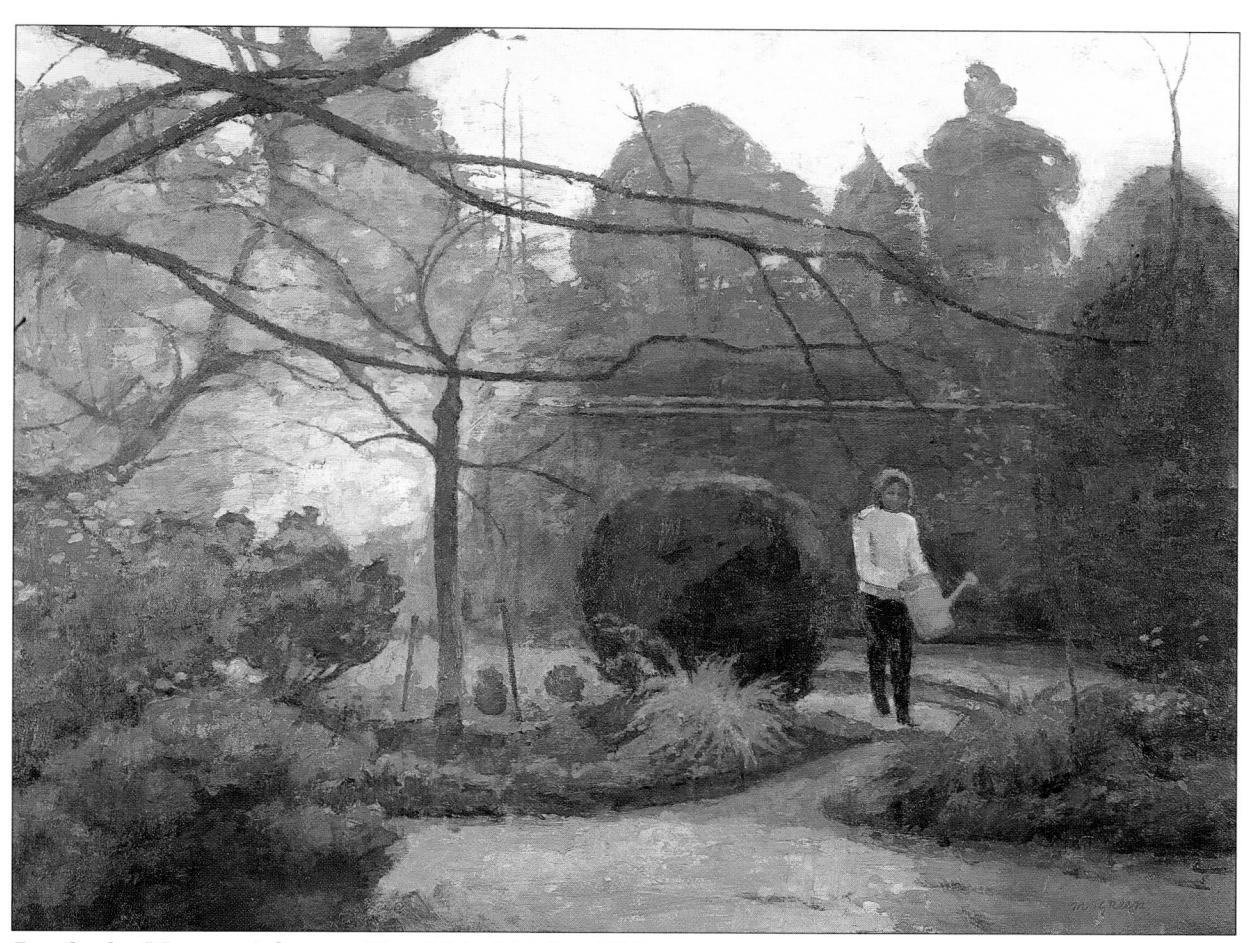

Bonfire by Margaret Green. $40 \times 30 \text{ in}/101.6 \times 76.2 \text{cm}$

The colors in my painting look much more garish than I intended.

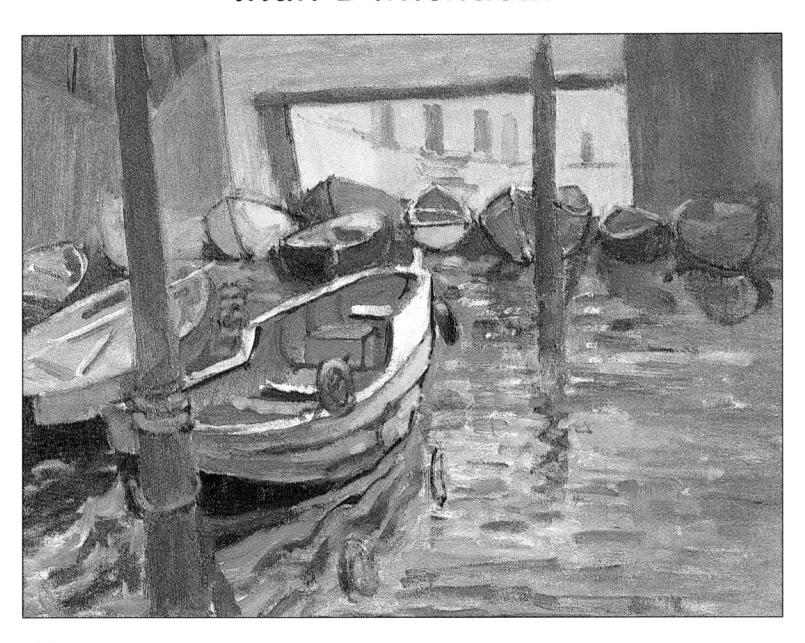

THE PROBLEM

If you look at any familiar outdoor scene late in the evening, toward dusk, you will notice that the colors are much more subtle than in the daytime: everything has a slight blue or gray cast, and a color that might have looked unpleasantly bright earlier on now blends in unobtrusively. If you want to create harmony in a painting you must do the same kind of thing make a conscious effort to banish any color that doesn't tone in with the overall effect you are seeking. You must also consider the kind of light that is falling on the subject, because this is what gives a scene its special color characteristics. The student's painting may well reproduce the actual colors of these boats, but only if they were seen under bright Mediterranean sunlight, which was not the case. The result is discordant firstly because there are too many colors of equal importance, each fighting with its neighbor to to claim a share of the limelight, and secondly because they have all been painted without regard to the prevailing light, so that it looks as though there is a spotlight trained on the foreground boat.

THE SOLUTION

The painting opposite, composed entirely in golden yellows and cool gray-blues, is an example of harmony achieved by a small range

of colors. It is an eloquent visual description of a quiet scene lit by a uniform gentle gray light, and the artist has achieved the effect by making a decision about the "color key" of the painting before starting to work, and eliminating any notes that might have destroyed the unity of the picture. If a subject strikes you as being predominantly blue, green, or yellow, try to stay within this range of colors, adding others only if the painting seems to need them. Squeeze out only the minimum of colors onto your palette, and rely on mixtures rather than pure tube colors. Using a restricted palette is a good discipline in any case, but it will also impose a natural harmony on the painting, since you will be using the same colors again and again.

■ Color echoes But a painting doesn't have to be quiet in color to be harmonious, and one way of balancing colors to provide harmony through rhythm and continuity is to repeat a bright color in varying proportions throughout the picture, similarly to the way in which a theme is repeated in a piece of music, but played by different instruments. In David Curtis's painting yellow ochers and slate blue predominate, but notice how the artist has picked up the crimson on the waterline of the boat on the left with little touches on the neighboring one. On the following pages you'll find some more ideas on how to orchestrate your colors.

USEFUL TIP

Artists often give themselves a head start when painting in a particular color key by tinting the canvas first. It is very difficult to assess the first colors you put down on a pure white surface: they only begin to make sense when you have other colors to relate them to, so it's easier to work out a cool blue color

scheme on a similarly cool blue-gray ground, or a warm yellow and red color scheme on an ocher or red-brown ground. Any small areas of the canvas left unpainted, either accidentally or deliberately, help to create harmony by pulling the painting together just as color echoes do.

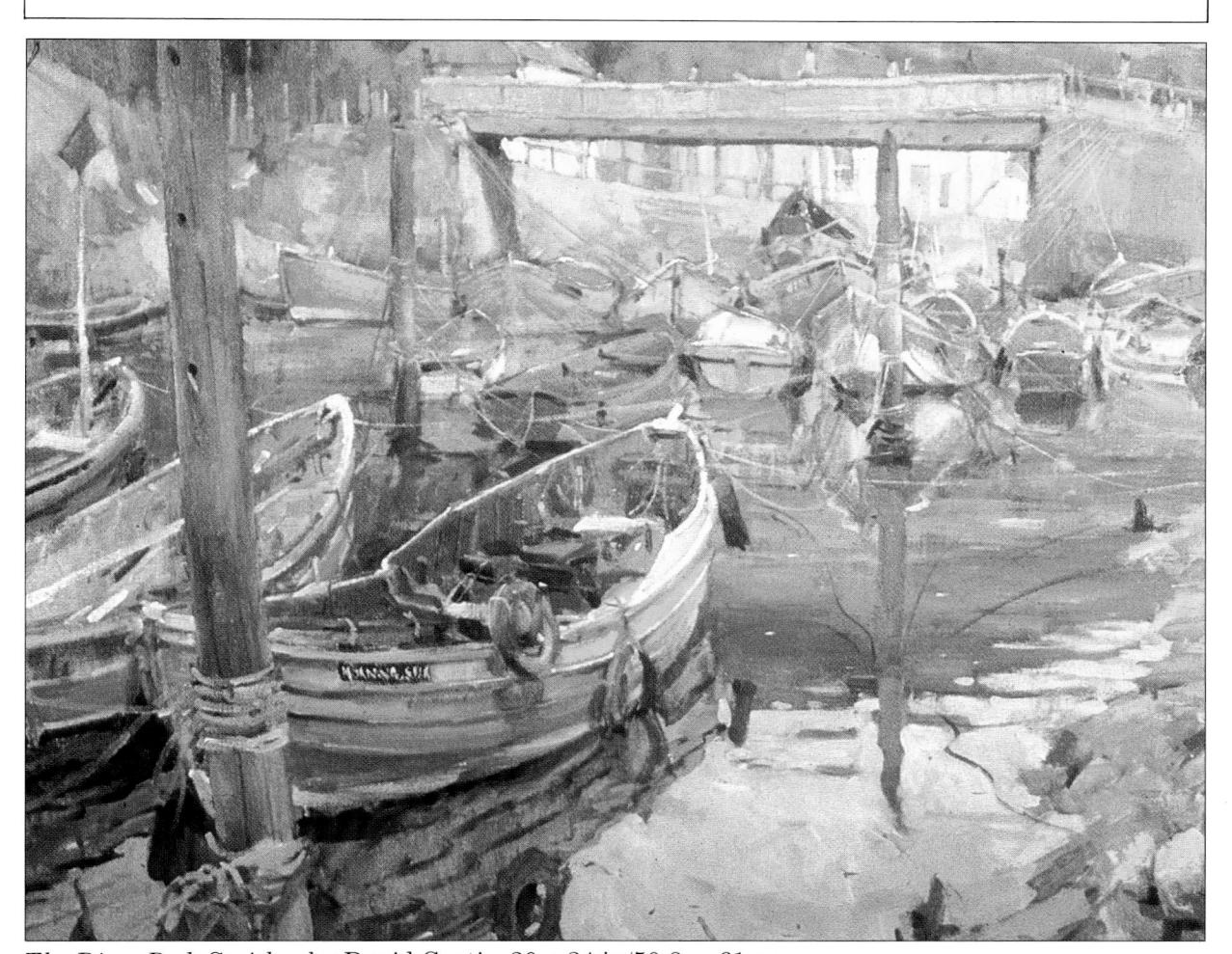

The River Bed, Staithes by David Curtis. 20 x 24 in/50.8 \times 61cm

Trehiquir, Brittany by Jack Millar. 21 imes 17 in/53.3 imes 43.2cm

Too much repetition makes for boredom, but a little of it is a good thing, at any rate in painting. A good way to create harmony is to repeat the same color in several parts of the picture, as the artist does here. All the colors are rich and bright, but the painting hangs together beautifully because the red of the foreground sail is echoed in the smaller boat and the lighthouse, while the pinks of the clouds appear again in the sea.

Terraces, Forna Lutx by Frederick Gore R.A. 25×32 in/63.5 \times 81.3cm

The phrase "harmonious color" tends to conjure up an image of soft, cool grays and blues, or muted browns and buffs, but vivid colors can be made to harmonize equally well. In this painting all the

colors are wonderfully bright and pure, with no safe, muddy neutrals, but they all work together, because the artist has chosen a color key in which red and orange are the dominant notes and has orchestrated the other colors accordingly. Even the greens are warm yellowish ones, and the blue of the sky is a hot, violet-blue which sets up thrilling vibrations with the glowing orange-yellows below.

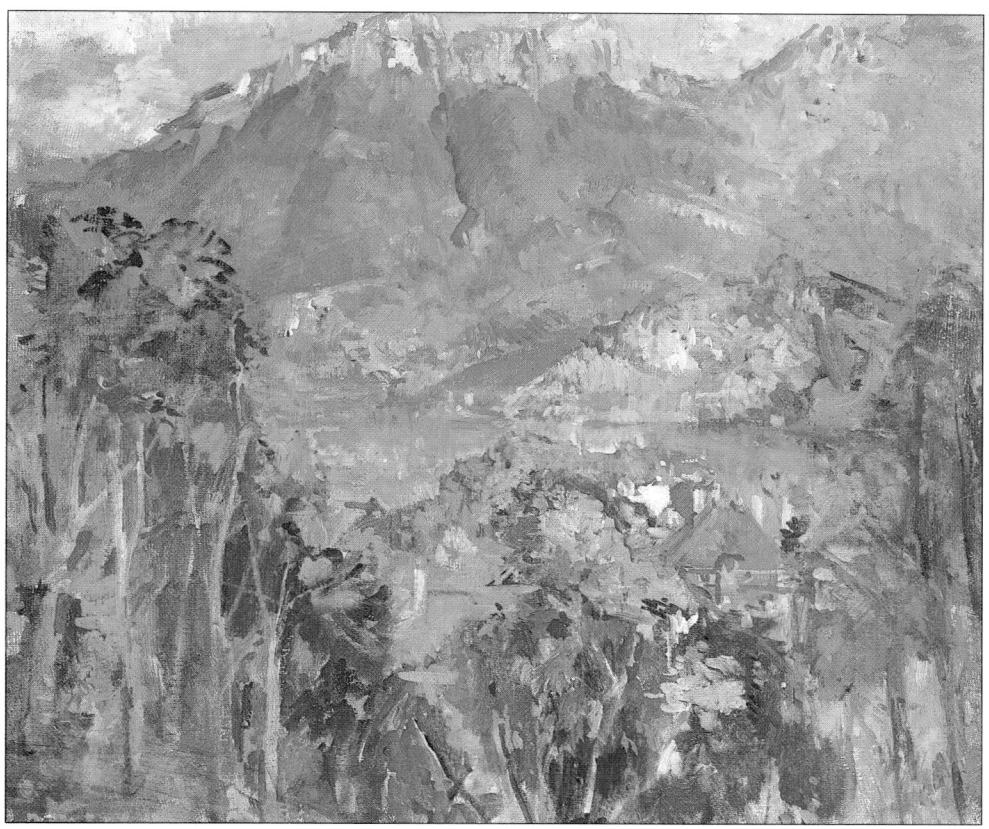

Lake Annecy by Peter Greenham A.R.A. 12×14 in/ 30.5×35.6 cm

▲ Here the artist has chosen a color key of violet-blue, deliberately playing down all the other colors so that they do not detract from the effect. Notice the unobtrusiveness of the greens of the trees and the muted brown-pinks of the rooftops.

▶ Sometimes nature is obliging enough to provide us with ready-made harmonies by filtering the light so that all the colors become muted. The danger with a misty scene like this one is that it can easily become boring, but this painting has a touch of magic. The artist uses a delicate, calligraphic style reminiscent of Chinese painting to create a lyrical impression of softly glowing light. At first glance it looks almost like a watercolor, which just goes to show how versatile oil paint is.

Hammersmith Gardens by Derek Mynott. 36 in/91.4cm square

I wanted to capture the feeling of a warm, cosy restaurant, but I think I've used too many colors.

THE PROBLEM

When you first begin to paint, your main preoccupation will obviously be to give a faithful rendering of the colors you see in front of you. But artists often use color in another way too to create a certain mood or evoke an atmosphere. This doesn't necessarily mean changing the colors perceived; it's more often a question of suppressing or playing down the ones that don't help the overall effect. The student has aimed at creating a cheerful impression, and has chosen yellow as the dominant color. There is nothing wrong with this, but pure unmixed vellow is a very strong color, and not at all restful. Coupled with the cold blue, the result is somewhat startling, failing to capture the warmth and intimacy of the scene. It is not that there are too many colors but that they are ill-chosen.

THE SOLUTION

The painting opposite gives exactly the impression of warmth and intimacy that a restaurant owner seeks when planning the decor, and the reason is that there are no "cold" colors. The artist has chosen to represent the scene in various shades of red and dull pink, and the result is restful and pleasing, with none of the jarring notes of colors that don't belong. Notice how even the faces are painted in a darker shade of the background color, and how the whites are a warm, creamy color.

- Warm and cool colors It is well known that certain colors catch the eve and make us feel cheerful - manufacturers claim that more or less any product in a red or vellow package will sell well. The colors that give us the most emotional "uplift" are the reds, pinks, oranges, and yellows, which artists describe as warm colors. Basically colors are divided into two groups on opposite sides of the color wheel, all those with red and vellow in them being perceived as warmer than the blues and blue-based colors. As we can see in Margaret Green's painting, color temperature, as it's sometimes called, is a way of creating mood. A painting in shades of blue and blue-gray will convey a feeling of peace and tranquillity, while one in bright, warm colors will evoke the kind of energy we feel on a bright, sunny day.
- Using value The overall darkness or lightness of a painting also has an emotional effect on the viewer think of the "gloomy" old paintings you see in some galleries. You may want a painting to look somber it may be a somber subject and if so the best way to do it is to keep the values dark and avoid bright colors. This kind of painting is called low key. If, however, you want an impression of gaiety and lightness, the values should be correspondingly pale and delicate, or high key. Over the page you will see some more examples of color used in an expressive way.

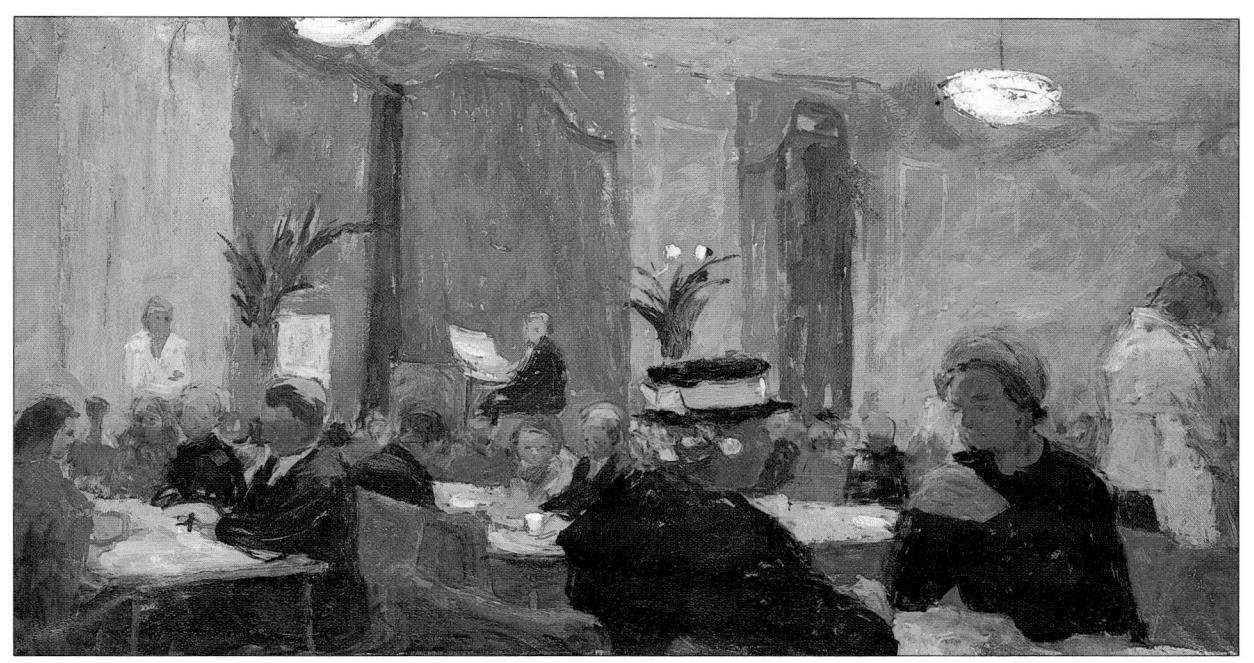

Lyons Corner House by Margaret Green. $17 \times 30 \text{ in}/43.2 \times 76.2 \text{cm}$

▼The deep color of the faces could look strange or wrong in a different context, but is perfectly in keeping with this warm colour scheme. Notice that the figure of the waiter, and all the other whites in the picture, are a warm creamy color. A harsh blue-white would have destroyed the intimate, relaxed atmosphere.

Flowers and a Staple Gun by Frederick Gore R.A. 36×32 in/91.4 \times 81.3cm

You couldn't possibly feel gloomy for long around a painting like this one, with its light, bright colors and lively pattern. It is tempting to think that the artist felt just as cheerful and buoyant when he was painting it.

The River Nene, Northamptonshire (detail) by Christopher Baker. 24×52 in/61 \times 132cm

Interior with Sian – Colonsay by David Curtis. $20 \times 24 \text{ in}/50.8 \times 61 \text{cm}$

▲ In this painting, the artist has used a limited range of dark, somber colors to give a feeling of brooding stillness and silence. There is something almost menacing about the spiky shapes of the trees and clumps of grass in the gathering dusk — this is a place we would want to hurry from before nightfall.

■Light, delicate, high-key colors and tones heighten the relaxed, meditative attitude of the seated girl bathed in sunshine from the window.

COMPOSITION

Organizing Your Picture

Amateur painters are often daunted by this word, and with some reason. There seem to be so many things you have to think about when you take up painting – first you have to draw the subject, which is hard enough, and then you have to persuade your paints and brushes to work with you to create a convincing impression of shape, form, and color. And then, when you are finally beginning to come to grips with these problems, somebody invariably brings up the difficult concept of composition.

Artists have always formulated theories about composition, but every time one generation thought up a "rule" it was promptly broken by the next. So you will be pleased to hear that nowadays the only important rule is "if it looks right, it is right." There is really no mystique about composition – the word simply means organizing all the separate parts of a painting into a pleasing whole, and the chances are that you will often do this without thinking about it, just as you decide what combination of clothes to wear or how to arrange the furniture and lighting in a room. The greatest of all the Impressionists, Claude Monet, devoted his entire

artistic career to "painting what he saw" and ignoring the current rules on composition, but because he was an artist, he composed his landscapes unconsciously, while giving all his mental energies to more technical problems.

If you are out sketching a landscape, you will choose the viewpoint that seems to make the best picture; if you are painting a portrait you will think about how and where to place the sitter. In both cases you have already started to compose your painting by making decisions about the subject, but now you must take the process a stage further and decide how to turn subjects into paintings. Before you start the portrait you will need to consider how you will place the image on the canvas. Are you only interested in the head, and if so, should it be placed in the middle or not? Would the portrait be more interesting if you showed more of the shoulders, or if you included the hands? How much background should be included? In landscape painting, the process of composing is less obvious, but just as important. You may be halfway through a painting before you realize that the subject is not quite as perfect as you

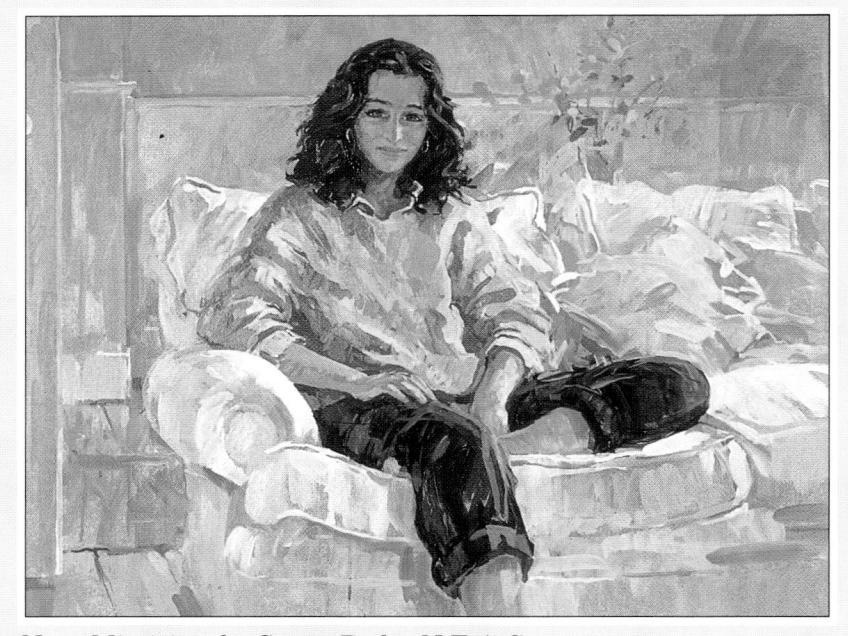

Neva Missiriam by Susan Ryder N.E.A.C. 30×36 in/76.2 \times 91.5cm

■ Composing a portrait or figure painting needs quite a lot of thought, as there are so many choices open to you. Here the artist has used the room setting, with its pale delicate colors and varied shapes, as an integral part of the composition. The figure stands out firmly as the focal point, accentuated by the strong value contrasts. thought. You feel that the picture isn't quite working, and then you begin to notice things you hadn't seen before. Perhaps a particular feature is too assertive, and needs something to balance it, or a shape overlaps another in a way that is less than pleasing. This is where composition comes in: never forget that you are an artist, and art is about interpretation, not copying.

This chapter provides solutions to a wide range of composition problems. There are suggestions

▶ A still life composition will not be successful unless it has a good balance of shapes, colors and values. But as you can see from this lovely

painting, it need not be complex. The main shapes are all variations on the circle.

The countryside where this was painted is flat and quiet, but the painting certainly is not. The artist has given a lovely feeling of movement to the picture by the way he has placed the curving path and the clumps of trees, with the small branches reaching up into the sky.

for improving dull foregrounds, creating depth in landscapes, balancing shapes and colors, editing out unhelpful details, and working out the best arrangements for still lifes and portraits. There's a wealth of inspiring examples showing how different artists have organized their paintings to make the most of their subject-matter — composition, like color, is a means of conveying personality and emotion, and no two artists can ever have the same approach.

Nasturtiums and Peaches in a Basket by Pamela Kay 10×14 in/25.4 \times 35.6cm

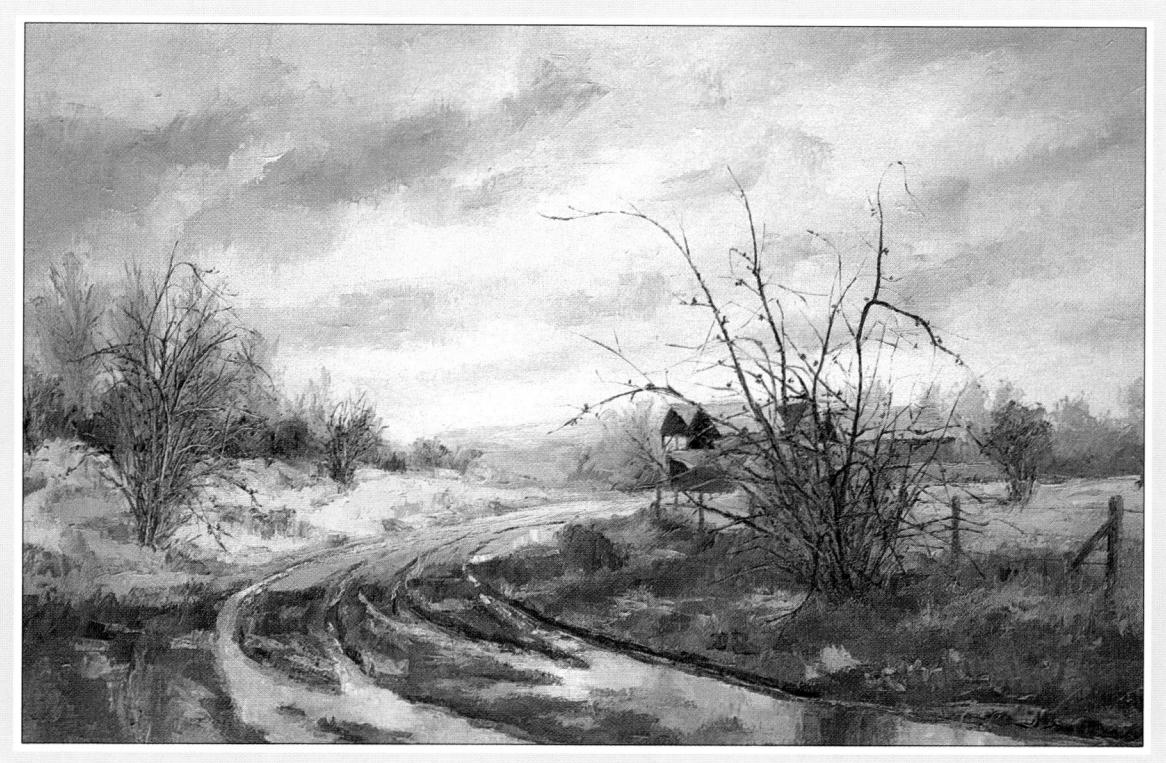

Farm Track by Brian Bennett. 36×24 in/91.5 \times 61cm

I did this landscape from life, but I seem to have lost the feeling of emptiness.

THE PROBLEM

One of the problems with painting on location is that it can make you feel rushed. In your desperate attempt to get the colors down and catch those marvelous sky effects before they have changed, you don't plan your picture as well as you might, and so lose sight of the very quality that originally attracted you about the landscape. The student can see in retrospect that an empty, spacious landscape has become crowded and over-detailed, but lacked the courage at the time of painting to "edit out" the details that detract from the impression of wild bleakness that is the essence of the scene. Nature exerts her own kind of tyranny, cluttering up the scene with extra rocks, bushes, and clumps of grass, and because they are there you feel you can't ignore them. But a good landscape is rarely simply a copy of nature - the golden rule is to put in only the elements that help the painting and leave out the rest.

- THE SOLUTION -

The painting opposite was actually painted in the studio, although the free treatment gives it the look of an on-location sketch. This artist, however, makes frequent outdoor sketches and notes to record the effects of color and light in the countryside around him, and these provide him with a reference file from which he later works. Here there are no unnecessary details, and the sheep and clumps of grass in the foreground have been treated so broadly and sketchily that they blend into the landscape rather than standing out as features worthy of special interest. But they nevertheless help to give a sense of scale to the picture, pointing up the expanse of moorland, distant hills, and sky—a device often used by artists is to include a small figure in the middle distance to serve this very purpose.

■ Using visual reference Photographs can be very useful as reference for this kind of landscape, as you can take a picture of a particular sky or effect of light in a matter of seconds, but you don't always have time to draw or paint your impressions. They are not a substitute for sketching and observation, but they provide a good backup. Always take several photos, not just one, as this will enable you to plan the composition by combining different elements and viewpoints without being too tied to your first impression. (There is more advice about using photographs on page 96.) It is easier to carry out the editing process from photographs than from life because there is no hurry, so look at the them carefully to see which details are best omitted, where the horizon should be placed and so on. Then make a sketch and work from this rather than directly from the photograph, or you could fall into the same trap as the student and find yourself copying instead of painting.

USEFUL TIP

One problem with working from photographs is that, since you have all the time in the world, your work tends to become tight and fussy. You can avoid this by setting yourself a time limit. Pretend to yourself that you are working outdoors and the light will soon

change, and decide you will finish the picture within two or three hours. Your painting will look far freer and more spontaneous than if you spend days reworking a sky, and it will probably be closer to your original impression.

Redmires Reservoir, Peak District by David Curtis. $18 \times 24 \text{ in}/45.7 \times 61 \text{cm}$

■There are few details in the painting, but those that are included, such as the sheep, are treated very broadly. A more precise description would have made them stand out too much, stealing attention from the true subject of the picture: the bleak, wild landscape.

I put in the figures to lead toward the focal point, but they don't really work.

THE PROBLEM

As the student has realized, the painting lacks impact because the figures look as though they have been added as an afterthought. The boathouses were obviously intended as the main focus of the painting, but she rightly decided that the buildings in their rather bleak landscape could not themselves hold the viewer's attention. The idea of drawing attention to them through the two walkers is fine as far as it goes, but it has not been worked out very well in pictorial terms. With sensible forethought, she has used bright colors to draw attention to the figures and lead the eye toward the ferry buildings. But the colors are too raw, making them jump forward to the foreground. Another fault is the lack of visual connection between the figures and the buildings. The expanse of muddy ochre that forms the foreground only encourages the eye out of the picture; it should lead into it.

THE SOLUTION -

It helps to have a focal point in a painting because it concentrates the mind and the eye, and when properly handled it can transform a potentially dull scene into a lively and exciting one. In *Evening Walk, Walberswick Ferry*, Margaret Green has orchestrated her values, colors, and shapes in such a way that every element in the composition flows in toward the old boathouses at the center of the picture. The

walkers are part of this plan, and catch the eye by the strong value contrasts in their clothing. Notice too how they are placed against the ferry buildings, ensuring a connection between the two, while the buildings themselves are noticeable because they stand out dark against the pale gold of the sky. The foreground is a stronger version of this golden hue, tying the painting together by repeated colors.

The focal point of a painting arises naturally from your own interest in a scene; for example if you feel excited at the way a small white house nestles among hills and fields, this clearly must be made the part of the painting to which the eye is led. But it won't look after itself - you must decide where to place it on the canvas and how to emphasize it. It is usually a mistake to place the focal point bang in the middle of a painting or to make it too large, as it will then steal interest from the rest of the picture. It can occupy only a tiny proportion of the picture area, as long as it stands out, and one of the the best ways to make it do this is to use contrasts, either of value or of color. A bright color surrounded by somber ones will have an immediate impact, and so will a patch of white or near-white among dark and mid-tones. Remember that you as an artist are designing, not copying, so ask yourself whether the hypothetical white house would stand out better with some dark trees behind it, or could be emphasized by a curving path or wall.

Evening Walk, Walberswick by Margaret Green. $20 \times 24 \text{ in}/50.8 \times 61 \text{cm}$

■The diagonal lines lead the
eye to the walkers and the
ferry houses. Notice how the
artist has achieved the lovely
golden color of the foreground
by working over a thin orange
underpainting. This is allowed
to show through the top layer
of paint in places, adding
visual interest and effectively
lighting the way to the focal
point.

I'm not at all happy with my treatment of the foreground; the wall looks too obtrusive.

THE PROBLEM

Foregrounds are one of the knottiest problems of all to solve: you paint the middle distance and the sky with great conviction, only to find the composition looks weak and unresolved because there's an empty space in the front of the picture. So what do you do? Do you add something that isn't actually there, make more of what is there, or simply leave it empty? The student has recognized the dilemma, which is half the battle. but has failed to win it because she hasn't seen the foreground in relation to the rest of the landscape. The combination of the hard horizontal line and the rather heavy painting of the wall serves to isolate it, so that instead of leading the eye toward the trees and hills, it fulfills the proper function of a wall and keeps the viewer out.

- THE SOLUTION -

Most landscapes can be seen as having three parts (excluding the sky): foreground, middle distance, and far distance, but unless the artist can integrate all these areas so that they "flow" into one another the painting will look disjointed and jumpy, with no feeling of space and recession. In Christopher Baker's landscape, we can identify the three parts, but notice how cleverly the foliage in the foreground has been "tied" to the middle distance. The diagonal brushstrokes and

lighter values of the sunlit, windblown grass on the right stand out against the dark shadow of the field beyond and take the eye straight in toward the trees.

- Using shadows Never ignore the possibilities of using shadows as part of a composition. The shadow cast by a tree outside the picture can break up a flat expanse of grass in the foreground into exciting shapes, and the value contrasts bring the area forward to the front of the picture. Try to look for such effects and memorize them, or better still make sketches or take photographs for future use. But if you are going to invent a shadow, do make sure it's consistent with any others in the painting, or you will create a bizarre and unsettling effect as though the sun were in two places at once.
- Using color and value It is not always desirable to have strong foreground interest: for example, if you want to stress the space and emptiness of, perhaps, a stony beach stretching away to a distant horizon, you will want to play down the foreground. But you must still find a way of giving it its proper place at the front of the picture, and this is where theory comes in. Remember that colors are always brighter and value contrasts stonger the nearer things are to you, so try to turn theory into practice picking out just a few of the pebbles on the beach in more detail and stronger colors should do the trick.

South Downs, Halnacker Hill by Christopher Baker. 12 x 18 in/30.5 \times 45.7cm

◀In the student's painting, the foreground wall is treated more tightly than the rest of the picture, but here the paint is handled consistently throughout. There is just the merest suggestion of individual leaves and grasses in the foreground, so that it points us toward the middle ground but does not assume too much importance.

It's always a temptation to overwork the foreground in a landscape because you can see each flower and blade of grass so clearly. But it's usually a mistake, as it detracts from the rest of the picture. Here the artist provides just the right touch of interest by picking out a few of the grass heads and buttercups. The directional brushstrokes used for the grass on the left bank lead the eye into the picture so that the viewer is encouraged to follow the course of the river.

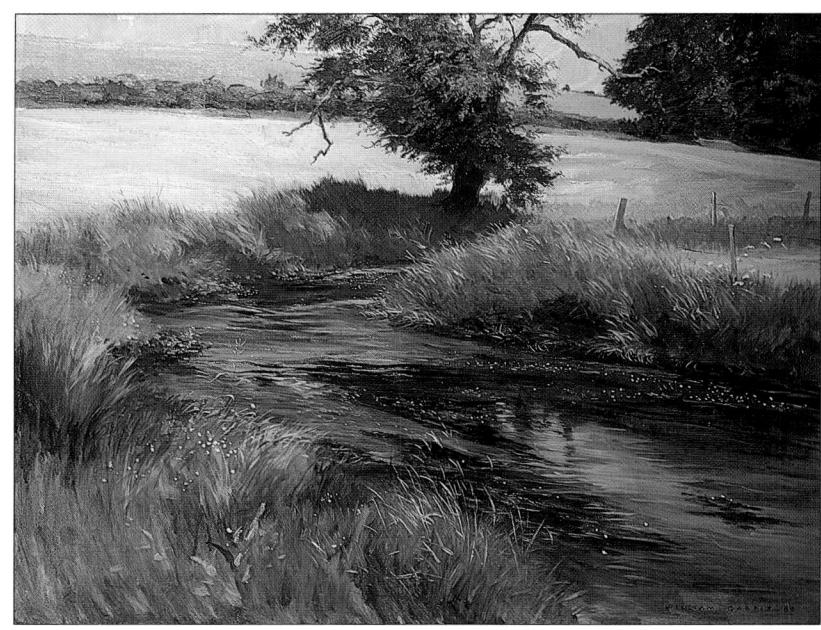

River Cerne by William Garfit R.B.A. $16 \times 20 \text{ in}/40.6 \times 50.8 \text{cm}$

Beach Taverna, Winter by Paul Millichip. $20 \times 24 \text{ in}/76.2 \times 101.6 \text{cm}$

A painting does not have to have an obvious feature in the foreground. This picture expresses the emptiness of the landscape, and unnecessary foreground "interest" would have weakened it. But the foreground must still be made to come forward to the front of the picture, and the artist has achieved this effect by the most economical of means—just little flicks of darker paint suggesting the shadows thrown by tiny shoots of sand plants.

Scalasaig Pier, Colonsay by David Curtis. $16 \times 20 \text{ in}/40.6 \times 50.8 \text{cm}$

Towards the Severn by Geoff Humphreys. 29×24 in/73.7 \times 61cm

▲ In this painting, the pile of rough-hewn stones is both the foreground and the focal point, its bold triangular shape occupying half the picture area. Notice how the artist echoes the triangle theme both in the buildings and in the group of stones on the right.

◀A plain expanse of green like this field could easily look dull, but the artist has used some cunning, dividing it into unequal geometric shapes by means of a cast shadow. There is no dramatic tonal contrast, but the band of darker color makes all the difference to the painting — try blocking it out with your hand and see how static the composition looks.

This painting doesn't seem to catch the feeling I had about the subject.

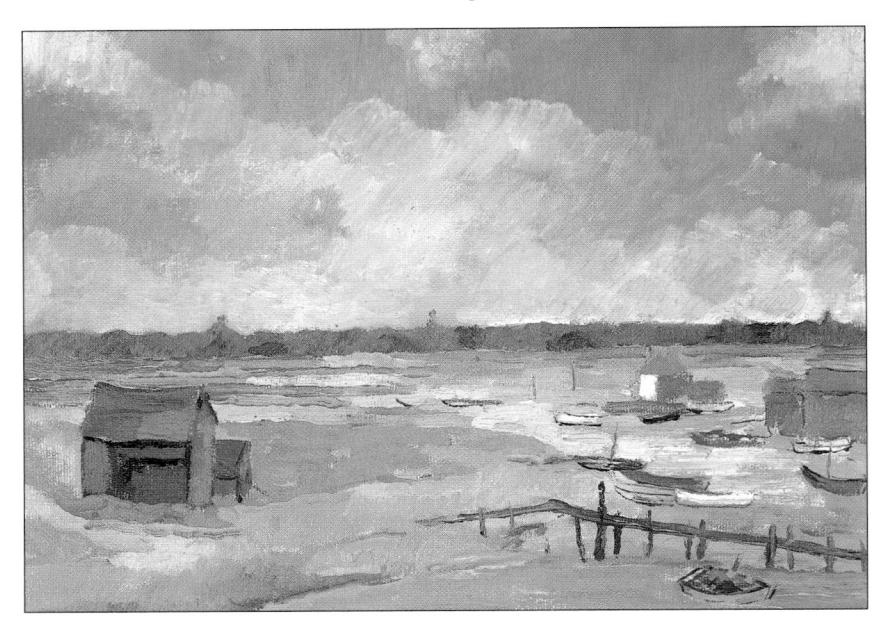

THE PROBLEM

Something that many amateurs don't realize is that proportion is an important element in the composition of any painting, whether a still life, a portrait or a landscape. If you are painting a portrait vou will do your best to get the proportions of the features right, but since the head will probably occupy most of the picture space you won't have to worry too much about the larger proportion – that of head to background. In landscape, this dominating proportion is the relationship of sky to land (or sea), and you do have to worry about it because it is crucial to the atmosphere you are trying to create. The student's painting is an example of a lost opportunity: placing the horizon bang in the middle so that it divides the picture into two halves tends to make the composition monotonous, but more important is the way it has robbed the picture of emotional content – there is no feeling that the painter has responded to a particular kind of landscape.

- THE SOLUTION -

The decision about where to place the horizon is often more or less made for you by the landscape itself. The part of the English countryside where *Southwold Harbour* (opposite) was painted is very flat, and always seems dominated by great expanses of sky. The artist has responded to her knowledge of and feelings about the area by

allowing the sky to occupy over three-quarters of the painting so that, although there is a good deal going on in the foreground, the domination of the sky is really what the painting is about.

You might want to do exactly the opposite: in a mountain scene, for example, you could emphasize the impression of a landscape pushing upward into the clouds by allotting only a tiny proportion of the picture area to the sky, perhaps even allowing a tall mountain to go out of the frame at the top.

There is slightly more of a problem when you want to give equal weight to sky and land, which happens quite often. What you want to avoid is a picture divided into bands of different colors that don't relate to one another, so try to break up the central horizon in some way so that it doesn't make a hard division between land and sky. Think about including one or two tall trees or some hills to provide a link between the two. Another way of tying a painting together is to repeat shapes and colors from one area to another. A cloud, for example, can be made to echo a tree or group of rocks in shape, and since the sky is reflected to some extent in the land below, you won't have to invent repeated colors. Look closely and you'll see that shadows are often a fairly vivid blue, while the blues and grays of distant hills may be very close in color to the undersides of clouds.

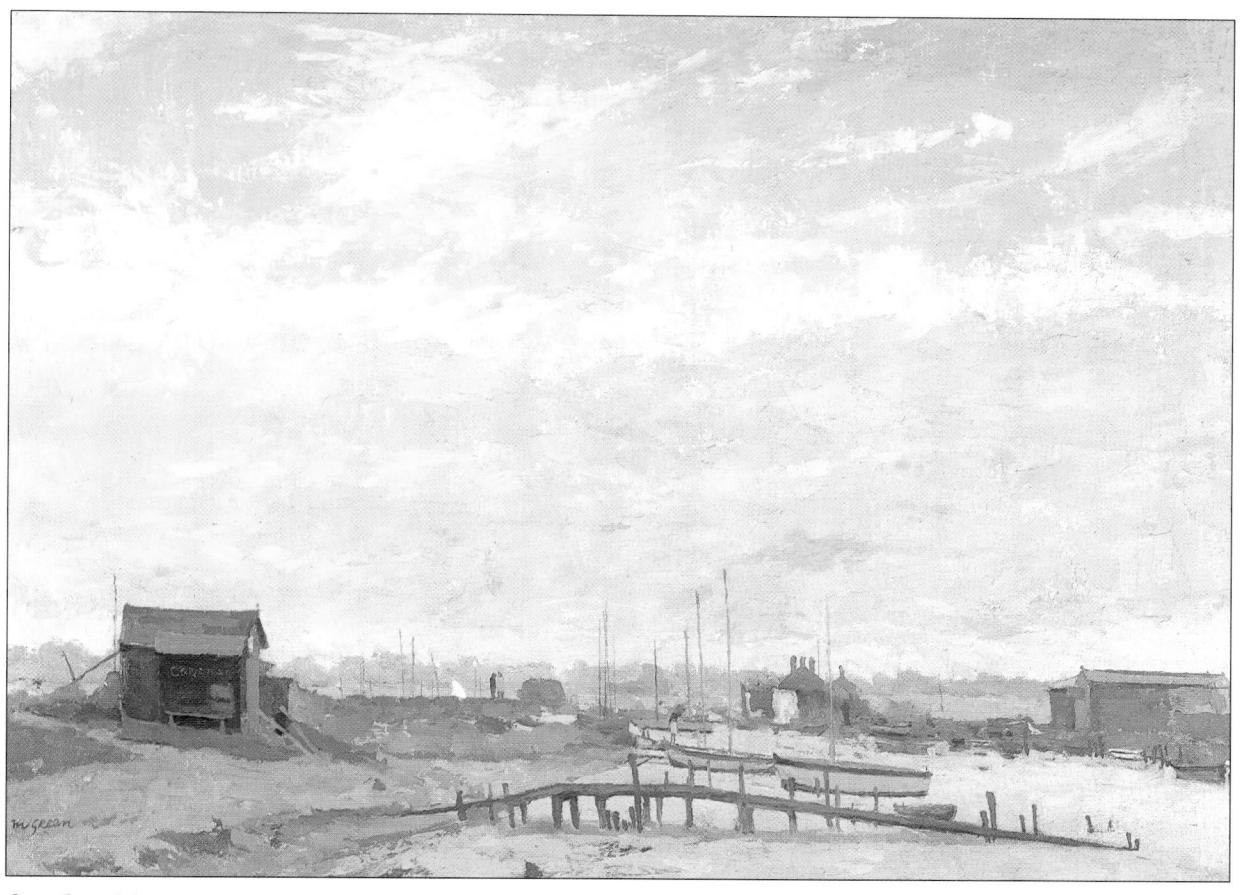

 $Southwold\, Harbour$ by Margaret Green. 20 \times 24 in/50.8 \times 61cm

■Although the sky occupies the greater part of the canvas, the boathouse, jutting up to break the horizon line, forms a strong link between the two parts of the picture.

I can't figure out why this painting looks so flat and dull.

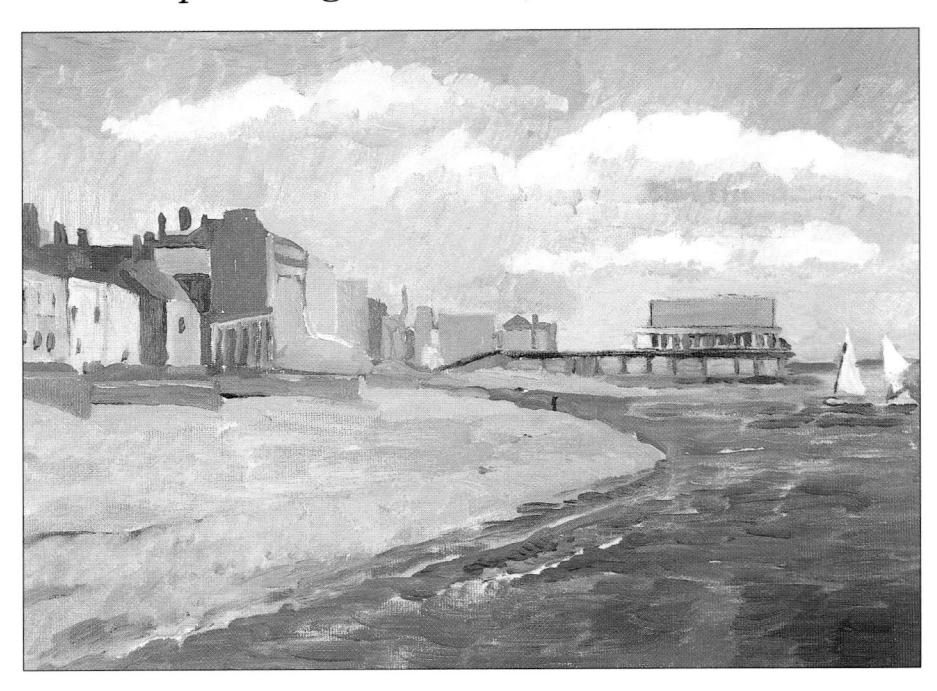

THE PROBLEM

Blue water, yellow sands, sailing boats, redroofed houses — what better ingredients could
you ask for, and how could you fail to make a
good picture out of them? But it is all too easy to
turn an exciting subject into a dull one by not
making the most of what you see, just as a cook
can spoil a dish by getting the balance of
ingredients wrong. This painting looks static
because the student has ignored the possibilities
for creating a sense of rhythm and movement.
There are plenty of visual events in the middle
distance, but instead of being led into the picture
toward them the viewer is stopped dead by the
dull, flat treatment of the water and sand.

- THE SOLUTION -

The idea of emphasizing the center of interest in a painting is discussed elsewhere in this chapter, but even when there is no obvious focal point, a good painting should always encourage the viewer to roam around it with a feeling of excitement and discovery. Geoff Humphreys draws us into the center of his painting opposite by using a combination of sweeping curves and sharper zigzags for the sand and sea in the foreground. The water is given extra emphasis by the use of rhythmical, directional brushstrokes of thick, juicy paint which the eye cannot fail to follow toward the busy scene beyond, and the sand is enlivened by the use of heightened

color. In the student's picture, the horizontal brushstrokes used for the sea and sand serve only to draw attention to the edges of the painting – we are given no incentive to look further.

- Creating movement Curves and diagonal lines are among the most powerful forces in the artist's battalion. They can be manipulated to act as signposts to a center of interest, and they set up a rhythm in the composition which prevents the static, frozen-in-time look we see in the student's version of the scene. Don't be afraid to exaggerate such features in the interests of composition, as Geoff Humphreys has done. His waves may not be one hundred percent true to nature, but the painting works.
- The picture surface A picture can be made more exciting by the way the paint is put on, and oil painters are particularly lucky because the paint can be used in many different ways to create a lively surface pattern. Never forget that a painting is a two-dimensional surface as well as a recreation of a scene. Try using thick paint in the foreground or center of interest, leaving it thinner in the background, and vary your brushstrokes too, using small ones in some areas and large, bold ones in others. On the following pages we show an example of lively, varied brushwork together with some other interesting suggestions.

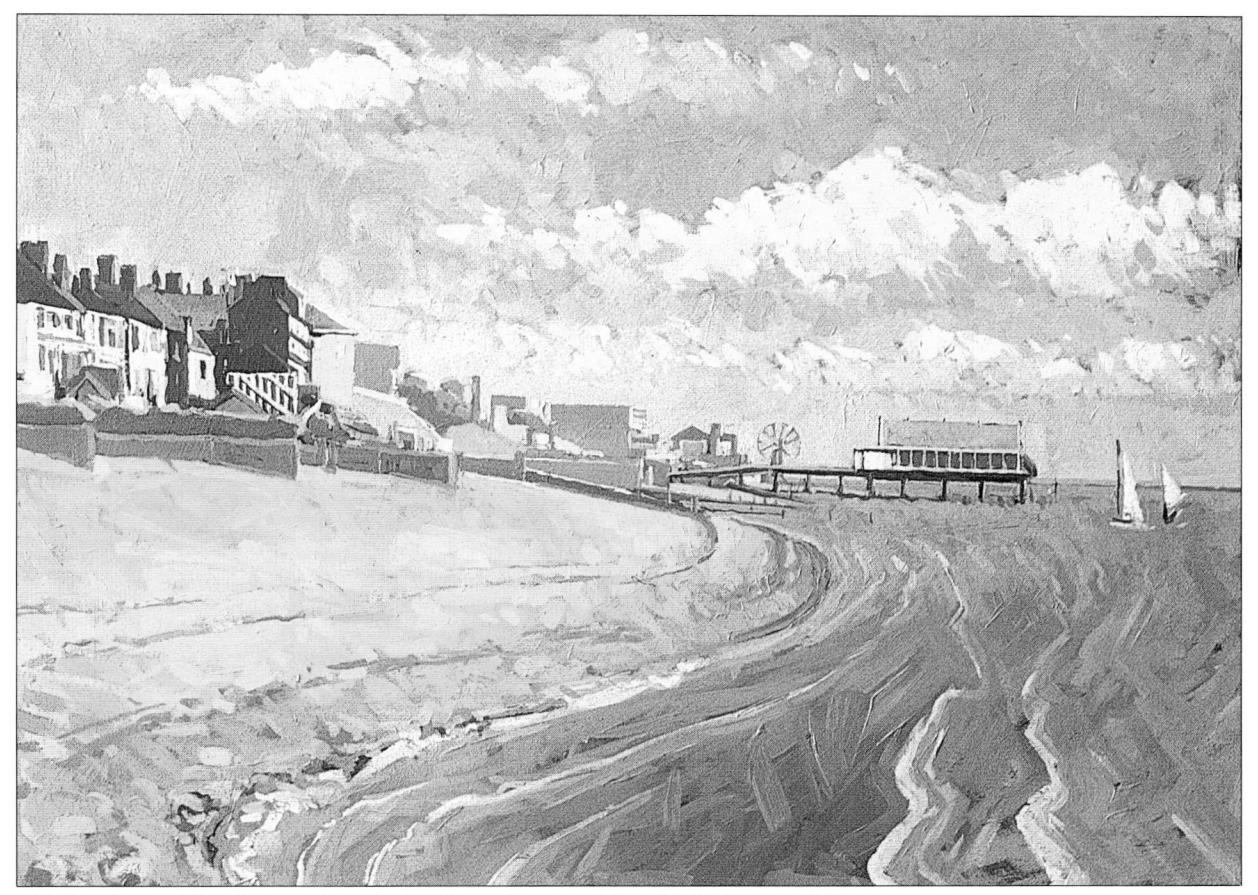

 $\emph{High Water, Cleethorpes}$ by Geoff Humphreys. 24×18 in/61 \times 45.7cm

The dark-toned, bold shape of the house encourages the viewer's eye back into the center.

The small, sharp curves at the end of the beach take the eye round to the walls and houses.

The upright diagonal of the sail serves a similar function on the opposite side.

Zigzag brushstrokes create movement and interest, as well as pointing the way to the boats and pier.

Figures can play a powerful role in giving the viewer a sense of involvement in a painting, simply because as fellow humans we identify with them. But they must obviously be planned as part of the composition, as here, where they are the focal point of the painting. They enliven what might otherwise be a dull expanse of green and provide a tonal balance to the pale tree trunks as well as "inviting us in" to share the sunlit clearing in the wood.

The Lunch Break by David Curtis. 10×12 in/25.4 \times 30.4cm

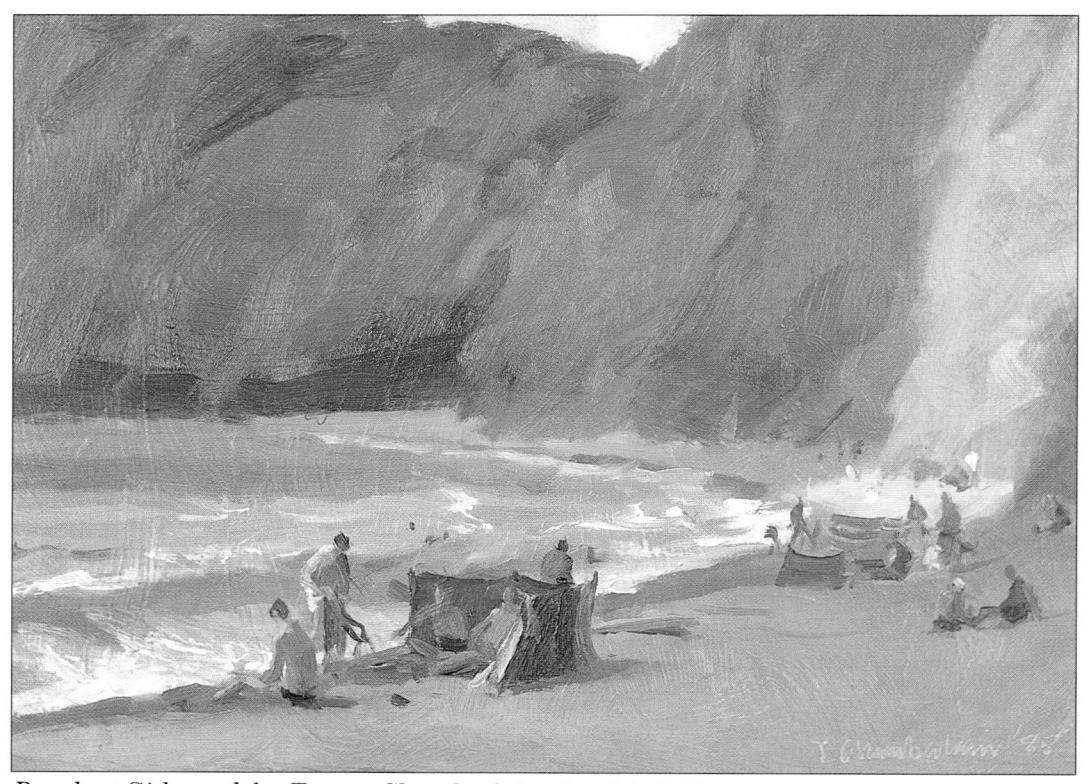

Beach at Sidmouth by Trevor Chamberlain. 6×7 in/15.2 \times 20.3cm

This artist has given extra excitement to his subject by an imaginative use of brushwork. On the cliffs and sand he has scumbled paint over a warm ochre ground, using a large bristle brush in a sweeping,

circular motion. The sea is painted rapidly, with loose slashes of white paint suggesting the foam on the wave tops, and the figures and windbreaks are laid in with just one or two brushstrokes.

Within the Wood by Sir Lawrence Gowing A.R.A. $17 \times 26 \text{ in}/43.2 \times 66 \text{cm}$

A painting like this, with its somber blue and brown color scheme, can look heavy and drab if there is no pattern or movement in it. But the artist makes sure we are kept alert and intrigued by the series of flowing curves that set up a dancing rhythm throughout the picture.

▶ A figure composition can become dull and static just as easily as a landscape, so it's equally important to draw the viewer in and encourage the eye to roam around the painting. When the figure is facing outward, as here, there is a danger that the eye will follow the same direction, but the artist has recognized the potential problem and taken steps to avoid it. Notice how the curve of the table and the horizontal of the print on the wall bring us back to the figure and the lamp, and the verticals then take us downward to the plant. Instead of focusing only on the figure, we are given visual interest wherever we look.

Beside the Lamp by Geoff Humphreys. $37 \times 30 \text{ in}/94 \times 76.2 \text{cm}$

What I wanted to paint was the drama of the stormy sky, but all I have is a forlorn little landscape.

THE PROBLEM

Dramatic weather effects have always been a popular subject for artists, but for obvious reasons it is seldom possible to work directly from the subject at such times. This means that you have to rely on memory - notoriously fallible or on photographs, which often flatten the perspective and fail to catch the full range of colors and values. Once indoors, the original impact of the subject becomes blunted by memory, so that when you begin to put down the colors on canvas they look either unbelievably dark or much too light. The student, with no visual aids to stimulate his memory, has only incompletely recalled what the sky looked like. Instead of using the bold value contrasts that characterize a stormy sky and would make a dramatic picture, he has fallen back on a range of timid mid-tone grays.

- THE SOLUTION -

The range of color and value in clouds can be very wide indeed, from almost white to very dark blues, blue-grays and purples. You can see in the painting opposite how the artist has caught these contrasts and expressed them with exciting brushwork so that the sky completely dominates the landscape. The foreground has been kept in its place with more sedate treatment and the use of mainly dark colors. The bright diagonal of the river helps to lead the eye toward the central drama of the gathering storm.

- Light and dark Most people will have noticed how a good monochrome photograph, with clear blacks and whites, can be more dramatic and exciting than a color print. Indeed, as we see in Christopher Baker's painting opposite, strong value contrasts are one of the surest ways to create visual drama. Never be afraid to exaggerate in the interests of your art. Make the contrasts as strong as you like, but try to plan them for maximum impact. A small area of a near-white surrounded by dark values is more telling than several light and dark areas of a similar size these could produce a checker-board impression that diminishes the effect.
- Size and shape Children are often frightened by stories of "a large, dark shape looming up out of the mist," and this is because large, nearby objects have more dramatic impact than small, distant ones. Shapes are also important in this context. Angular, spiky shapes stimulate us more than gentle, rounded ones or soft curves, which give a feeling of peace and tranquillity. Certain landscape features, such as sharp-edged, pointed rocks or mountains, have "built in" dramatic interest, so when aiming for drama, always consider adding such extra elements to enhance the effect. And think about where to place them to make the picture more powerful. Don't relegate your chosen rock or gnarled tree to the middle distance; put it in the foreground and let it dominate the picture, as Christopher Baker's sky does in his painting.

Fenland Landscape by Christopher Baker. 32×48 in/ 81.3×121.9 cm

The eye naturally follows the line of the light cloud down to the center.

Strong value contrast makes a focal point in the sky.

Small shapes outlined against – the sky help to avoid a monotonous horizon line.

The bright diagonal of the river points the way to the central drama of the storm.

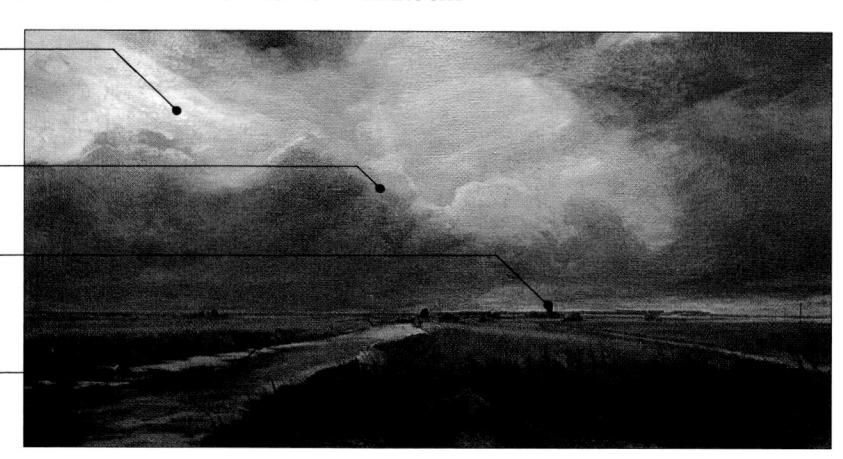

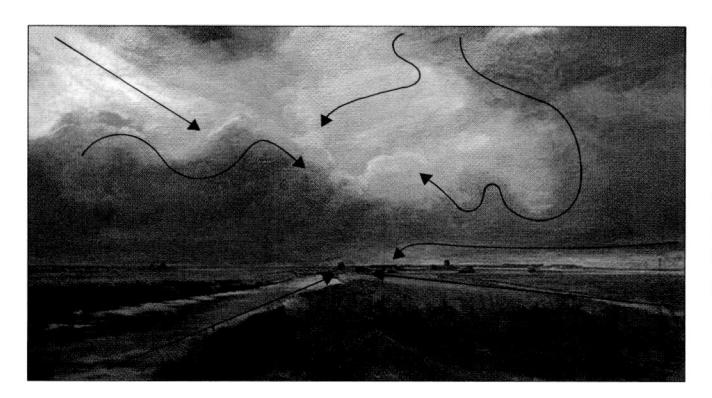

◆One of the reasons the student's picture lacks drama is that it is very static. Here the artist has used all the compositional elements to set up a rhythm throughout the painting, in keeping with the swirling movement of the clouds.

There is no feeling of space in my painting; what have I done wrong?

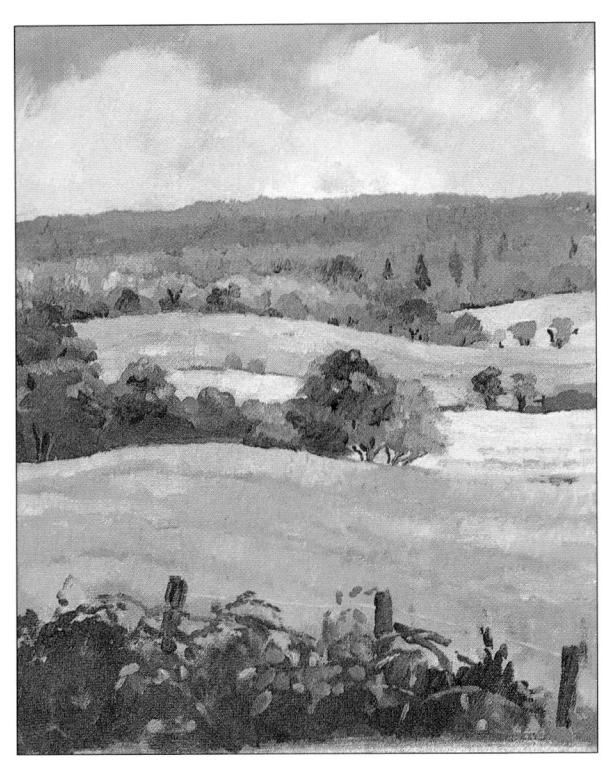

THE PROBLEM

One of the most exciting things about a panoramic landscape is the way it surrounds you on all sides and stretches away to a distant horizon that may be many miles away. But how are you to cope with the task of representing this three-dimensional space on the flat surface of a canvas? We all know that objects appear smaller in the distance, but what is often overlooked is that they also become paler and flatter, with less and less detail the farther away they are. This oversight has caused the student's failure, in that the distance, middle distance, and foreground have all been treated in the same manner. The middle- and background are too bright and too dark, so that they appear to jump forward. Likewise the strong blue in the far-off hills comes forward, destroying the illusion of space even further.

THE SOLUTION -

The kind of perspective that makes colors and values appear progressively lighter as they recede into the distance is called aerial perspective, and it is one of the surest ways of suggesting depth in a landscape. This effect is

caused by dust and moisture in the atmosphere, which diffuse the light, affecting the way we see colors. Notice how Christopher Baker uses this system in his landscape opposite to create a strong sense of recession. The foreground bramble patch and barbed-wire fence are painted in careful detail, and there are strong contrasts in the deep brown briers with their flecks of white highlight. Toward the background hills, the colors become paler, cooler, and bluer, the outlines of the trees increasingly less distinct, and the value contrasts very small.

■ Controlling colors It takes a little practice to get the colors and values right in oil painting; you'll often find that a mixture that looks right on the palette is far too warm or too dark when put onto canvas. The secret lies in mixing more blue and gray – and more white, of course – with your greens or yellows for the distant features. A cool blue such as Prussian blue is the best bet for such mixtures (but use it sparingly as it's very powerful), and lemon yellow is better than cadmium, which is bright and hot.

There are several other cunning devices artists use to give depth to their paintings, and you'll find some examples of these overleaf.

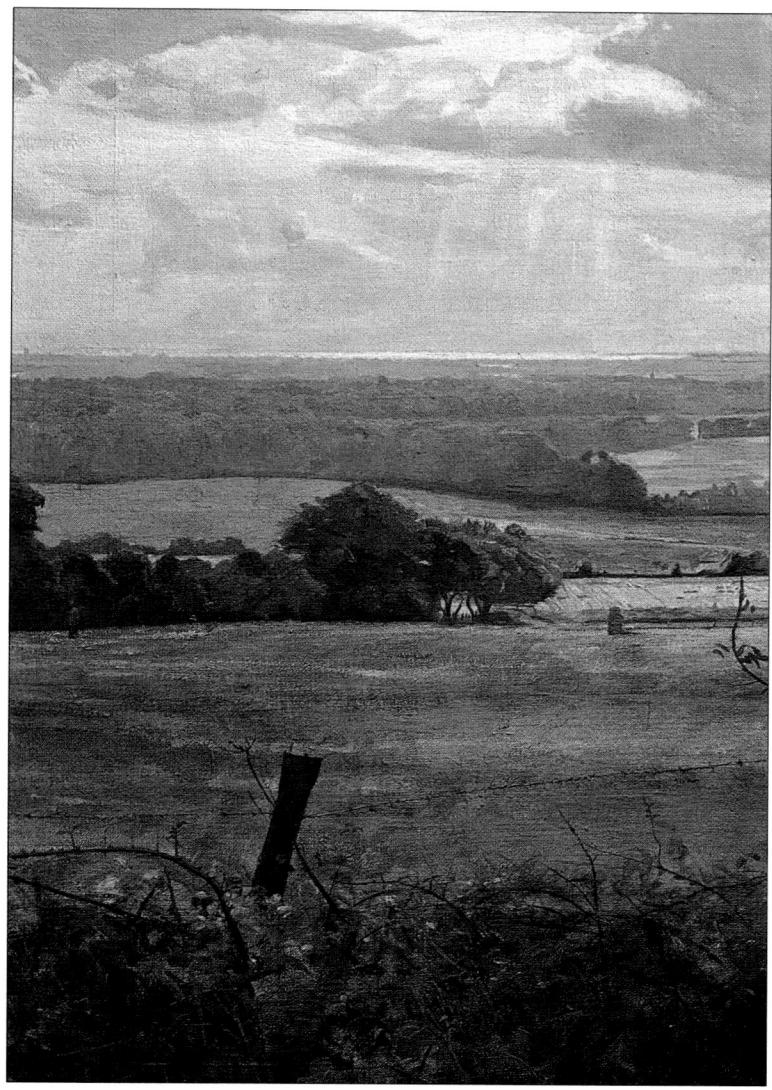

View from the Folley (detail) by Christopher Baker 36×52 in/91.4 \times 132cm

The artist has used aerial perspective with great skill. There are only minute variations in tone, and the dominant color is blue, with small additions of pale green to hint at the clump of trees.

Just a touch of linear perspective can be a powerful aid to the illusion of recession. Always keep on the lookout for small details like this suggestion of converging parallel lines.

USEFUL TIP

Never throw paint away, as the pale, cool colors you need for painting distant landscape features are difficult to match when you want to make corrections. If your palette becomes overloaded and you have no room for mixing, scrape off the colors you've used, either onto the side of the palette or onto some other receptacle such as an old plate. They can be kept for a day or two by covering them with cling film, or almost indefinitely by submerging them in water, which is then simply poured off, leaving the paint intact.

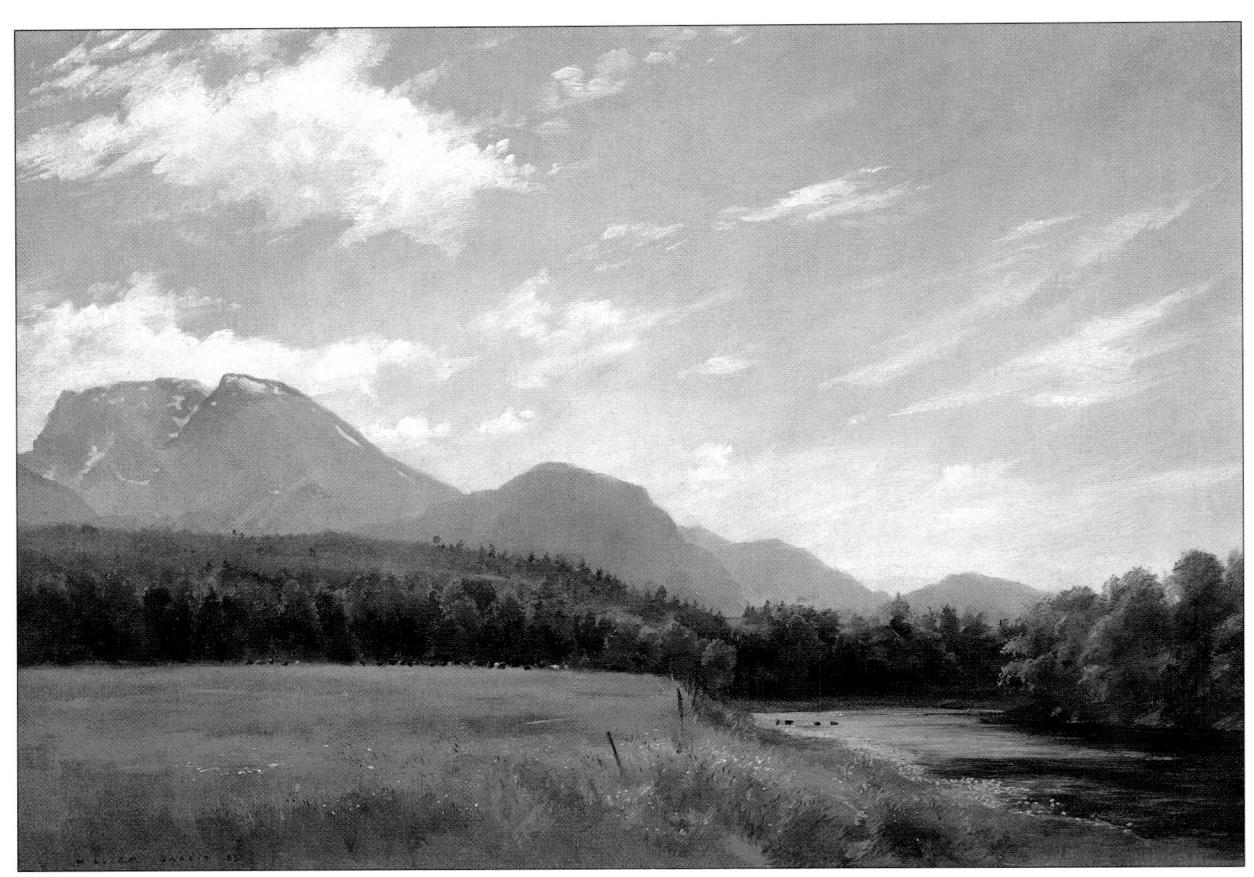

Camisky Pools and Ben Nevis by William Garfit R.B.A. $14 \times 20 \text{ in}/35.6 \times 50.8 \text{cm}$

The artist has used aerial perspective to create the illusion of space, the cool, pale blues pushing the mountains into the background. Notice the subtlety of the value contrasts and color changes:

the merest whisper of yellow suggests a touch of sunlight, while the patches of snow, although reading as white in the painting, would appear on the palette as a mid-tone gray.

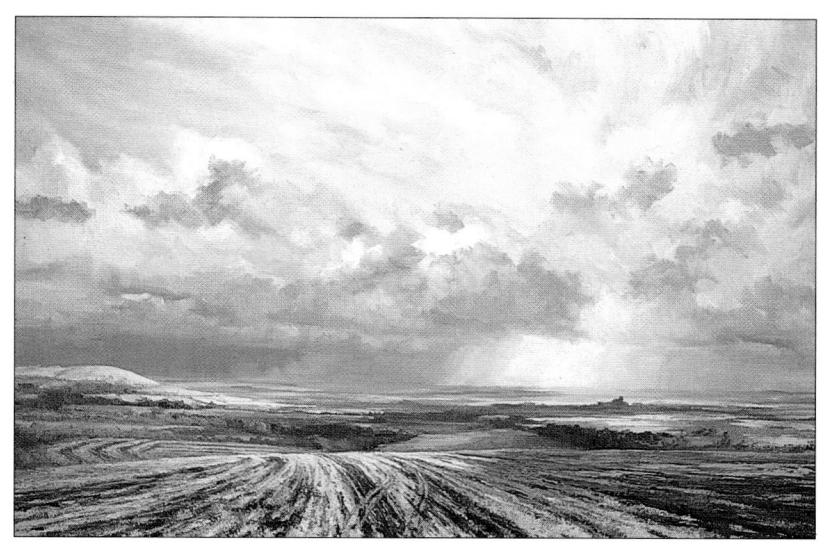

Here recession is created almost entirely by linear perspective. The converging lines not only take us from foreground to background; they also provide a convincing description of the contours of the land.

Burnt Cornfields by Brian Bennett. $48 \times 30 \text{ in}/121.9 \times 76.2 \text{cm}$

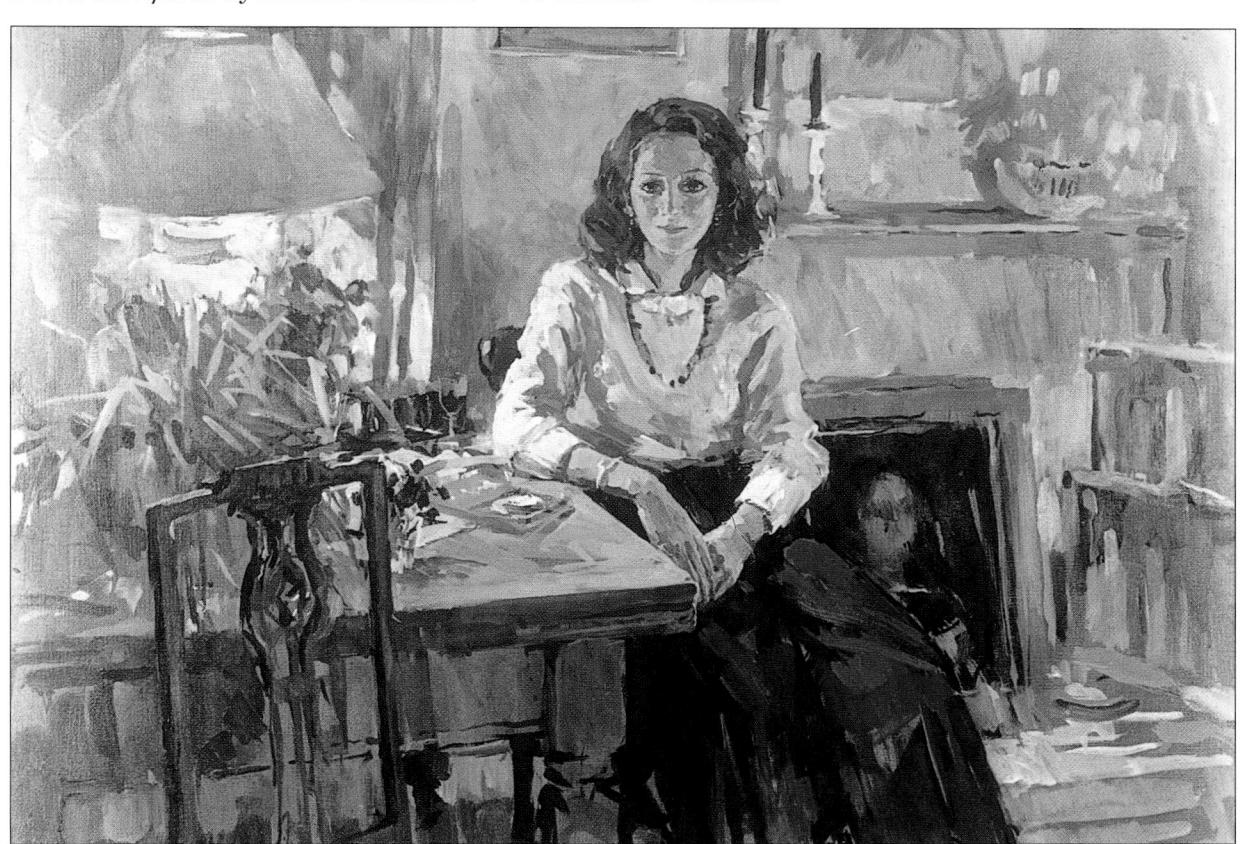

Chantal Brotherton Ratcliffe by Susan Ryder N.E.A.C. 30×38 in/7.2 \times 96.5cm

We tend to think of recession mainly in terms of landscape, but a room also has three dimensions, and it's just as important to create the illusion of space. The artist has used stronger colors and more value contrast in the foreground, and although her overall color key is cool, the warmest colors – pinks, ochers, and a touch of bright orange – help to place the figure, table, and chair in front of the background walls.

I have used the same basic composition as the professional, but his painting somehow has more punch.

THE PROBLEM

When you look at a wide expanse of land and sky vour eyes always take in more than will fit within the confines of the picture area, so it's easy to assume that nature has provided the perfect composition. But unfortunately this is seldom the case; when you start to paint you realize that all the interesting visual features are bunched up in one part of the picture, and you have no room to fit in a tree or cloud that might provide a counterpoint to something on the opposite side. The student's painting is fairly pleasing, but she has rightly observed that some small changes to the composition could give it extra punch. Everything in the picture is happening on the left; the tree and its reflection have no echo elsewhere, and the possibility of using the sky as a balance to the strong shape of the tree has been ignored.

- THE SOLUTION -

In *River Test at Leckford* the artist has planned his composition carefully, right down to the smallest detail. Notice how the the large tree is echoed first by the smaller, similarly shaped one in the center background of the picture and then by the one on the right. The latter has a further function, that of acting as a block to prevent the attention of the viewer from wandering out of the picture. In the student's painting, the right bank of the river trails out of the frame.

- Using clouds as shapes But what gives William Garfit's painting drama as well as balance is the treatment of the sky. It looks innocent enough, but this artist uses cunning to keep the viewer's attention and ensure that the painting is properly explored. The eye travels naturally along the bright path of the river and pauses to admire the reflections. At the barrage across the river, it is guided left to the tree, then up to the sky, where the blue area between the clouds follows the line of the tree until it is blocked again by the darker cloud at the top. Always remember that the sky is more than just light and air: clouds can be used as shapes in their own right. As an artist you are not restricted to copying exactly what you see, so don't be afraid to exaggerate or alter their forms, and experiment with different colors, too. A good way of giving a painting unity and cohesion is to include muted versions of the land colors pinks, yellows, browns, and greens - to modify the whites and grays of cloudy skies or the blues of clear ones.
- Making a viewing frame When you are working outdoors, a viewing frame is a great help in planning the composition. Making one is simplicity itself just cut a rectangular "window" about $4\frac{1}{2} \times 6$ in $(11.5 \times 15.25 \text{ cm})$ in a piece of cardboard. Hold it up in front of you and it will help you to visualize how your chosen landscape will look on canvas.

- USEFUL TIP -

A painting can be saved from dullness by a a dramatic, colorful sky, so if you use a camera, try starting a reference file of cloud formations; they are difficult to recreate from memory. Get your file out whenever you feel a painting needs more sky interest, but try to make sky and land consistent – super-

imposing a golden evening sky on a painting done in the morning would give a bizarre and disjointed effect, so make a note of the time of day each photo was taken. This is a useful exercise even if you never use the photos, as it will show you how widely the shapes and colors vary.

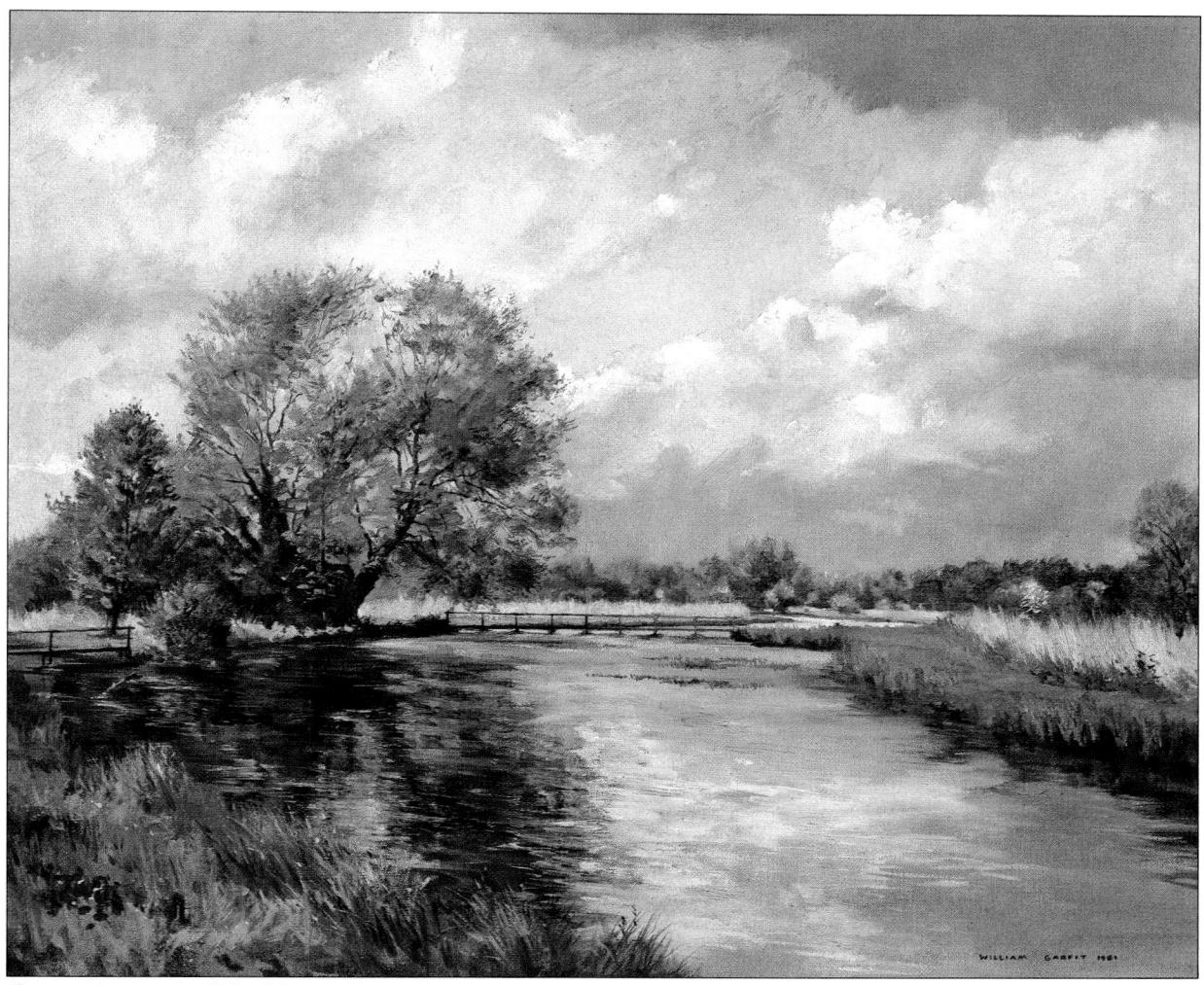

River Test at Leckford by William Garfit R.B.A. $20 \times 24 \text{ in}/50.8 \times 61 \text{cm}$

■The arrows show how the artist has planned a series of visual signposts to lead the eye into and around the painting. It is often a good idea to start with quick outdoor sketches and then paint another, more planned landscape indoors. This gives you more time to think about how to place the compositional elements to the best advantage.

I arranged this group carefully, but the painting lacks cohesion.

THE PROBLEM

The student has clearly thought about the composition of the group, and hasn't been afraid to overlap some of the shapes, but he has made two basic mistakes. The first is a very common one: his concern over the choice and placing of the objects has led him to ignore both the background and the immediate foreground, so reducing the impact of the group by isolating the fruit, flowers, and utensils in a sea of characterless brown and gray. The second mistake is less obvious but just as important. Not everyone realizes that in the West we tend to read paintings as we do the pages of a book, from left to right, and because the jug is facing out of the painting, we are not encouraged to "read on" to the rest of the picture. This negative effect is heightened by the hard, uncompromising horizontals formed by the table top, which contribute to the static quality of the picture and do nothing to lead the eye into the flowers and fruit. Although these do stand out as the focal point of the painting simply by virtue of their bright colors, color alone is not enough; a successful still life is one that has movement and rhythm, so that the eye is guided around the painting, from one object to another.

- THE SOLUTION

If you compare this picture with Pamela Kay's Still Life with Apricots opposite you'll see how

the very same subject can be treated in a way that gives it excitement and drama. Here there are no dull areas; something is happening in every part of the picture, yet it is obvious that the flowers and fruit are the center of interest. The jug on the left is the signpost that directs us inward, and this is balanced by the foreground drapery on the opposite side, which also acts as a block, taking the eye back into the the center again instead of out of the picture on the right. You can see how well this device works if you put your hand over the drapery – the rhythm is destroyed, and there is nothing to provide a balance for the background curtains.

■ **Backgrounds** When you are setting up a still life group, always consider the background as part of the picture; it can be plain and unassertive, but it should never be just an area where nothing goes on, as it is in the problem picture. Choose an overall color that harmonizes with the objects, or one that provides a color-enhancing contrast, and try to figure out ways of linking background and foreground. The student has chosen a blue-gray color to set off the vellows and oranges, which is fine, but there are no echoes of this color elsewhere to give unity to the picture. In Pamela Kay's painting, the cool blues and blue-grays are repeated all around the central group, even on the marble table top, so that the warm, glowing colors of the fruit and flowers stand out in firm contrast.

Still Life with Apricots and Buttercups by Pamela Kay. $15\frac{1}{2} \times 19$ in/39.4 \times 48.3cm

The curtains echo the foreground drapery and take the eye down to the jug.

The white flower adds interest but does not steal attention from the central group.

The box-lid continues the circular rhythm set up by the leaning flowers.

The blue of the bowl acts as a counterpoint to the yellow of the fruit.

A common mistake when setting up a group is including too many shapes and colors, resulting in patchy and incoherent paintings in which all the diverse elements vie for attention. If you do opt for an elaborate group, you will have to devise a means of uniting the various components in pictorial terms, as the artist has done here. There are a lot of shapes and colors, but the picture has a marvelous unity because each one has an echo in another part of the painting.

Oranges and Gold Box by Pamela Kay. $16 \times 20 \text{ in}/40.6 \times 50.8 \text{cm}$

Still Life with Garlic by Roy Herrick

Never ignore the possibilities of shadows when planning a still life. Here they have allowed the artist to introduce a considerable range of color and value and to break up the forms of the jars into a lively series of geometric shapes.

- USEFUL TIPS -

It pays to take time over the initial setting up of a still life group — it's no good thinking it will all come right when you start to paint. So if you have a polaroid camera, take a shot of your arrangement when you think it's right. This instant two-dimensional image will crystallize any problems and give you a real idea of how the group will look in paint, so you'll be able to spot any weak areas. For example, you may notice that the background

is dull, and would look better if it was broken up by a curtain or window frame, or you might see that the objects you've chosen are insufficiently varied in shape, or that a tall object needs something else to balance it. If you have no camera, make quick thumbnail sketches to figure out the best placing of the objects, but try to draw in value rather than just line, because this will help you to work out the distribution of light and dark areas.

Primulas by Margaret Green. 20×24 in/50.8 \times 61cm

This artist has taken a novel approach to still life, placing her small collection of objects in the context of the room instead of letting it occupy most of the picture area. She

gives as much importance to the door, ceiling, wall, and the pattern made by the reflected light as to the flowers and drapery on the table top.

I'm not happy with the composition of this portrait; it looks awkward and ugly.

THE PROBLEM

Portrait painting presents such a range of difficulties that the actual business of planning the composition is often overlooked. First there are the questions of what to ask the sitter to wear, what kind of background will best show up the face and clothing, and how the light should fall. And then you must arrange a pose that is both interesting to you and comfortable for the model, or there will be endless breaks to take a rest. All this before you even begin to draw or paint, which is when the real problem begins – that of actually achieving a likeness. If you are painting in an art class, the pose, clothing, and background will probably be chosen by the instructor, but you still have to decide what angle to paint from, how much of the figure to show, and how to place the subject in relation to the background. The student's painting simply suffers from a lack of planning. The awkwardness derives from the expanse of background above the head pushing the figure down so that she appears to be slipping out of the bottom of the picture. In addition, the decision to place the sitter in mid-canvas, coupled with the straighton angle of viewing, detracts from the drama of the pose and creates an awkward shape.

THE SOLUTION

It pays to take your time over a portrait and to plan it carefully. Achieving a likeness is only one aspect of the task; an artist's prime concern is always making a good picture, and this means searching for a balance of color and value and a composition in which there are no jarring notes or unpleasant shapes. Don't rush into it - make some quick sketches before putting paint on canvas so that you have a clear idea of what is most important and exciting about the subject. In a half-length portrait like this one, the focal point is the face, with all the other elements, such as hands, clothing, background, and the like, playing a supporting role, so try to see how you can place these to make the most of the face. In the portrait opposite, every shape is thought out. The way the head is cropped at the top, leaving small shapes of near-white on either side, is no accident, nor is the placing of the arms, which lead the eye up to the face as well as creating a pleasing triangle of blue at the bottom of the picture. The shadow plays a dual role: it is an interesting shape in its own right, balancing those of the hair and the sweater, and its dark tone allows the rich, glowing skin tones to stand out in dramatic relief.

Ennuie by Geoff Humphreys. $18 \times 12 \text{ in}/45.7 \times 30.4 \text{cm}$

Every part of the composition is carefully planned. In the student's version, there is an awkward shape where the arm intersects the black garment, but here the arrangement is pleasing, and the diagonal and vertical lines of the arms lead firmly up to the face.

Alice Baker Wilbraham at Rhode by Susan Ryder N.E.A.C. 25×30 in/ 63.5×76.2 cm

◀If you are planning a portrait of someone you know well it's a good idea to do the painting in the sitter's own home, since a person's choice of furniture and decor, like the clothes they wear, expresses their character and interests. Here the artist gives us a great deal of information about the sitter by painting her among her own possessions, with her charming pet on her knee. The cat serves a pictorial purpose as well, providing a dark tone to bring out the blue of the sweater.

▼ Oddly enough, we usually think of portraiture as an indoor activity, but if the subject is a sporting, outdoor type it makes sense to choose an informal, open-air setting. You don't have to take your paints outside unless you want to; a portrait like this one can be done at home from sketches and notes made on the spot.

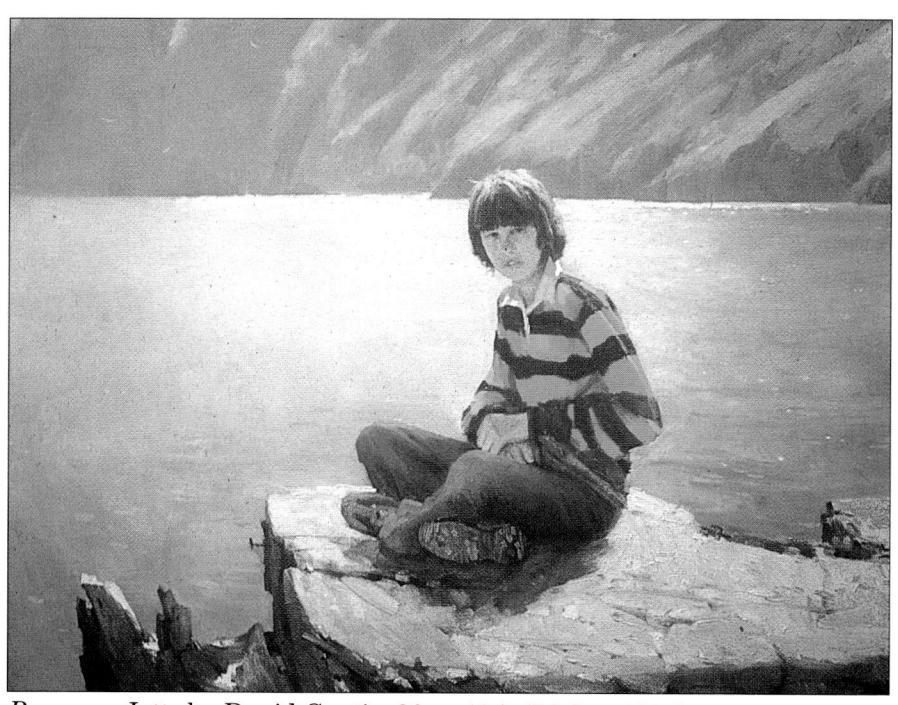

Boy on a Jetty by David Curtis. $30 \times 40 \text{ in}/76.2 \times 101.6 \text{cm}$

Anne Draws a Horse by Margaret Green. $9\frac{1}{4} \times 7$ in/23.5 \times 17.8cm

Painting children successfully requires a less static and posed approach than you might choose for an adult. Children are always on the move, and a child's face staring solemnly out from a canvas tends to look unnatural, and is almost

certainly untypical. This artist creates a realistic and intimate impression by showing the young girl absorbed in her drawing, unaware of her audience, but we are drawn into the painting by our interest in what she is doing.

I did this from a photograph, but people tell me I should always work from life. Why?

THE PROBLEM

The main reason for the often-encountered look of moral outrage at the idea of working from photographs can be seen all too clearly in the student's painting. What she has used for her reference is fine for the family album, but the trouble with such photos is that they can distort features, flatten the colors, and give exaggerated value contrasts. Then, once you start painting, you discover that you don't really understand the forms and structures very well. You can't check up by looking at the living subject, because it is no longer there, so you find yourself slavishly copying the only thing you do have, the photograph. If you look objectively at the man's hands in the photo you will see how the soft modulations of value and color that would describe the form have been bleached out. The student, having to rely on the photo, has faithfully reproduced this formless plastic look.

- THE SOLUTION -

But you *can* use photographs successfully, and doing so is not wicked, or an easy option, as some people would have us believe. Most amateurs do not draw with confidence, and the camera can be enormously useful as a sketchbook; many prominent portrait painters use photos in combination with sketches, particularly for details like clothing, hands, or backgrounds.

- Exploiting the camera Paintings can often "take off" from photographs, but successful ones are seldom straight copies. The best way to use the camera as a useful aid to the creative process is to treat your photos as the first stage in planning a painting, just like preliminary sketches. Don't just take one photo of a subject; take several, from different angles, and make visual 'notes' of any small details you think you will find hard to draw when you start the painting.
- Putting the "sketches" together Ian Sidaway uses the camera a good deal for portrait work, and keeps a large reference file. But he warns that photos must be used with caution, as "they can be surprisingly unhelpful." Although one particular shot may spark him off by suggesting an idea for a painting, he never works from this one alone, drawing on his photographic file for further ideas, and backing these up with drawings and observation. For his portrait of a mother and child opposite, he has used a series of photos taken specifically for the painting – two of which are shown here. But as he points out, such combinations do need planning. Obviously you will be in for trouble if you try to work from photographs taken at different times of day, but sometimes even two photographs of the same thing, taken at the same time but from different viewpoints, come out differently.

■The student's picture suffers from being too exact a copy of the photograph. It is nicely painted, but not enough thought has been given to the composition.

In the Garden, Richmond by Ian Sidaway. $52 \times 48 \text{ in}/132 \times 122 \text{cm}$

▶ Ian Sidaway uses his camera extensively as a sketchbook; these are two of the many reference shots he took for this portrait. But he is aware of the dangers of working excusively from photographs, and always backs them up with studies and sketches as well.

I don't feel I've made the most of this subject. How could I have made the composition stronger?

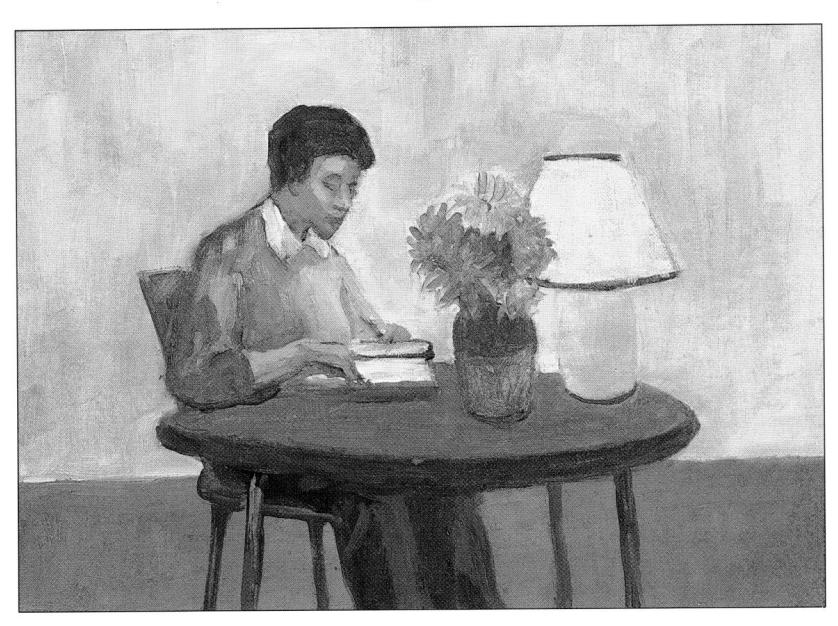

THE PROBLEM

When you see a subject that excites you, the first step in turning it into a painting is to recognize exactly what it is that has sparked you off. This is not as silly as it sounds; the problem is that you often see something that you know will make a great painting without understanding precisely why. As the picture progresses you become so involved in the actual business of putting on the paint that the original half-understood message from eye to brain becomes lost. The student has chosen quite a complex subject but has been unable to decide what the picture is "about," and consequently has failed to arrange the parts into a convincing whole.

- THE SOLUTION -

Look at Geoff Humphreys's painting opposite and you'll see what I mean. The same subject has been approached from a different angle, and in consequence has gained in stature. We do not see everything from the same viewpoint: life would be a dull business if our perceptions were restricted to those objects which coincided with our own eye level. But although we frequently look up or down as we go about our daily lives, noticing the patterns made by paving stones or the shape of roofs against the sky, it never seems to occur to beginners that a painting might be done from above or below a subject. It's amazing, though, how different and how much more

exciting an ordinary subject can look when seen from an unusual angle. Try this out for yourself by arranging a still life on the floor or on a low table. You'll find that the shapes and angles change completely, and the objects arrange themselves into fascinating semi-abstract patterns. If you are painting a figure, don't commit yourself until you have explored all the possibilities: walk around the figure, and then stand on a chair or sit on the floor to see if a ■ Pattern in painting Geoff Humphreys has recognized that the starting point of his painting opposite was the round table. An eye-level perspective would have turned it into a less dramatic shape, but viewing it from above has allowed him to make the most of the circle and the way it is intersected by the various smaller shapes. This painting is about shapes and the pattern they make: the figure may look realistic - and may even be a good likeness - but she is just one piece in the jigsaw, no more nor less important than the others. A good painting always has an element of pattern, sometimes strong, as here, and sometimes barely noticeable, but sufficient to give rhythm and unity to the picture. Always try to plan the shapes in your work, balancing large and small ones to give variety. Notice how Geoff Humphreys has used rectangles to set off the circles, and has emphasized the roundness of the table by echoing the curve on the wall to the right.

Reading by Lamplight by Geoff Humphreys. 22 in/55.9cm square

A smaller, mid-toned rectangular shape is used to offset the large central circle.

The bright shape made by the reflected light takes the eye into the center, and the curve echoes the edge of the table.

The circular motif is emphasized by the smaller, overlapping circles.

The pale area of table makes an interesting shape and balances the lamplit wall.

This subject really excited me, but the painting doesn't express my feelings at all.

THE PROBLEM

When you decide what clothes to buy or work out a color combination to furnish a room, you are expressing your own personality, interests, and preferences. This is exactly what you should be doing in painting, although you may have to think about it in a more analytical way. The first step in learning to express yourself through painting is to ask yourself why you have chosen a particular subject and what it is that you like about it. Is it color, pattern, shapes, and structure or the quality of the light that inspires you? Boats in a harbor are an "okay" subject, and the student has understandably responded to it. But although the painting is good in places, with a well-planned composition, she can see in retrospect that it fails to express her personality or feelings. This is probably because she has become too involved with the technical difficulties of painting boats and water, causing her to lose sight of the original idea.

- THE SOLUTION -

Chian Fishing Boats, Greece (opposite) is a highly individual painting. Colin Hayes is an artist who loves bright color, and here the pattern element is very strong because it plays a vital supporting role in orchestrating the colors. Unlike the student's picture, this one is essentially two-dimensional. Instead of trying to represent form and structure in a realistic way,

the artist has deliberately stylized them, treating all the details of the boats as semi-abstract colored shapes. While the student has attempted to indicate reflections and ripples on the water, Hayes has left it almost flat, suggesting reflections by nothing more than a slightly darker blue below the boats. The strong, simple shapes and bright, warm colors convey a strong sense of atmosphere – we can almost feel the heat of the Mediterranean sun.

■ Choosing your subject Beginners often believe that if only they could afford to travel they would find really inspiring subjects and become fine painters overnight, but some of the greatest artists are those who paint their own "backyard," that is, the things they know most about. If you choose a subject that has been painted over and over again by others, it's difficult to take a personal approach: you begin to feel an earlier artist breathing down your neck. Don't allow familiarity to breed contempt, but try to look at your own surroundings with an artist's eye. If you love your yard or a nearby park, then don't be afraid to paint it because no one else has. If you think a pile of books, the corner of a room, or a pet cat curled in a fireside chair would make a good painting, the chances are it will, because it is your own choice. Artists today are fortunate: they can paint anything they want, whereas in the past they were often severely constrained by the dictates of patrons.

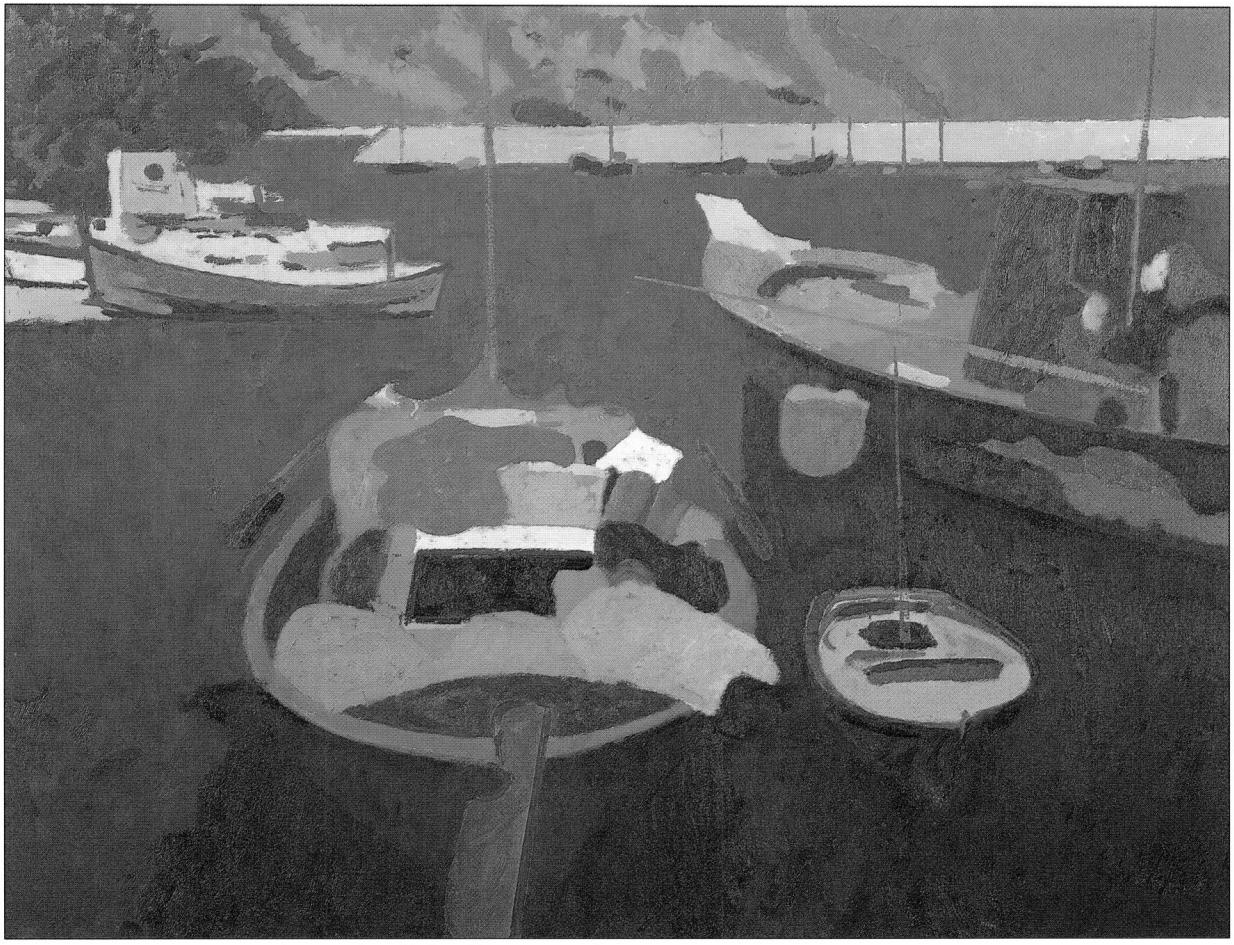

Chian Fishing Boats, Greece by Colin Hayes R.A. 28×36 in/71.1 \times 91.5cm

◀This detail looks almost like an abstract painting. The artist has deliberately avoided a strictly realistic representation, choosing colors and shapes that make an exciting pattern.

- ▶ You can often make a stronger statement by cropping in on your subject to make it fill the whole picture. Here the artist lets the mast and the right bow of one boat go out of the frame, thus tightening the composition and making the most of the lovely curving shapes and the patterns made by the the black, blue, and white paintwork.
- ▼Although the deep, rich, glowing colors are not strictly true to nature, they are both powerful and evocative. Color is a personal matter, and the artist has imbued the painting with his own deeply felt emotional responses to the atmosphere of this late-afternoon winter scene.

Low Tide by Roy Herrick

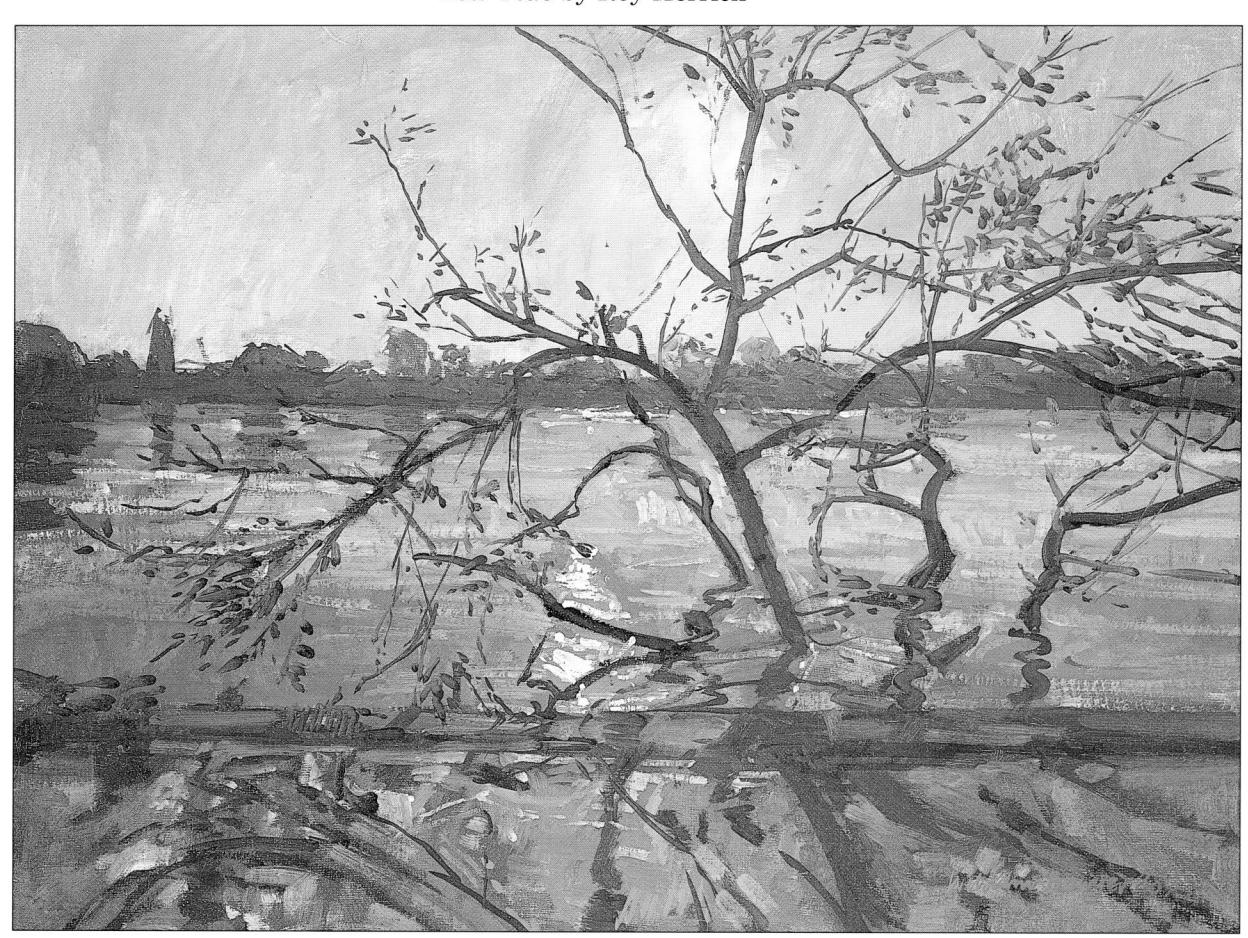

Sunken Tree by William Bowyer R.A. 15×18 in/ 38.1×45.7 cm

► Here the artist gives impact to her beach scene by using just one area of bright color and two small, dark shapes, all set against the horizontal bands of beach, sea, and sky. These point up the emptiness of the scene, giving a strong sense of atmosphere as well as providing the essential visual interest.

▼The charm of this delightful painting lies in its naive, almost childlike quality. The artist has made no attempt to achieve textbook correctness of perspective or proportion – her preoccupations are with color and pattern, not the realistic portrayal of three-dimensional space.

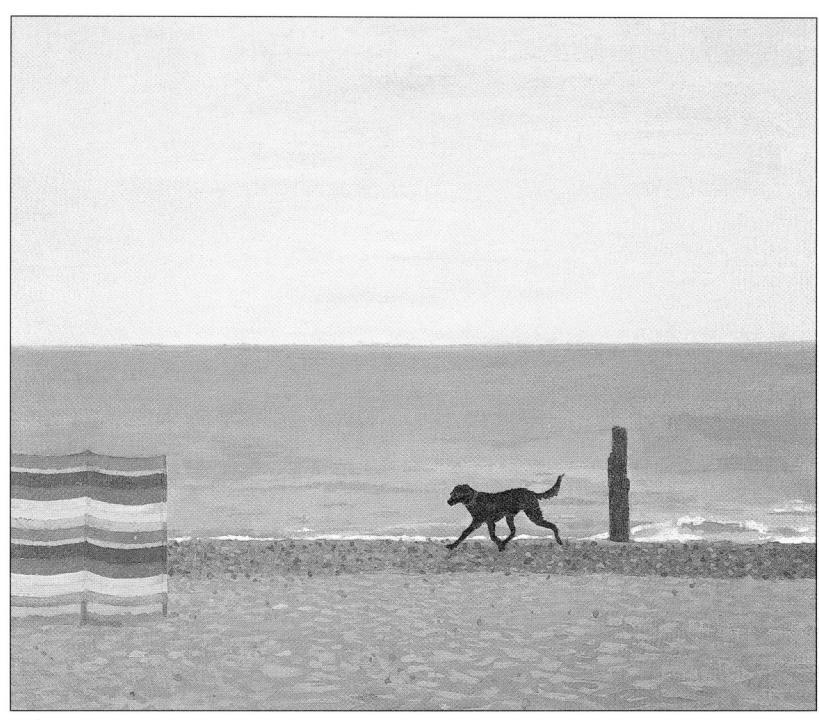

The Black Dog by Margaret Green. 24 in/61cm square

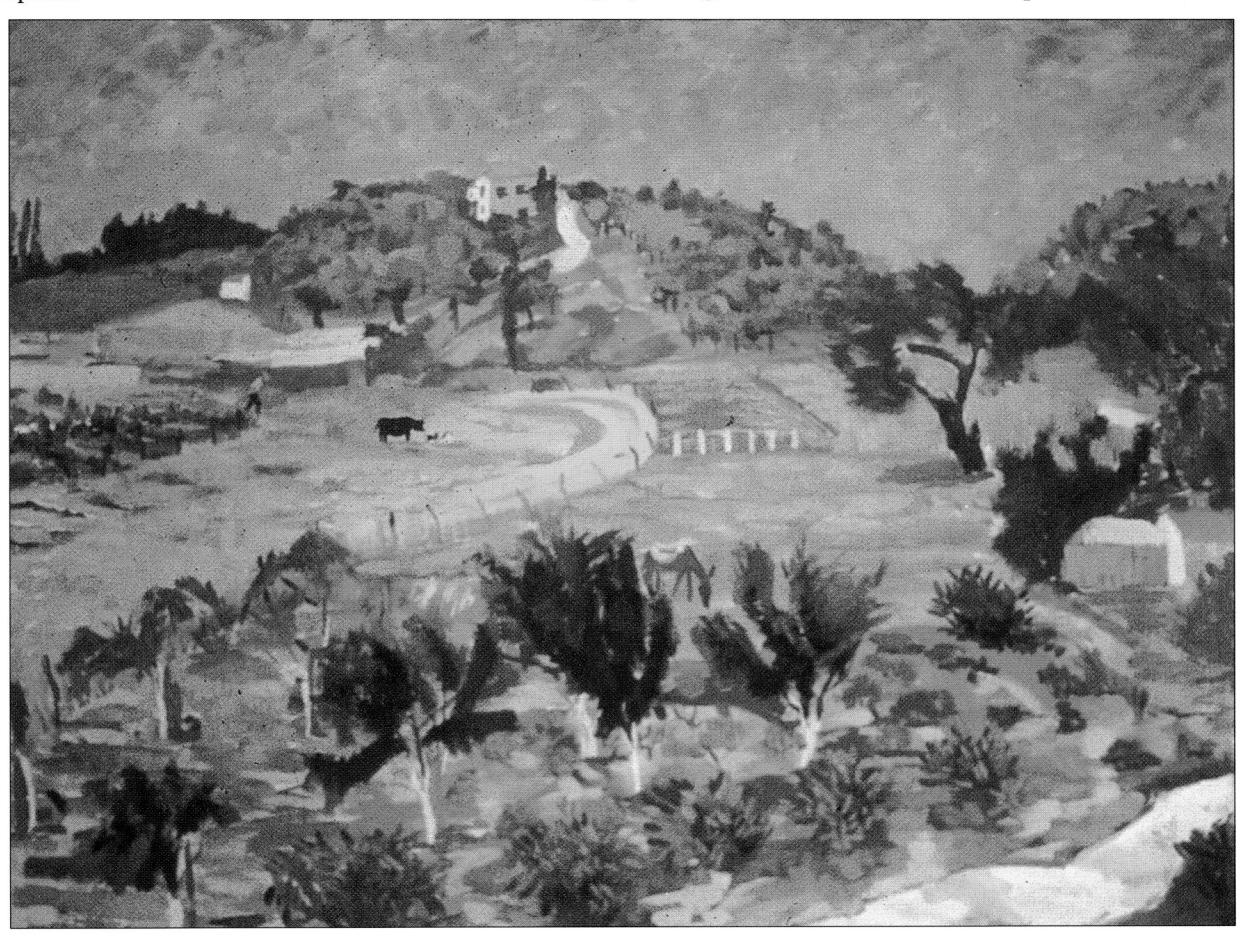

Skiathos by Olwen Tarrant. $30 \times 36 \text{ in}/76.2 \times 91.5 \text{cm}$

PROBLEM SUBJECTS

Special Techniques and Tricks of the Trade

Some subjects may seem hard to paint really well in oil only because they appear to be irreconcilable with the nature of the paint itself. Flowers, water, and clear blue skies are all examples of this kind of difficulty. The colors of flowers are so much more brilliant than even the most expensive tubes of paint that it requires some ingenuity to to match them successfully, and we may wonder too how we can imitate their fragile delicacy with opaque pigment and bristle brushes. Yet it can be done, as this chapter demonstrates. Skies are perhaps even more of a problem, because they are not really "there" in the way that a solid object is - we are trying to paint an illusion, and however bright the blue used, the paint has a unfortunate tendency to look more like a wall than an expanse of

luminous space. But don't despair; there are techniques that will guarantee you a more successful result. Water is a three- or sometimes fourfold problem: it is transparent; it is reflective and it has ripples or waves on the surface. This is just for starters, but sometimes it's even more complicated, because it's in movement in some places and still in others. And all we have at our disposal for this lovely but elusive element are what may seem to us clumsy, prosaic paints and brushes! But really these paints and brushes can do almost anything — it's just a question of knowing how to manipulate them to the best advantage.

■ Tricks of the trade Oil painters have been producing convincing representations of flowers, skies, and water for centuries, so we know it's

Welsh Cockle Gatherers by Trevor Chamberlain. 10×14 in/25.4 \times 35.6cm

possible. Painting, after all, is a giant deception – a two-dimensional surface on which the artist arranges his or her colors, values, shapes, and lines in such a way that our eyes are tricked into believing that we see three dimensions. In the case of our "problem subjects," we are persuaded that we are seeing sky or water even when we know it is only paint. Perspective, which creates the illusion of space, is only one "trick of the trade." Artists have many more up their sleeves for coping with difficult subjects, so turn the pages to see how to make oil paint look like air or water.

■ I can't draw well enough This is often given as the reason for failure at portraiture or architectural subjects, the most notorious "problems". It is true that drawing is hard for many people, but even some professionals have to work at it, and there are some useful hints here on how to improve your standard sufficiently to enjoy your painting.

■ Observe and simplify Some subjects, such as snow, sunlight, and misty scenes, are difficult to paint well, partly because they call for close observation and on-the-spot "notetaking," and partly because they require very careful control of values and colors. Others, like summer foliage and reflections in metal and glass, give trouble because it is so tempting to try to paint every minute detail, seldom a recipe for success, as it tends to result in dull, fussy pictures. This chapter suggests ways of simplifying your subjects so that you exploit the full potential of oil paint to convey broad impressions, and there are many lovely paintings to inspire you to continue with the struggle.

≪Cloudy skies are one of the
most exciting of all landcape
subjects, but it's easy to make
them look heavy and wooden.
Later in the chapter we look at
some ways of avoiding this,
but one of the best is to work
wet in wet, as the artist has
done here, so that the colors
blend softly together.

▶ Painting snow on a gray, misty day can be a problem. Too little color and the painting looks drab; too much and the effect is ruined. This one is just right — cold and gray but full of atmosphere.

Sunflower Corner by Norma Jameson. $31 \times 48 \text{ in}/78.7 \times 121.9 \text{cm}$

▲ This artist uses a precise and careful technique to create her lovely, delicate effects.

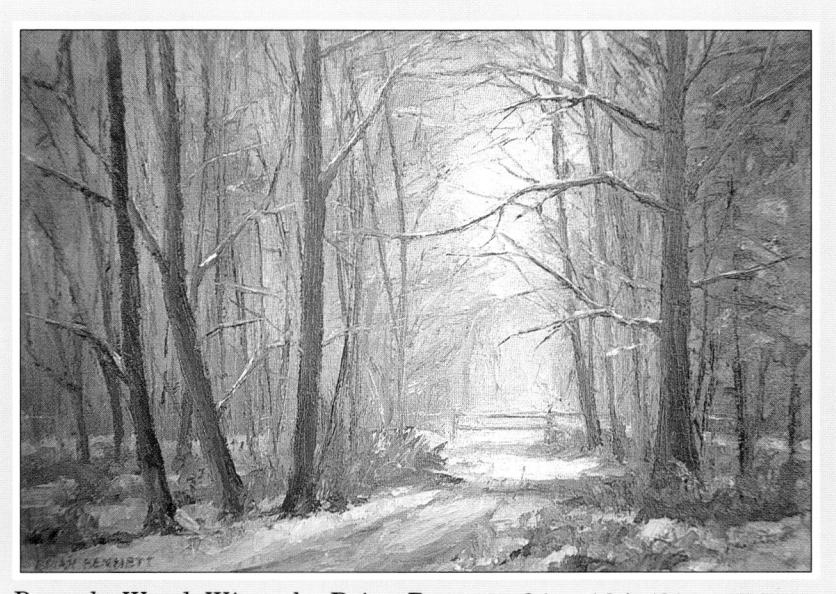

Pancake Wood, Winter by Brian Bennett. $24 \times 18 \text{ in}/61 \times 45.7 \text{cm}$

This picture looks fussy – I couldn't figure out the best way of painting the trees.

THE PROBLEM

The student's concern is shared by many, and it's perfectly understandable. The trouble is that you can see too much for your own good – every leaf and twig seems to claim equal right to inclusion in the painting, so how can you decide which ones to discriminate against and which to single out for special attention? And how are you to put the paint on – in small dabs that look like leaves or in broad sweeps to suggest the shapes? The student has no reason for despair; she has observed the shapes well, and varied the color, but has treated all the trees in the same way.

THE SOLUTION

The first thing to do is to stop looking at the details and concentrate on the broad masses. Try the old trick of half-closing your eyes before you begin to paint, as this will help you to see the shape of each tree and its overall color and tone. Try starting with a large brush, blocking in the shapes and colors, and then you'll be able to see whether some areas need to be given more detailed treatment.

- Characteristics A tree has a "skeleton," which gives it its shape, even when clothed in leaves, and no two species of tree have the same skeleton. Nor are they the same color, so get into the habit of noticing which ones are light yellow-green and which are a cooler, bluer green.
- Form Try to avoid the common error of

painting flat cardboard cutouts. Trees are made up of separate clumps of foliage, thicker toward the ends of branches where the leaves are supported by a multitude of tiny twigs, and each clump is given form and solidity by the way the light falls on it.

- **Outlines** Don't make the outlines too regular as there are always little gaps between leaves where the sky shows through, both at the ends of branches and near the trunk.
- Wet-into-wet Because the light shines through strongly at the tops of trees, the colors appear very pale, blending into the sky with little contrast of value. Notice how William Garfit has achieved these subtle gradations in his painting (opposite) by applying his greens over a still-wet layer of paint below. Wet-into-wet is a marvelous method for foliage, so try it for yourself.
- Brushwork The stippling technique the student used is very descriptive for some types of trees, but is tedious if used throughout, as it gives no feeling of the different textures of the trees. Try using your brushstrokes in a directional way, letting them suggest form and movement, as William Garfit has done. Notice how broadly he has treated the dark trees on the right, in contrast with the small strokes used for the lighter-colored ones at left and center.

For further ideas turn the page to see how other artists deal with this tricky subject.
USEFUL TIP

Looking at botanical or horticultural books on trees is an excellent way of getting to know and understand the individual shape, texture and color of each species, and the more you know about a subject, the better you can paint it. Never try to copy directly from a nature book, because the drawings in them are only "prototypes," but if you get stuck on a painting because you can't recall the way the branches grew, or the width of the trunk in relation to the height and spread of the tree, a reference book will help you make a convincing try.

Trees by the River Test by William Garfit R.B.A. 20×24 in/50.8 \times 61cm

◀ To create the appearance of the treetops blending softly into the sky, the artist works wet-in-wet. Try this method for yourself – you will find it gives a more realistic effect than painting over a dry layer of pigment.

► The amount of detail you put into foliage or flowers is to some extent dictated by your viewpoint and the importance of the tree or shrub in the general scheme of your picture. Here the colorful pink blossom is the central theme of the picture, and the artist is painting it from close to, so he describes it in some detail, using a separate short dab of paint for each flower head. Notice how he echoes the colors of the sky and water in the fallen blossoms in the foreground.

▼When willows are blown in the wind, they show the lovely silvery undersides of their leaves – a marvelous painting subject. The artist creates a strong impression of movement by using broad, directional strokes of a painting knife.

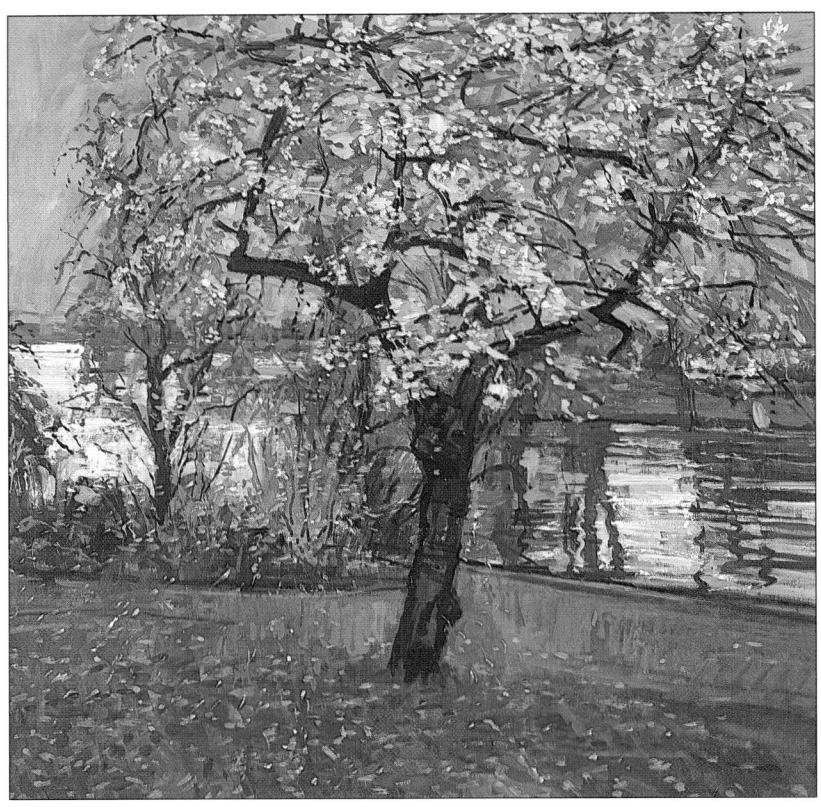

Falling Blossom by William Bowyer R.A. 26 in/66cm square

Willow Trees by Brian Bennett. $24 \times 18 \text{ in}/61 \times 45.7 \text{cm}$

A similar subject to William Bowyer's painting opposite, but a very different treatment. This artist has chosen to simplify, conveying an overall impression of the delicate colors of spring trees and flowers by using broad brushstrokes and thin paint. The clumps of bluebells under the trees are little more than whispers, but we have no difficulty in identifying them.

A Corner of Sandbeck by David Curtis. $16 \times 20 \text{ in}/40.6 \times 50.8 \text{cm}$

Trees over a Stream by Sir Lawrence Gowing A.R.A. 16×20 in/ 40.6×50.8 cm

Trees in leaf don't have to look like a botanical illustration; they can be both convincing and exciting with no detail at all. In this lovely bold, free painting, the artist is concerned with the overall effect, and the colors and the shapes made by the clumps of foliage are all-important.

My flower paintings look so unlifelike. How can I achieve a more natural effect?

THE PROBLEM

It's a familiar story: you start full of enthusiasm and confidence, so enraptured by the subject that vou know vou can produce a masterpiece. But then things begin to go awry. You notice that you've got the shape of a petal wrong, so you rework it, and then a bud suddenly begins to unfurl and you feel you must get that in too. And so it goes on. Then you take a break, come back and look at the painting again, and realize you have lost the very qualities that attracted you in the first place; the flowers don't look like delicate, ephemeral living organisms; they look heavy, overworked and wooden. This is exactly what has happened here; the student has worked very hard indeed, but in trying to say everything she has ended up saying nothing.

- THE SOLUTION -

In the painting opposite the artist has carefully observed each flower in relation to those near it in the arrangement. You will notice how the student has painted most of the flowers facing us, which gives an artificial flatness to the group. In Pamela Kay's painting we see flowers from the back and side as well as from the front, which adds interest as well as looking more natural.

■ **Drawing flowers** Don't despair – you can improve your standard, but it involves being a little tough with yourself. Close observation is

the first prerequisite: look at each flower carefully and try to understand how it is formed. Has it a small or a large head in relation to the stem? Are the petals long and spiky or short and rounded, and how do they grow from the center? Practice drawing flowers whenever you can. It doesn't matter if the results are not brilliant: drawing is like taking notes — it commits a thing to memory more effectively than just looking.

■ Flower shapes Almost every flower can be simplified into one or more basic shapes. Some are bell-shaped or tubular, and some, such as daffodils, are a bell inside a circle. In Pamela Kay's painting, they are mainly rounded or flat circles, which become ellipses (squashed circles) where the flower head is turned away from you. Don't start drawing petals until you're sure you have these shapes right, and don't start painting until you really understand the forms. The other thing to watch out for is the way the flowers "sit" in the vase. Stems will often be hidden from view behind other flowers, but you must still give the impression that each bloom grows from its own stem. If you paint a flower head disproportionately large, or too high up, it will look as though it's floating in midair, instead of being "rooted" in the vase.

■ **Keep it simple** The student has given herself a difficult task by choosing such a varied arrangement. We can see why, as the different shapes and colors are very enticing, but until

Summer Flowers in a Blue and White Jug by Pamela Kay. $12\frac{1}{2} \times 13\frac{1}{2}$ in/31.7 \times 34.3cm

Flowers look so complex that it's often hard to decide where to start, but most of them can be simplified into basic circles or cup shapes. Sketches like these are not difficult to do, and they make a better foundation for a painting than over-elaborate drawings with every petal included. They are also a good discipline, as they help you to assess both the flowers' structures and their proportions, such as the width of the stem in relation to the center.

you gain confidence and expertise it's wiser to start with a simple bunch of just one kind of flower. One of the many problems with painting flowers is that you're always conscious of their limited lifespan, and you don't want to be forced to work faster than your normal pace. It can take a long time to draw and paint each flower when you are not very experienced, so five or six could be enough. Even when you are experienced, it can take a long time – the 17th-century Dutch flower painters charged by the bloom!

■ The arrangement Whatever arrrangement you've decided on — a mixed assortment or a few daisies or daffodils — don't just dump them in any old vase and hope for the best; take some trouble over arranging them, since this is nearly as important as painting them. If you're committed to a mixture, avoid having too many different colors, because they will compete with each other and look garish and unpleasant. Decide which color you want to be the dominant one and orchestrate the others accordingly: Pamela Kay's

flower piece on the previous page is a "symphony" in blue and white, with just one orange flower providing the contrast. Remember that flowers are living organisms and should look natural and "relaxed," so don't arrange them too stiffly; let them overlap each other here and there, and don't try to make them all "face front."

■ Brushwork It's always a temptation to paint every single detail of a flower, because they are all so lovely, but this is where you really do have to take yourself in hand. There is nothing tight or fussy about the picture on these pages or that on page 111. In all of them the brushwork is loose and impressionistic and the details are suggested in the broadest possible way, yet we have no difficulty in recognizing each flower as a particular species with its own shape and character. So don't reach for that nice little sable brush and try to outline each petal; try instead to use bold brushstrokes, and make each one as descriptive as you can.

Hellebores in a Vase by Pamela Kay. $10 \times 9 \text{ in}/25.4 \times 22.9 \text{cm}$

- ■A simple group can be just as effective as a complex one, but the placing of the flowers is possibly even more important. Pamela Kay gives movement and dynamism to the composition by positioning the glass off-center and using the diagonal line in the foreground to lead the eye in to the white flowers on the left. Imagine how dull this group might have looked if placed squarely in the middle of a table.
- ▶ Flowers in a tall vase look lovely, but it can be difficult to make a satisfactory composition out of them what are you going to put in the *rest* of the picture? Here the artist solves the problem by treating the whole painting as a series of verticals, anchored by the triangles made at the bottom of the picture by the corner of the table.

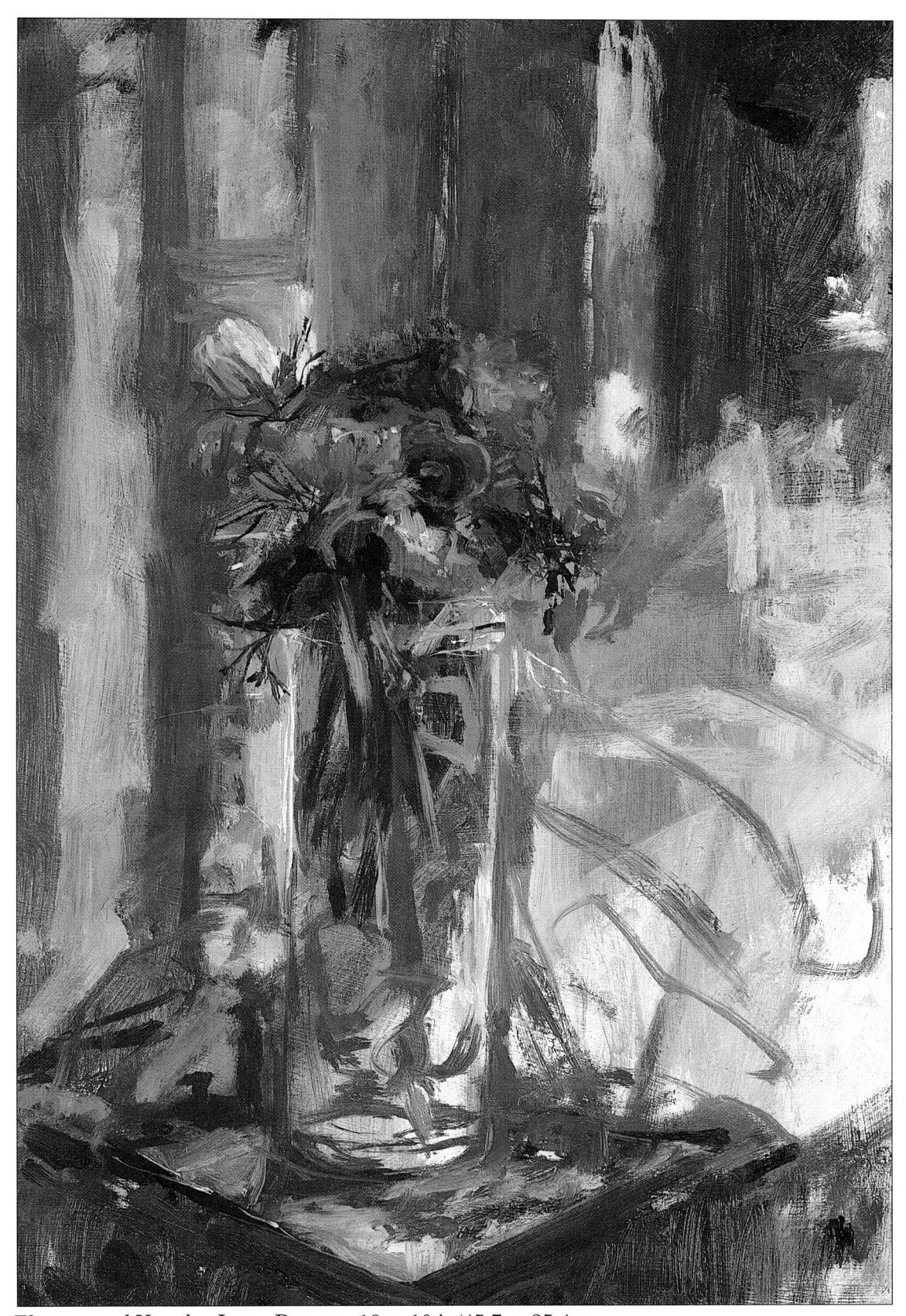

 $\overline{Flowers}~and~Vase$ by Jason Bowyer. 18 \times 10 in/45.7 \times 25.4cm

I wanted to catch the impression of winter sunlight, but it looks more like summer.

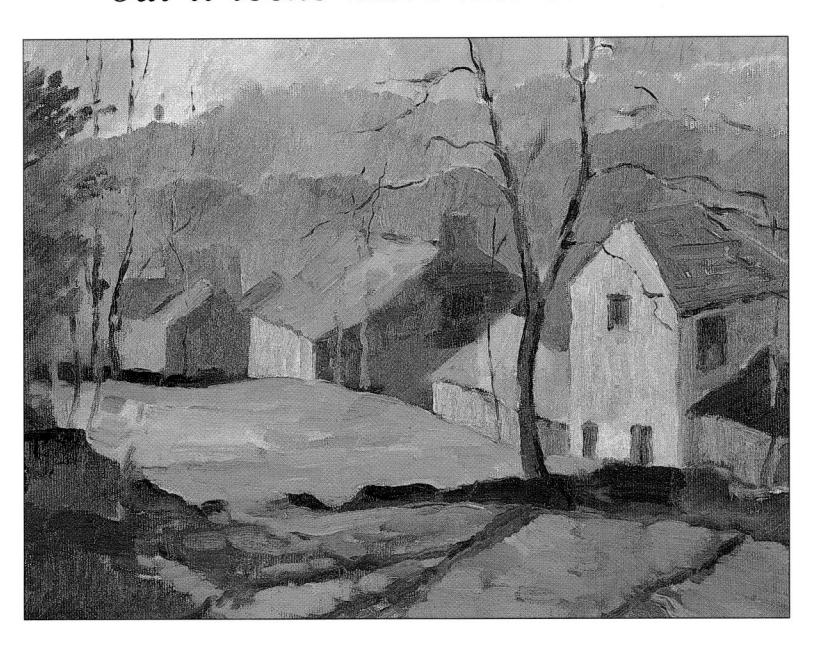

THE PROBLEM

Making a sunlit scene look really convincing is more than just a matter of putting in some dark shadows and bright highlights, as the student has done. There are as many different kinds of sunlight as there are of artificial light, and each one affects the colors and tones of the landscape in its own way. If you see strong value contrasts and hard, blue-violet shadows in a painting you'll know, even if no sky is visible, that the sun was hot and bright; if the values are lighter and the shadows less pronounced the sun is obviously weaker or more diffused. The direction of the light is an equally important element -alow sun will throw long shadows and an overhead sun short ones, or none at all. The student's painting doesn't hang together because no consistent light source has been established: the sun appears to shine on the front of the houses and at the same times casts shadows forwards from the tree. The colors are crude because the subtle gradations we see under a weak winter sun have been reduced to harsh, flat areas. Perhaps the painting has been done from memory, or from a poor photograph which failed to catch the quality of the light and shade.

- THE SOLUTION -

For a subject like this, where the quality of the light is all-important, there is no substitute for firsthand observation. Try to work outdoors

whenever you can, making small, rapid color sketches to record the way the shadows fall, the precise shade of the grass where the sun strikes it, and the way the colors and values interact with one another. Although most people can recall the overall impression of a scene, few successful paintings are the result of visual memory alone, and most artists make use of such on-the-spot sketches even if they do most of their painting in the studio. The painting opposite has a freshness and immediacy that comes from careful observation as much as from deft handling of paint, so it's no excuse to say you "just can't paint as well as that." It is not just a sunlit scene; it is a scene lit by a particular kind of sunlight - a low, winter sun that gives all the colors a pale, delicate sparkle. Notice how restricted the tonal range is, with even the darkest areas nowhere near the black end of the scale and the yellowish side of the main house much lighter than someone relying on memory might have painted it. The top of the mauvishblue background is only just darker than the sky, while at the bottom it merges into the similar color of the slate roof, picked out by just a touch of darker paint along the ridge. The direction of the light is unequivocal, coming from behind the viewing position and falling on the roof of the foreground house. The intricate tracery of branches and twigs, picked out with near-white, complete the sunlit impression.

USEFUL TIPS -

It isn't too easy to paint tiny, thin lines with oil paint, but a subject like this does sometimes need that touch of delicacy. A normal bristle brush won't give a really fine line, so either buy a special pointed sable brush and keep it only for this purpose (soft brushes are quickly spoiled) or use the sgraffito technique illustrated on page 33. The point of an excise knife will give the finest line you can imagine – ideal for the smallest twigs. But don't go crazy and overdo it or your painting will look like a spider's web.

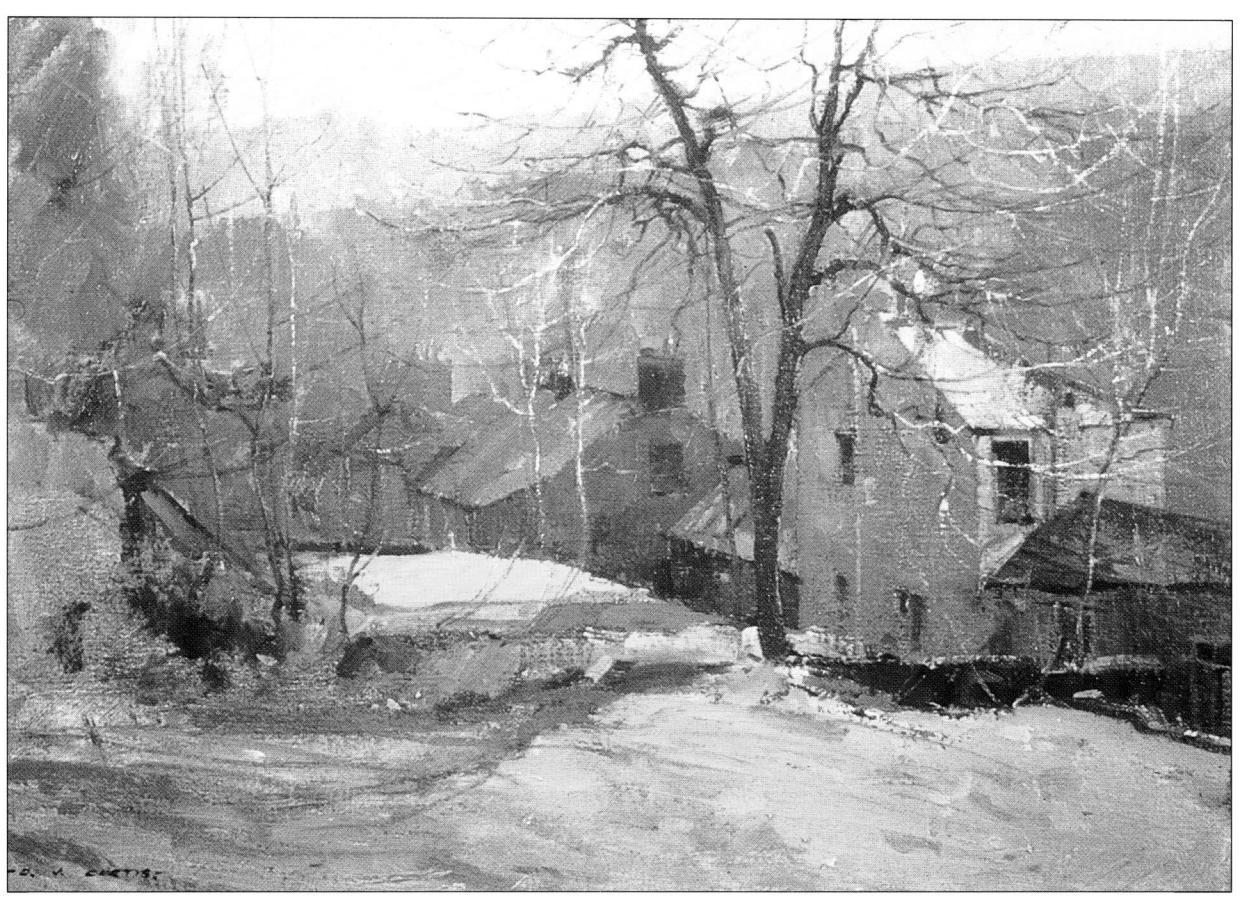

The Old Village, Dronfield, Derbyshire by David Curtis. 18×14 in/ 45.7×35.6 cm

The intricate pattern made by the small branches catching the light in places adds the finishing touch to the picture, breaking up the more solidly painted areas of gray-mauve and yellow ocher.

I had trouble with the paint, and the boats look awkward and badly defined.

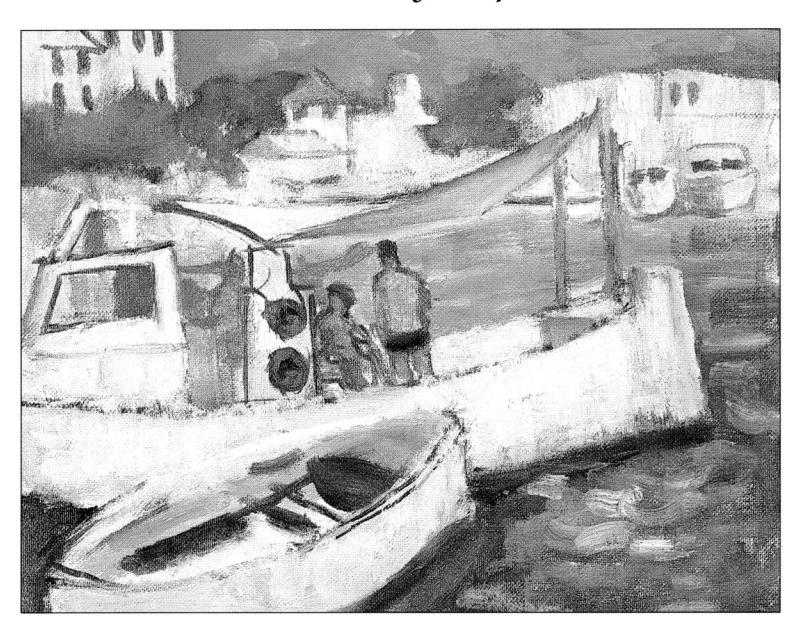

THE PROBLEM

There is nothing much wrong with the color or the composition in this picture, but because the foreground boats are poorly defined, with soft, fuzzy outlines, they look unconvincing in terms of structure. They also fail to stand out as nearby objects, merging into the background and destroying the illusion of space. The student has encountered one of the technical difficulties in oil painting: how do you put on thick paint with clumsy bristle brushes without losing the sharp, clear edges that describe the boats and give them their special character?

- THE SOLUTION -

The answer is that there are several ways of working, and the ones you choose will depend on your individual style and approach. Artists often begin a painting by applying the paint broadly with large brushes and then complete it with smaller ones, adding details and tidying up the outlines. In the painting opposite the artist uses the paint fairly thinly, filling in the white areas of the boats with a medium-sized flat brush and allowing his brushstrokes to follow the lines of the curved edges. The detailing of the boats is then added with a small pointed brush, bringing them into focus. This is done with swift assurance - nothing blurs an edge more surely than too much overpainting. If you look closely you'll see that the edges are not so very sharp, but they

are made to seem crisper by the contrast with the softer background boats and the blurred reflections in the water below.

- Avoiding build-up If too much paint is allowed to build up around your outlines they will quickly become fuzzy and unclear. To stop this happening, keep the paint thin in the early stages, using more turpentine than oil. As the painting progresses, reduce the proportion of turpentine until you are using really juicy paint (straight or thinned with just a soupçon of oil. You will find it easier to control if you let the early layer(s) dry before applying more paint. This sounds laborious, but paint diluted with turpentine alone dries very quickly. Try to keep overpainting to a minimum. If you need to alter or redefine a line or curve, the best method is to scrape of the paint, wipe the area down with a rag and try again.
- Surfaces If you want a clean, crisp outline, avoid very heavily textured surfaces which break up the painted stroke. The paint adheres to the "peaks" but won't fill the "troughs," giving a blurred, uneven line.
- Start with the dark values Work light over dark whenever possible. It is very difficult to make a clean, dark line over light paint, particularly when it's still wet. The darker colors are less opaque than those mixed with white and will pick up the layer below without covering it fully.

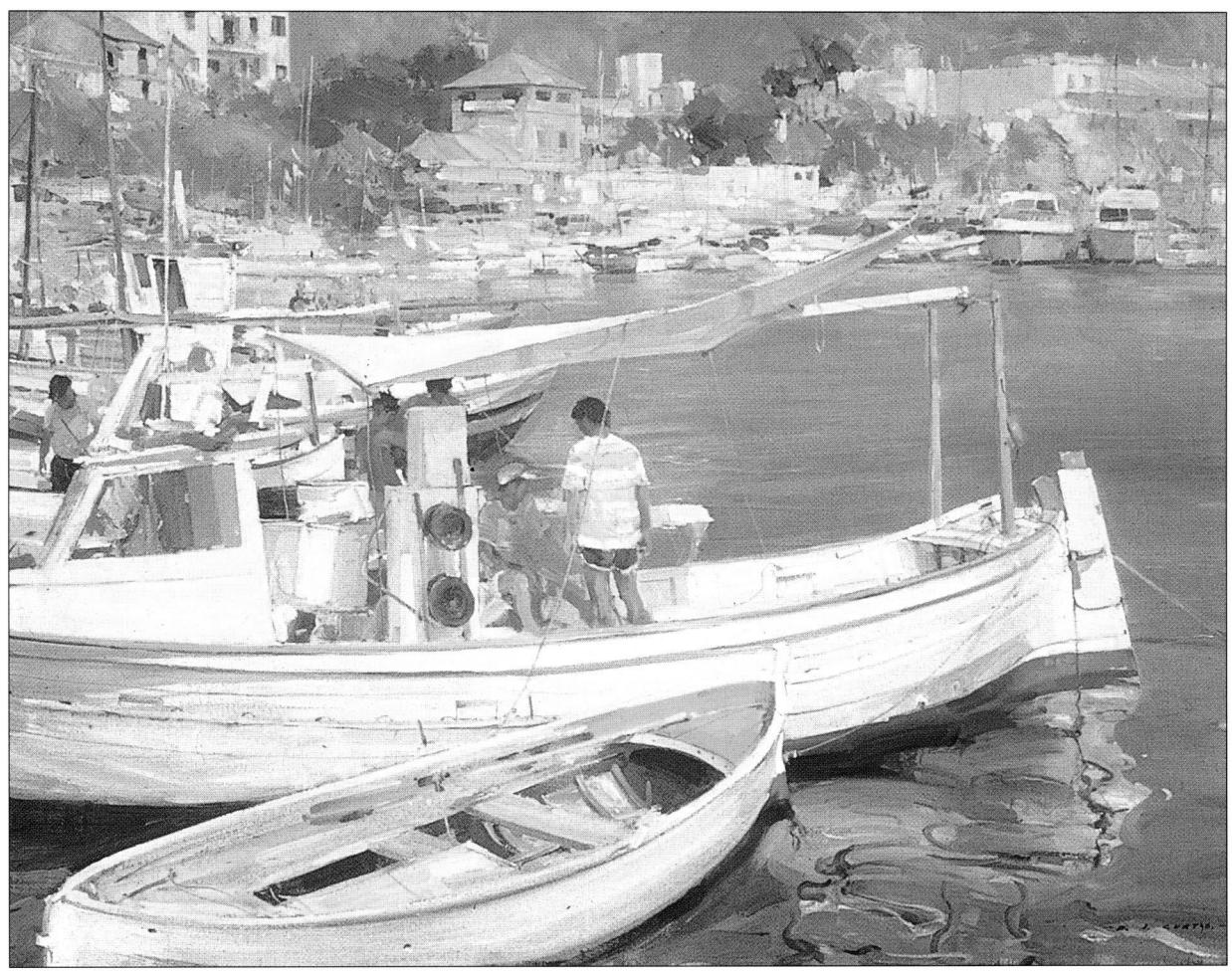

 $Puerto\ de\ Soller, Majorca\ {
m by\ David\ Curtis.}\ 30 imes24\ {
m in}/76.2 imes61{
m cm}$

- USEFUL TIP -

Painting clear lines and small details is much easier if you can support your painting hand so that it doesn't shake or slip while you're in mid-brushstroke. Even professional artists have this problem, and many use a simple gadget called a mahlstick. The traditional mahlstick is made of bamboo and has a soft leather pad at one end which can be rested on the canvas while the stick supports your hand. You can make your own from a piece of rigid cane with a bundle of rags tied at one end, or you can dispense with the pad and simply rest the stick on the side of your canvas or board.

The figure doesn't look at all convincing; how can I learn to draw better?

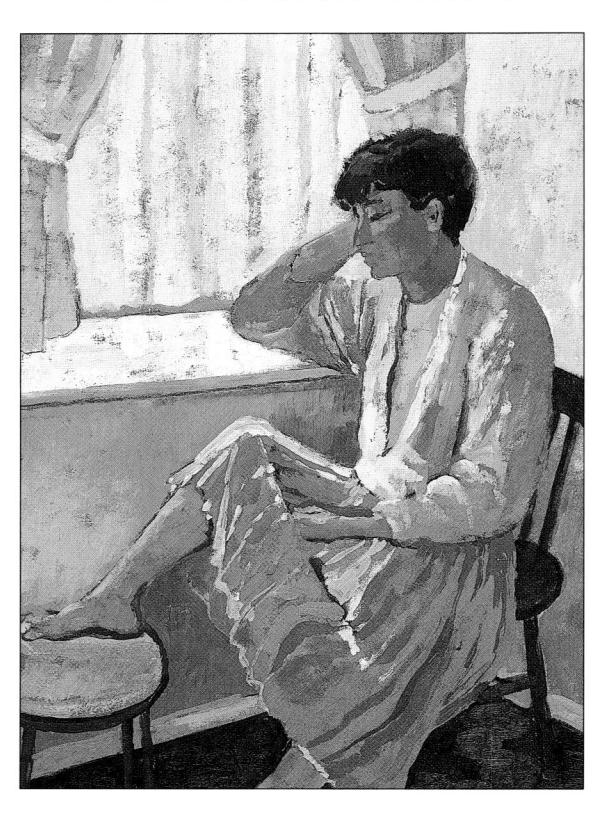

THE PROBLEM

The student has correctly identified what is wrong with this otherwise promising picture: the sitter looks uneasy and uncomfortable, as though she is not so much sitting on the chair as hovering above it, and the proportions are not right. But he or she could obviously improve the situation; although poor drawing and preparation have lost the elegance of the figure and the relaxation of the pose, parts of the picture are well painted, with a nice quality of light.

THE SOLUTION –

Amateurs all too often abandon figure and portrait work because they believe they can never learn to draw well enough. But drawing is not so very dissimilar from other learned manual skills, such as typing, sewing or carpentry. It is true that great draftsmen are born, not made, and you may never be a Rembrandt, but you can certainly improve your drawing so that it doesn't let down your painting. In Geoff Humphreys's painting opposite, the same subject appears in a relaxed pose, realistic and convincing because it has has been built on the solid foundations of a

careful underdrawing. When you are painting the figure, you must learn to do the same thing. It's mainly a question of self-discipline (sorry, but it must be said), of really forcing yourself to see what you are drawing and keeping on the lookout for visual "clues." My own erratic drawing improved vastly when I learned the following smart method.

■ Negative shapes The idea is to draw the spaces between objects, not the objects themselves, and if you look at the opposite page you will see how it works. Instead of drawing the right leg, draw the two shapes of the wall above and below the leg, then the other wall behind the head and shoulder, and the little triangle formed by the right arm and the face. And so on. You may find it hard at first, because you'll keep wanting to niggle away at features or the folds in the garments, but keep at it and you will be surprised at the improved accuracy of your drawing. Incidentally, negative shapes form an important element in composition too, so when you are planning a portrait or a still life, try to look at the spaces between objects and think about them as shapes in their own right.

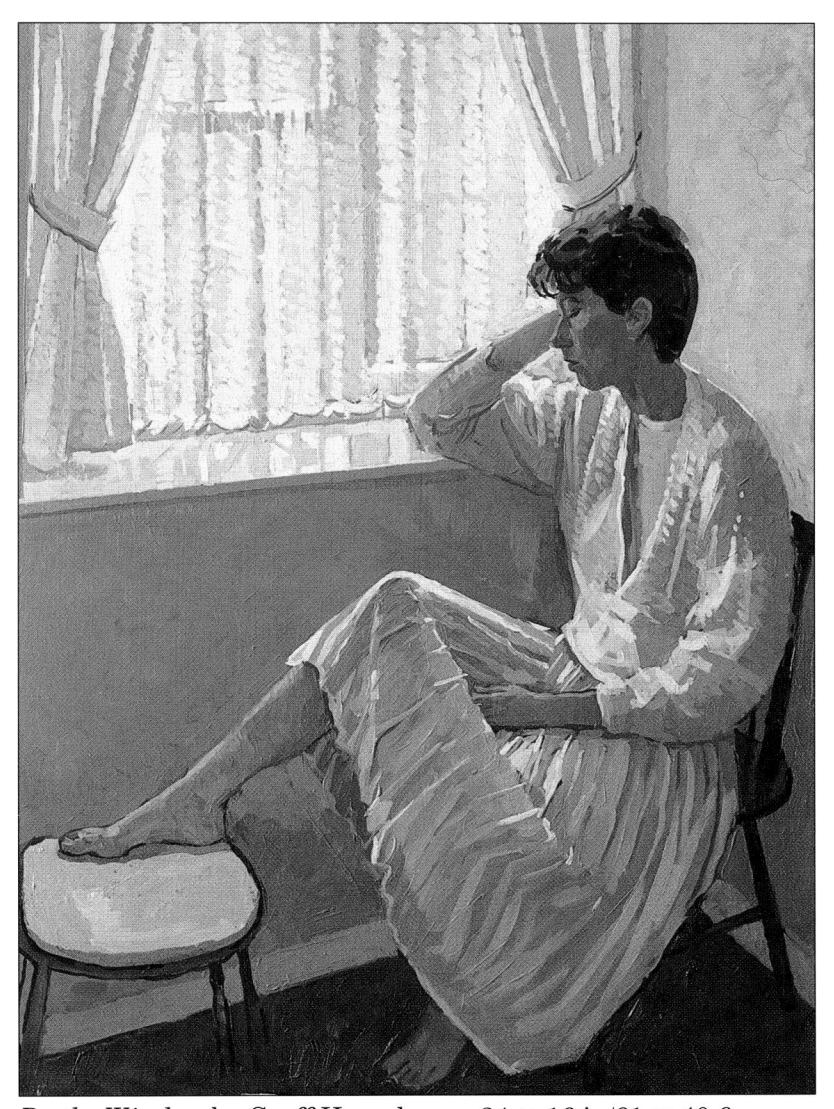

By the Window by Geoff Humphreys. $24 \times 16 \text{ in}/61 \times 40.6 \text{cm}$

The drawing shows you how to look for the spaces between objects, a method which prevents you from getting bogged down in small details. In addition, a system used by most artists is that of checking angles and proportions by measuring them. Hold up a pencil and slide your thumb up and down it to check the size of a hand or foot in relation to

the body, then angle it to follow the slant of shoulders and arms. Use any vertical or horizontal lines behind the figure to double-check: for example, in this picture, the sitter's ear is directly below the line where the curtain meets the window frame, and another vertical just meets the right elbow.

How can I get the effect of mist without losing all the color? My painting just looks dull.

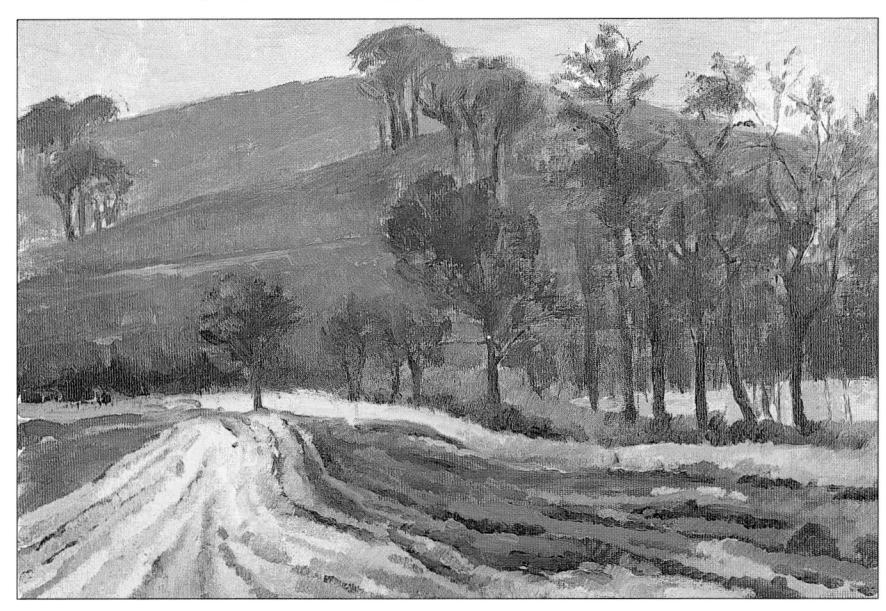

THE PROBLEM

There are few more beautiful sights than that of an early morning mist rising to reveal the delicate, pearly colors of land or water. Even fog has its attractions, creating soft outlines, muted colors and strange, suggestive shapes. But subjects like these are among the trickiest of all to paint, simply because the colors are so different in quality to those seen on a clear day. The student has observed that mist makes everything paler, and has managed the tones of the hill in the background well by making them lighter and bluer as they recede. But there is still too much contrast, both of value and of color, in the foreground, and the colors in general are all somewhat lacking in subtlety.

THE SOLUTION

All good painting starts with observation, but beginners don't always trust what their eyes tell them. The student has not quite believed that the mist could have changed things so radically – after all, tree trunks are always fairly dark, aren't they? But look at David Curtis's landscape opposite and you will see that this is far from being the case. Here the colors are pale but well-observed and varied and the range of values is very small indeed; even the darkest notes, those

provided by the trees, are the equivalent of a very pale gray. Test this out for yourself by putting a black object against the reproduction in this book – you could be in for a surprise.

■ Techniques Light colors are more opaque than dark ones, so in most oil paintings, it is best to start with dark colors and build up to the highlights. But try reversing the procedure this time: if you start with the lightest areas, such as the sky and the background hill, you will give yourself a "key" so that you can see immediately if the next colors you put on are too dark or too bright. Manipulating values and colors in such a limited range needs iron control and infinitely careful color mixing - one wrong note and the effect is ruined, so don't put down a color on canvas until you are sure it is right, and if you make a mistake, scrape it off immediately. Always start with a good dollop of white for pale color mixtures, keeping your brushes superclean, and adding the pure colors carefully in tiny amounts - it's amazing how little vellow or red you need to make even quite a bright color. Once you have a satisfactory mixture for one part of the painting, mix the next one close to it so that you can assess their relationship before committing yourself.

A Derbyshire Landscape by David Curtis. 20 \times 24 in/50.8 \times 61cm

- USEFUL TIP -

James McNeill Whistler often scraped down his portraits at the end of a sitting, preferring to start again rather than overworking. On one occasion he scraped down a portrait of a girl in a white dress, intending to repaint it—and suddenly he had just the effect he was after, a lovely transparent gauzy look. This could be the ideal technique for mist, so if your painting is not going well try the Whistler method.

I used ultramarine with white for the sky, but it looks wrong. Would another blue have been better?

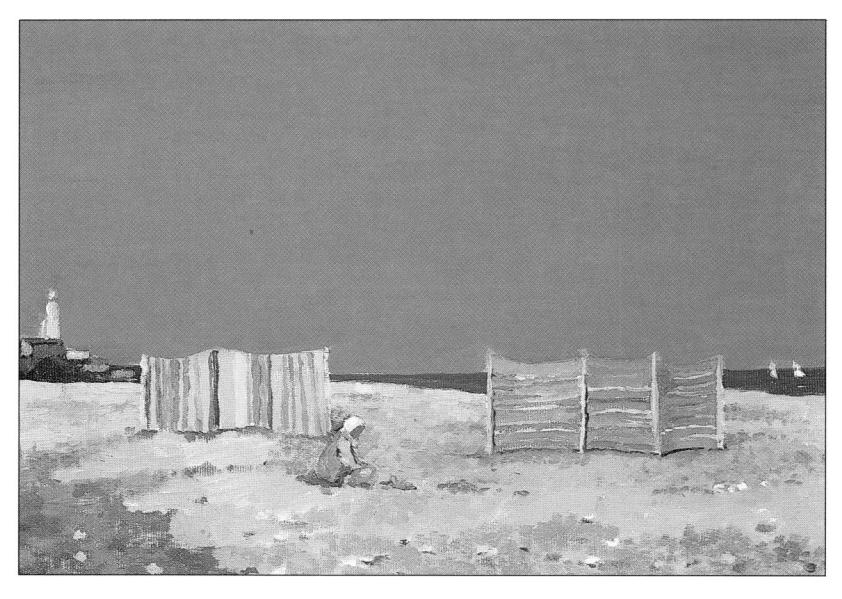

THE PROBLEM

You might think that painting a clear blue sky is the easiest thing in the world, but in fact it can present quite a few pitfalls for the unwary. The student has fallen straight into two of them: first by painting the sky virtually the same color all over, and second by treating it in a different way from the foreground. The wide blue expanse was obviously what struck the painter most about the scene, and it was a bold move to devote so much of the painting to it, but because of the flat, dense brushwork it looks more like a wall than an insubstantial element. Just as important is the failure to relate sky and land. A painting derives much of its unity from consistency of brushwork, and here the pleasant, broken paint surface of the foreground finds no echo in the flat treatment of the sky.

- THE SOLUTION -

If you look closely at the sky you will notice that what at first sight appears as a uniform blue actually has considerable variations in color and value, becoming paler and greener as it recedes toward the horizon. Therefore using just one blue, even if it is lightened with white, is seldom sufficient. For a really deep blue, try starting with pure ultramarine, or even ultramarine darkened with violet, and gradually lighten it with cobalt blue and then cerulean – the sky near the horizon is sometimes almost pure cerulean. But do avoid putting colors on in

bands, as this will create entirely the wrong effect. Start by mixing up three or four shades of blue on your palette and then blend them together on the canvas so that they merge gently into one another.

- **Doptical illusions** The main difficulty with painting blue skies arises from the nature of oil paint. It is opaque, but the sky is transparent, so how can one be made to resemble the other? This is the time *not* to paint exactly what you see, but to cheat a little. In *The Beach with Sunbreaks* (opposite), the artist has used patches of pink and mauve among the brushstrokes of blue, which gives an impression of shimmering, vibrating light. This is a well-known "trick of the trade," based on the fact that our eyes are unable to focus properly on small areas of color provided they are of the same value, so we are in effect "dazzled," just as we are by a bright sky.
- Unity and echoes Always try to plan your work as a unit and think about how you can relate colors to one another. In Margaret Green's painting, the sky is a warm, summer blue a winter sky usually has a greener hue and the other colors match its warmth. Notice how she "ties" the sky to the foreground in two ways: by using the same kind of brushstrokes for both and by repeating the blues of the sky in varying amounts all over the painting. The largest foreground patch is the child's dress, but there are also tiny echoes in pebbles, shadows, and even the stripes of the windbreaks.

The student has painted the sky fairly flat, but here a variety of colors is used. Pinks, mauves, and even a greeny beige can be seen among the blues, but they are all close in value so that the sky reads as a unified area.

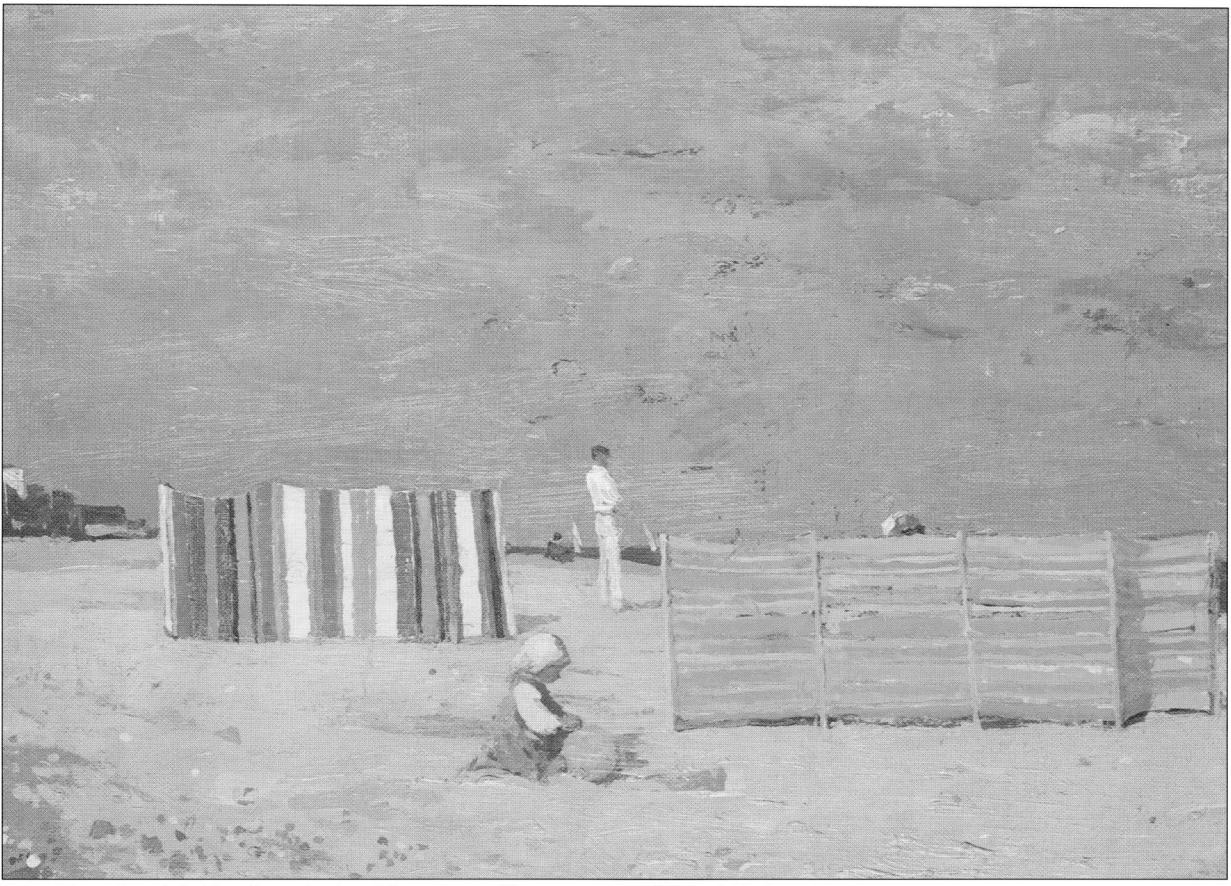

The Beach with Sunbreaks by Margaret Green. $16 \times 20 \text{ in}/40.6 \times 50.8 \text{cm}$

▼The foreground is related to the blue sky by repeated colors, such as these small, bright pebbles in the immediate foreground.

My clouds look very heavy and solid. Have I used too much dark gray?

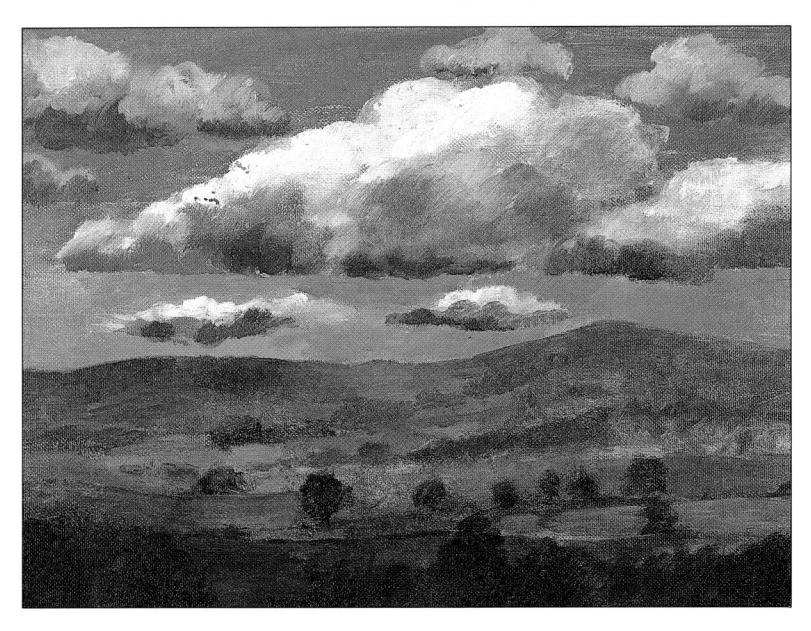

THE PROBLEM

Unsuccessful skies are sometimes simply the result of poor observation, but it can't be denied that clouds do present difficulties. However careful you are to observe their shapes and structures, you still have the technical problem of painting strong value contrasts without sacrificing the luminosity of the sky and the soft, vaporous quality of the clouds. The student actually has little reason for dissatisfaction; this is an excellent attempt. But the clouds do look rather weighty, particularly in relation to the hills and foreground. Because the value contrasts are so strong, the sky dominates the scene, and the more sketchily treated landscape trails apologetically out of the picture.

THE SOLUTION -

At the outset, you will need to decide whether the sky is to be the main focus of your painting. But even if it is, don't forget that it is the source from which the land receives its light, so there must obviously be an interaction between the two. In the painting opposite, the artist has skillfully woven sky and landscape together by repeating similar colors throughout and by using the same kind of brushwork. The student has introduced some blues into the hills, but notice how Arthur Maderson has repeated the wonderful violet-blue in the foreground as well. These blues

in the landscape are only a slight exaggeration of reality, as shadows always reflect the colors of the object that casts the shadow.

■ Cloud types Clouds, like trees, have individual characteristics within certain types. They also form on a particular level, and sometimes you will find two or three different types of cloud, each on its own level. When you are planning your painting you will need to recognize which type they are — cumulus or cirrus — and how high or low they are in the sky. Once you have established this, and understand the general principles, you can work on the actual forms you see before you. The student has not really looked at a particular cloud, but has produced a "cotton-ball" type, presumably from memory.

■ Value control As a general rule, the sky is lighter than the land because it is the source of illumination. There are, of course, dark grays, blues, and browns in clouds, but they need careful handling, so if you want to stress the value contrasts, try to avoid harsh gradations, since this will make them look heavy and rocklike. In the student's painting, the line where the bright cloud top joins the sky is too hard, giving a two-dimensional cutout effect. Try stippling the paint at this point so that it takes on some of the blue, making the gradation more gradual. Another alternative is to work wet into wet, which also gives a soft and subtle effect because

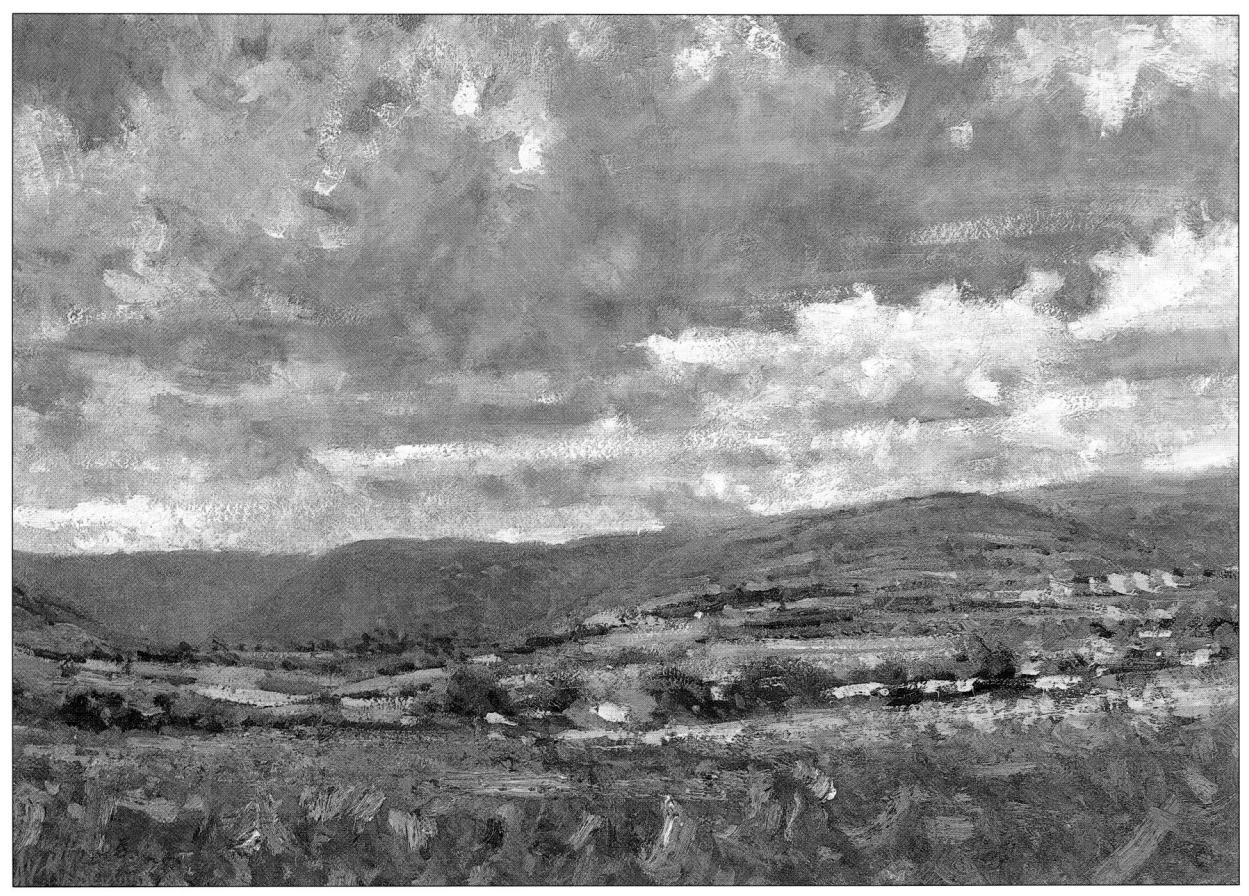

Welsh Valley, September Evening by Arthur Maderson. 36×3 -0 in/91.5 \times 76.2cm

The sky is a kaleidoscope of marvelous, pure colors, but it looks perfectly convincing because the artist has kept the same color key throughout the picture, repeating the cloud colors in the foreground and middle distance.

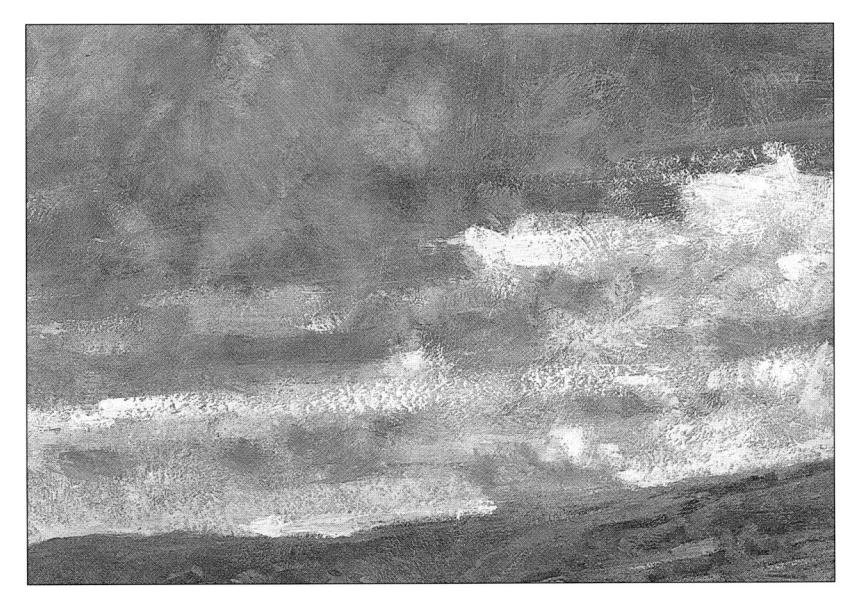

each new brushstroke mixes slightly into the paint below. You can even blend the paint with your fingers if you don't mind the mess – many artists do this.

- Color The colors of clouds depend on the position of the sun and on the other colors they reflect. At midday, when the sun is high, the tops of clouds are pure white, and there is less variation in the colors than at any other time of day. But the golden light of an evening sun creates a panorama of lovely hues yellows, warm pinks, violets, and red-browns. The sunlit edges of a cloud high in a blue evening sky are often quite a bright yellow, while the undersides reflect the blue and take on a blue-gray or violet tinge. In an overcast sky with no blue showing, the darkest areas are distinctly brown.
- **Perspective** We tend to think of the sky as a flat backdrop, but in fact it is subject to the laws

of perspective, just as the land is. It may be quite dark at the top, but as it recedes toward the horizon the colors become paler, and clouds bunch together into small, indistinct shapes. If you think of the sky as an upturned soup bowl overhead you will understand how it works: the clouds directly above you, in the flat of the bowl, are closer to you than those at the horizon, or the distant rim, so the shapes are bigger, the colors brighter, and the contrasts more marked. If the clouds are scattered, the areas of blue between them will be larger overhead than near the horizon. As the sky ranges downward to the horizon, your angle of viewing prevents you from seeing so much of the clear sky between the clouds, and if there is a heavy covering of cloud you will just glimpse the undersides of those in the distance, which become less and less distinct before disappearing altogether.

Floods on the Ouse by Brian Bennett. $40 \times 30 \text{ in}/101.6 \times 76.2 \text{cm}$

Cloud formations are fascinating to look at, but it's only too easy to make them look wooden in paintings, particularly if you try too hard, piling up layers of paint in an effort to show every detail. There's a lovely feeling of airiness in this picture because the artist has taken care not to overwork, touching in the mackerel clouds with delicate little flicks of a painting knife. Notice that the sky is lighter

than the distant land except in one place, where the light catches the sides of the three trees on the right. It's this kind of well-observed detail that helps to give vivacity and authenticity to a painting. An expanse of dark, lowering sky like this one is a challenging subject. If you paint it all in one color it looks flat and dull, but if you put in too many contrasts of value and color you may lose the very feeling you are trying to capture. Notice how the artist has blended together a series of warm blues, violets and pinkish grays, reserving the strong contrasts for the top and bottom of the sky, where the sunlight breaks through.

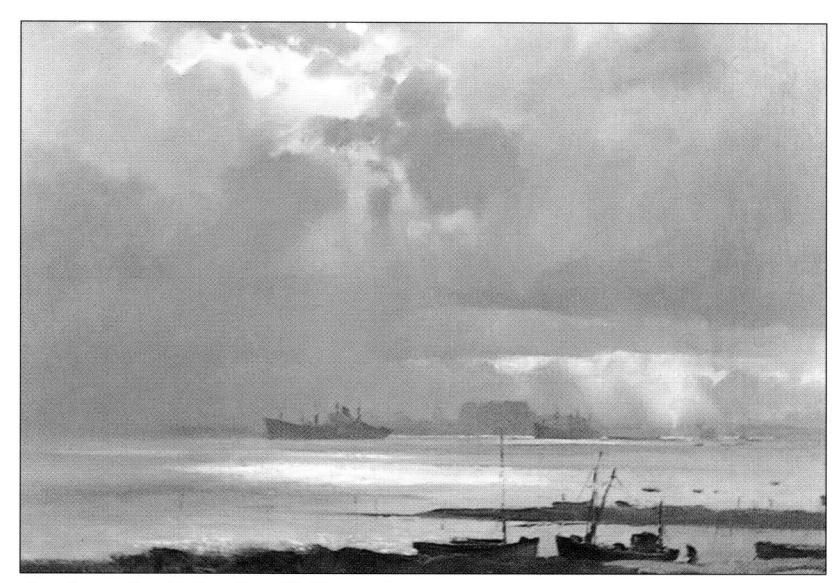

Anchored off Bradwell, Essex by Trevor Chamberlain. 14×18 in/35.6 \times 45.7cm

Summertime, Budleigh Salterton by Trevor Chamberlain. $24 \times 30 \text{ in}/61 \times 76.2 \text{cm}$

Clouds directly in front of the sun are particularly exciting to paint because the back lighting gives them marvelous golden or yellowwhite edges, depending on the time of day. They look completely different from clouds illuminated from in front or above; the colors are warmer because the sun is shining through them in places, and the tonal contrasts are usually less pronounced.

I really like the look of bare trees, but mine always come out looking flat and unreal.

THE PROBLEM -

Logically speaking, trees in winter should present fewer problems than leaf-clad summer ones. You can see their shapes and structures so well, with none of that confusing, amorphous green hiding the branches, so where is the difficulty? But they undoubtedly do give trouble, and it's mainly because it's difficult to decide how to treat them. The intricate pattern made by branches and countless tiny twigs against the sky seems to demand a very precise, detailed treatment, but even if you are brave enough to try to paint every one, how are you to make the lines thin enough? What kind of brush should you use? The student has compromised by painting some details while blurring others, and there is nothing wrong with this approach, but the painting falls short of success because the foreground tree looks like a flat cutout. Because all the boughs and twigs have been painted in exactly the same near-black, we gain no impression of some branches being nearer than others, and the branches look unrealistic because they taper too suddenly.

THE SOLUTION -

In the painting opposite, the artist has made the obvious compromise, similar to that the student has tried, of picking out the inside branches individually but treating each cluster of twigs at the outside edges as one mass. But in this case

the tree looks three-dimensional and convincing because each of these masses makes sense; we can trace each cluster back to its own branch, and we can tell that some branches are growing toward us by the way they are foreshortened as well as by small differences in value.

- **Shapes** The contortions of some of the branches have been carefully recorded in the painting, making it a portrait of a particular tree rather than an imaginary one. Trees vary enormously in shape and formation, so sketch and observe them as often as you can. When you start to draw or paint a tree, don't begin with the trunk, because unless you have the luck to get it just right you may find you have no room for the ends of the branches. If you are patient and persevering you will start again; if not, you will try to squeeze them in, and this is often the reason for the unnatural tapering we see in the student's picture. Instead, before you start on the detail, look for the main shape of the whole tree and draw an outline.
- Measuring A tree will never look real if the proportions are wrong, so once you have your outline, make some quick measurements by holding up a pencil and sliding your thumb up and down it. Measure the width of the trunk in relation to the spread of the branches; the ratio of height to width; the distance from the bottom of the trunk to the first branches and so on.

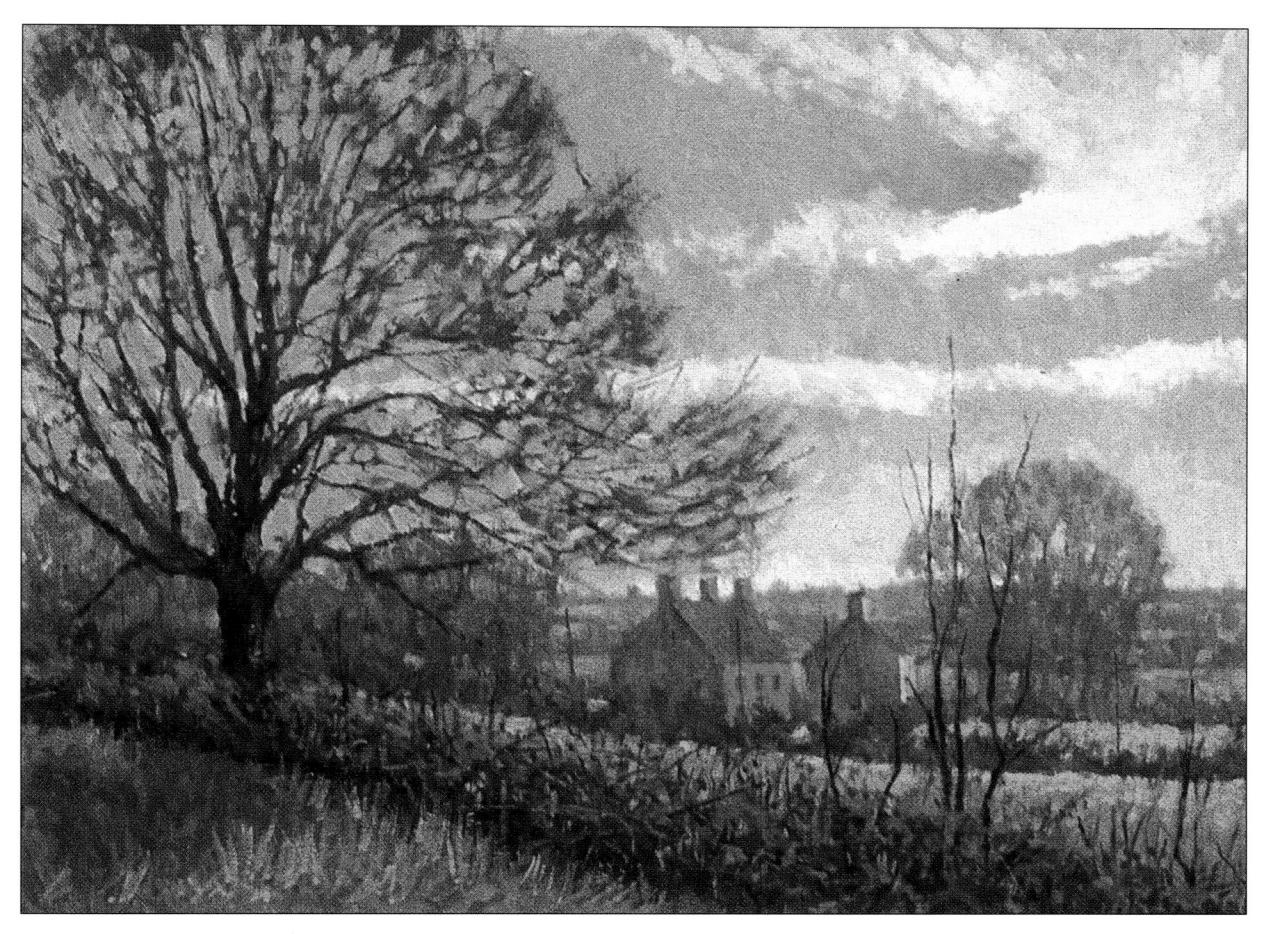

Near the Taunton Canal by Oliver Warman. $24 \times 20 \text{ in}/61 \times 50.8 \text{cm}$

The contrast between these two details is revealing. In the student's picture, the branches look wooden and two-dimensional, and the clusters of twigs are thick and clumsy. The professional has used a dry-brush technique to "stroke in" these areas lightly, picking out just one or two minute twigs against the light cloud.

I knew snow would be a problem. Should I have tried to vary the colors more?

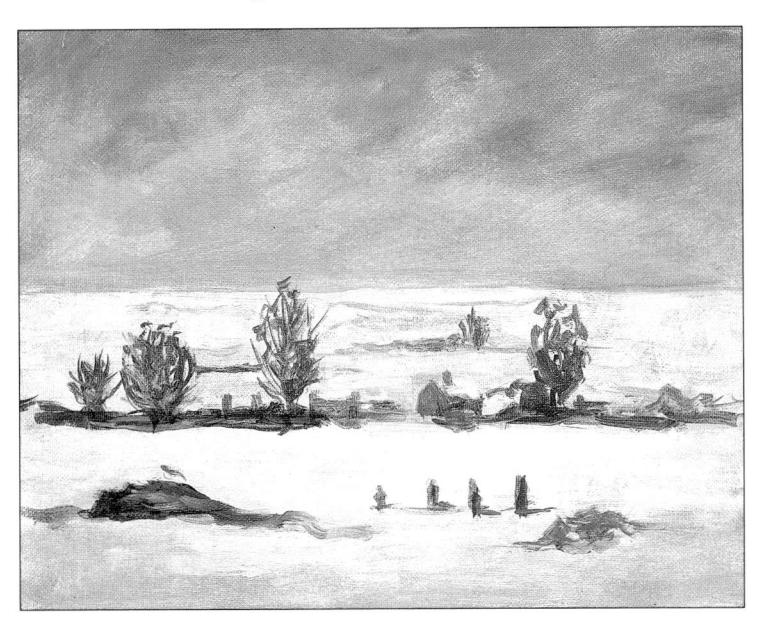

THE PROBLEM

The student was right in thinking snow is difficult to paint, although many have been deceived into believing that the blanket of white conveniently simplifies the landscape, and therefore the range of decisions. But snow paintings often go wrong for precisely this reason - you are so intent on making the snow look white that you overlook the fact that under certain conditions it is actually very colorful. You can paint an effective snow picture with very little color, making strong value contrasts "tell the story", but the student's painting has little color or value; it is an amorphous mass of gray and dirty white which fails to capture the magic of the transformed landscape. It seems unlikely that the artist painted this on the spot, and this is a pity, as snow is such a marvelous subject that it deserves to be experienced firsthand. If you feel cold, warm yourself with the knowledge that you are suffering for your art.

- THE SOLUTION -

Snow, like all white surfaces, is highly reflective, and takes on colors from the sky. Its whiteness, therefore, is dramatically modified by the prevailing light. When the sky is blue the sunstruck, areas of snow are dazzlingly white and the shadows very blue. If the sky is overcast, the overall color of the snow depends on the thickness of the cloud; sometimes a winter sun

filtering through cloud is yellowish, in which case the snow will reflect this color. Dark winter storm clouds may make the snow look very white by contrast, but if you try to paint it pure white you'll soon see your mistake; it will certainly be off-white, and possibly even a mid-gray or brown.

- Keeping it cool However many colors you can see in snow it must look cold, so use cool colors, as the artist has done in the painting opposite. There are a surprising number of really vivid blues, blue-greens, and violets in the painting, but they are predominantly cold, and because they have been juxtaposed in small dabs they merge in the eye to give an impression of shimmering whiteness much more beautiful and evocative than slabs of pure white.
- Balancing colors Arthur Maderson has emphasized the feeling of coldness in his picture by scattering little touches of warm colors reds and yellows all through the painting. Never ignore the merit of this kind of contrast; it's the easiest thing in the world to include one or two small figures in bright clothes or exaggerate the warm red-brown of a tree.
- Toning the ground An even simpler way of contrasting cool with warm is to tint the canvas ochre or red-brown. The color will show through the paint if it is applied thinly, or you can deliberately leave small areas uncovered between brushstrokes.

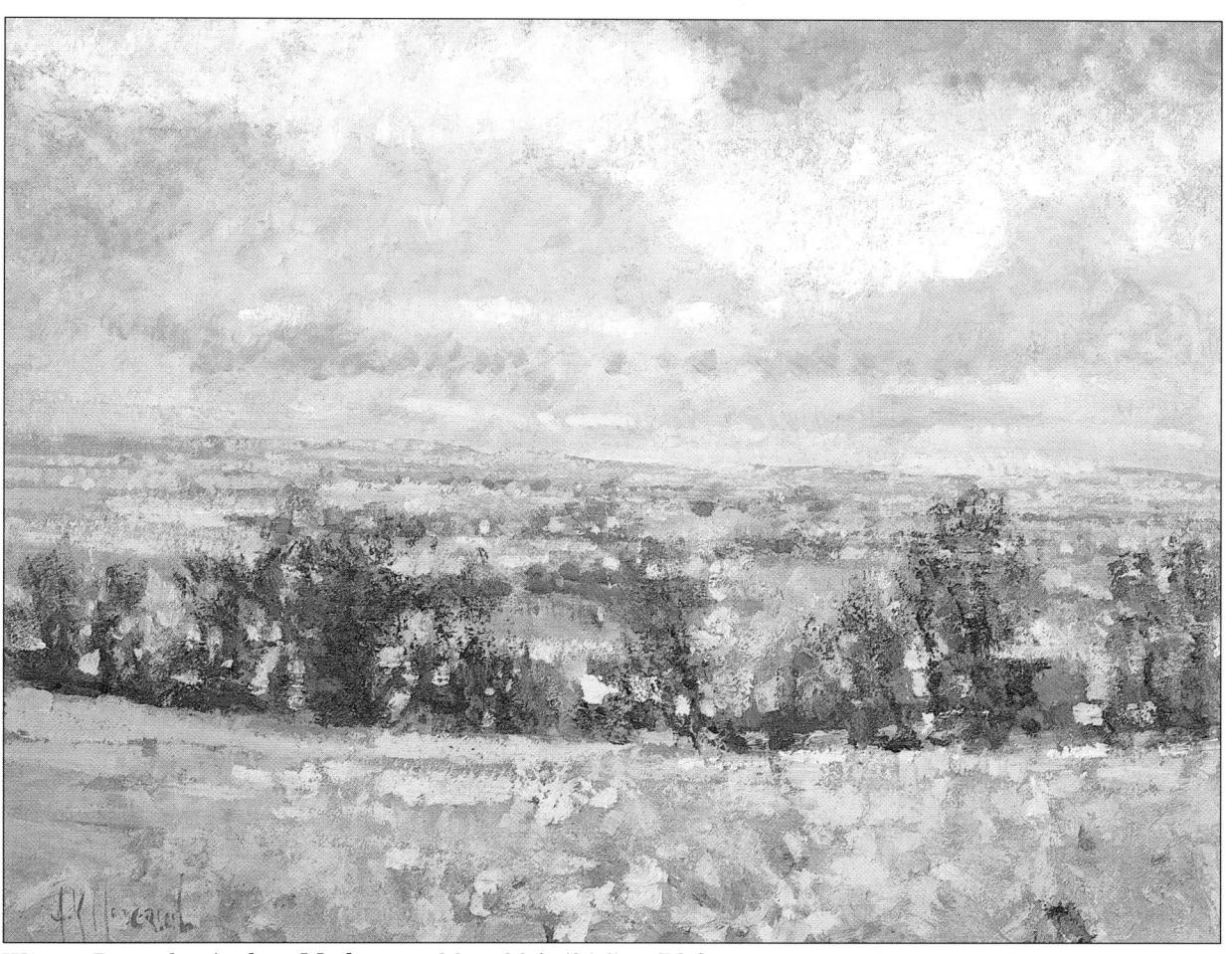

Winter Dawn by Arthur Maderson. 36×30 in/91.5 \times 76.2cm

▶ Seen as a whole, the painting looks suitably cold, with a predominance of blues and cool mauves, but you can see from this detail that some of the colors are actually very bright. The trick is to restrict any warm hues, such as reds and yellows, to small areas so that they provide a contrast to the cold colors but don't overwhelm them.

The river in my painting looks too solid. How can I give the impression of movement?

THE PROBLEM

The artist's job is not that of reproducing nature, which is both pointless and impossible, but of finding visual equivalents for things seen, logical and effective ways of making paint express the qualities of water, air, sunlight, flesh, or whatever subject is chosen. The student has made a good attempt at capturing movement, with lively, swirling brushstrokes, but has obviously lacked a clear overall plan for conveying the feeling of the subject. The brushwork is inconsistent, and the colors confused, with the result that the water, instead of flowing rhythmically and smoothly in one direction, looks choppy, unhomogeneous, and not very wet. The colors are used thickly in one layer, depriving it of depth or translucency, and there is no sense of recession because the foreground and background are both treated in the same way.

- THE SOLUTION -

Making opaque paint resemble a liquid substance may seem a daunting task, but surprisingly, water is easier to paint with oils than with watercolors because there are so many different techniques that can be brought into play. In the painting opposite, Christopher Baker has chosen to solve the problem by making the paint almost physically resemble water, using it thinly, with the brushstrokes following the direction of the flow, so that there is a contrast in texture

between the river and the tighter treatment of the countryside on the banks. The river itself has been simplified in color to an overall vivid blue, with loose brushstrokes of darker color indicating reflections and currents, and slashes of yellowwhite suggesting the fast-flowing water breaking over stones or perhaps waterweed. But this is only one way of painting water; there are as many different ones as there are artists, and several clever techniques and individual interpretations are shown on the following pages.

When painting water, whether it's a waterfall in constant agitated movement, a choppy sea, or a still lake with mirror-like reflections, always try to observe the essential features, such as the main colors and values; the patterns made by ripples and the direction in which they move; the shapes of waves and the way they curl over at the top, showing the dark underside below the white crest. Notice how reflections always fall directly below the object casting the reflection, and take on the color of the object but in a slightly paler hue. Reflections are usually - but not always - slightly uneven in outline, as any movements in the water, however slight, cause them to blur and soften. Never attempt to paint every tiny detail of a reflection, ripple or wave, as this will almost certainly result in a fussy and weak painting, but trust your own observations and feelings about the scene and try to achieve strength through simplicity.

- USEFUL TECHNIQUES -

Wet-in-wet Work a light color gently over a darker one to suggest the highlights and shadows of ripples.

Short, jabbed brushstrokes are useful for painting choppy seas. Remember that the sea is hardly ever completely without movement.

Fingers are ideal for smudging and blending paint to give a soft, wet look.

Crisscross brushstrokes used alternately vertically and horizontally are a good technique for reflections.

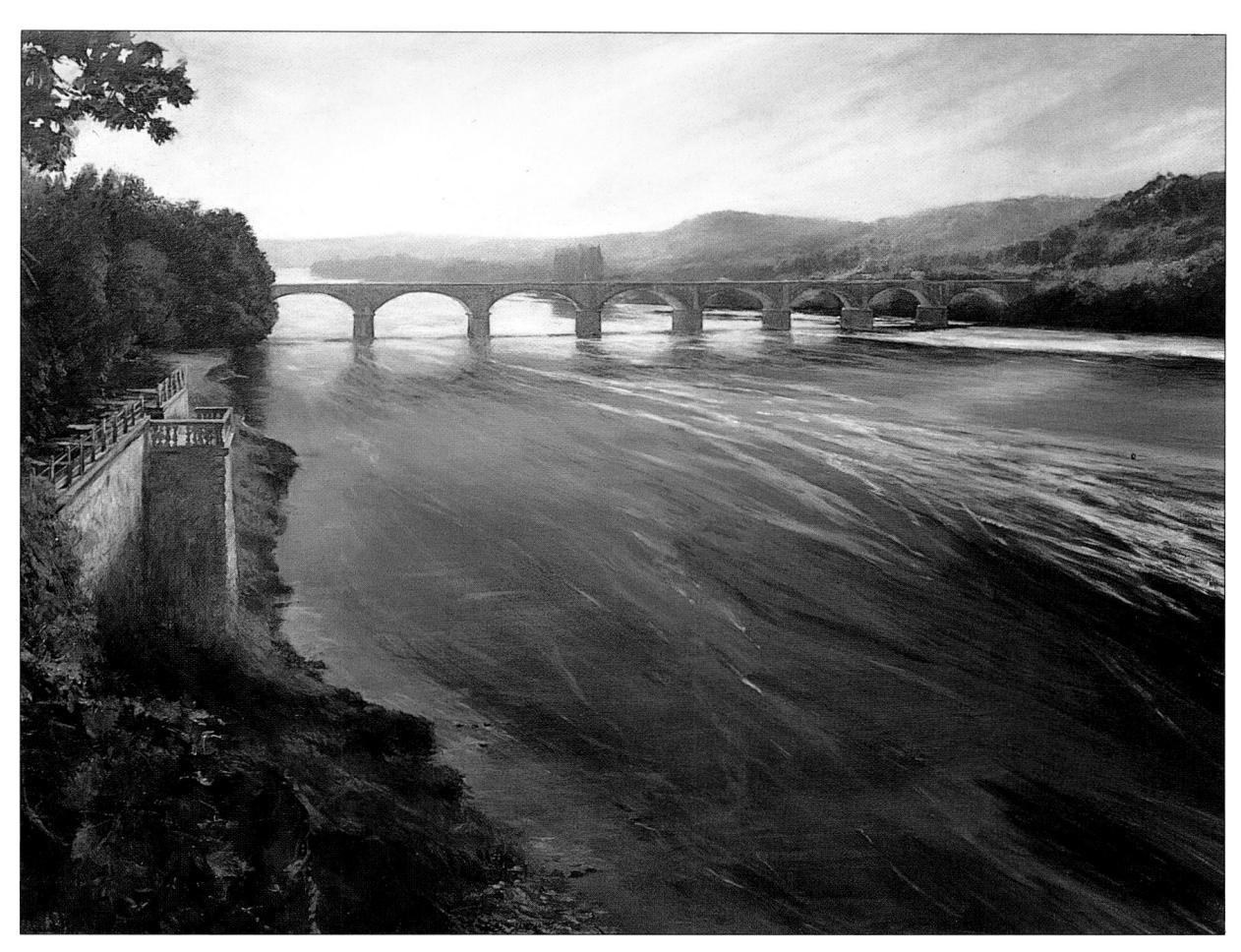

 $Bridge\ over\ the\ River\ Dordogne\ by\ Christopher\ Baker.\ 32\times58\ in/81.3\times147.3cm$

■ To achieve the translucent water effect, the artist begins by applying a layer of thinned dark colors. He allows these to dry and then scumbles drier, lighter, and richer color over the top.

▶ Reflections, like shadows, are a marvelous aid to composition because they allow you to repeat and echo shapes and colors without having to invent. But take care you don't lose the impression of wetness by making the reflections into perfect replicas of the trees or houses; there is nearly always enough movement in water to cause a little distortion and some subtle changes of color. Here the artist treats the reflections broadly but realistically, using a combination of crisscrossing vertical and horizontal brushstrokes and dark, wiggly lines.

Reflections at Kew by William Bowyer R.A. 26 in/66cm square

Black Shore near Southwold – Dusk by Raymond Leech. 12×16 in/ 30.4×440.6 cm

The Crises, River Beauly by William Garfit R.B.A. 14×18 in/35.6 \times 45.7cm

A common mistake when painting still water is to make it the same color all over. But since water reflects the sky, which is almost never a completely even color or value, there must be variations in it also, if only slight ones. These depend on both the angle of viewing and on any adjacent land that may also be reflected. Here the water is darker in the foreground because it is close by, and so reflects less light from the sky, while the darker band of color in the distant sea is reflected from the spit of land.

▲ There's no denying that fastmoving water is hard to paint. You can see so many different patterns forming and reforming, and if the weather changes all the colors alter as well, so it's almost impossible to know what to put down first. But be firm with yourself; look for the main effects and don't attempt photographic realism. Short brushstrokes are best for agitated water, and longer ones for the calmer areas, so "give your brush its head," as the artist has, letting it follow the direction of the ripples and wavelets.

My buildings are just like boxes; how can I make them look realistic?

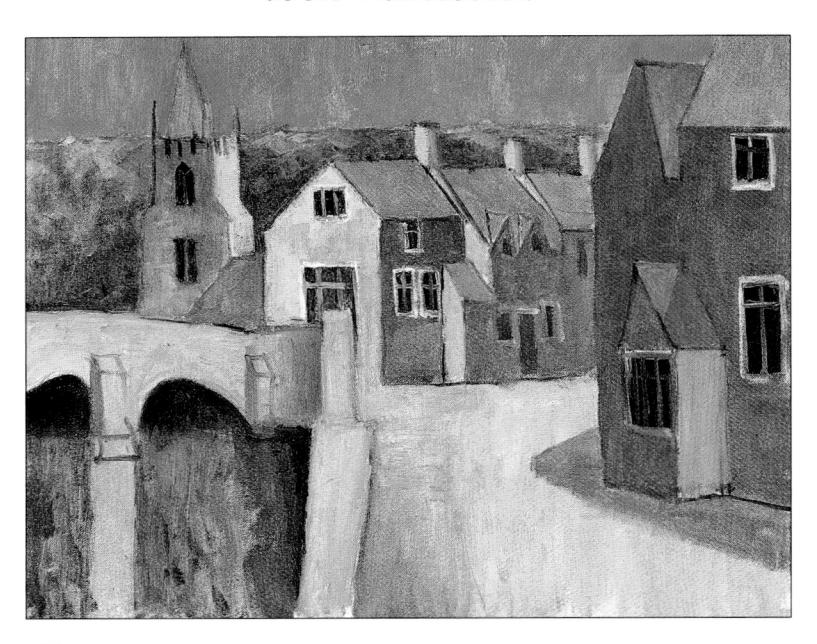

THE PROBLEM

Urban and village scenes can be very appealing subjects for the artist, but beginners understandably become discouraged when they find walls seeming to tilt of their own accord and houses looking like children's toys. As a result they quickly retreat to the relative safety of pure landscape, feeling unable to cope with the intricacies of perspective. But in fact the most common cause of failure is too *much* attention to perspective: so much time is spent making sure the parallel lines converge at a vanishing point that the shapes, textures, proportions, and individual characteristics of the buildings are overlooked. In the student's painting, perspective and the proportions are both awry, but the cause is lack of observation, not failure to understand a set of rules. Perhaps even more important is the lack of attention paid to texture. Houses derive much of their character from the materials used to build them, but here there is nothing to tell us that these are old stone buildings.

- THE SOLUTION -

The only really essential rule of perspective is the one mentioned above – receding parallel lines meet at a vanishing point which is on the horizon. The words in italic are the important ones, because the horizon, at your own eye-level, determines the angle at which these lines slope. If you are on a hill looking down on a group of buildings, the horizon will be correspondingly high, and the receding parallels will slope up to it; if you are lying on the ground looking up at a tall building, they will slope dramatically downward. Once this rule is mastered, however, you would do well to tuck it away in the back of your mind and use your eyes instead, because it is no more than a general guide, and there are always other factors to complicate the issue, such as whether the buildings themselves slope upward because they stand on a hill.

- **Proportion** Just as a portrait will not succeed if one feature is out of proportion with the rest, a building will not make sense if the windows are too large or too small, or if there is no overhang where the roof joins the top of the wall. The buildings in Gordon Bennett's painting opposite look solid and convincing because their structure and proportions have been well observed. The treatment is broad and painterly, but the few details that are included are telling ones, for example the deeply inset window of the central house hints at the thickness of the walls.
- Texture The buildings in the student's painting might as well be concrete, or even cardboard, but here the artist has made clever use of rather dry paint and broken brushwork to suggest the irregular texture of the old stonework. (See pages 30–33 for ideas on texturing.) Notice how he has varied the shape and size of the brush-

USEFUL TIPS -

A crooked or wavering line that should be straight can ruin the effect of a building, but painting straight lines is not easy, particularly in oils. There is no law that says all painting must be done freehand; it's better to use a ruler or masking tape than to fall prey to the temptation of hard lines applied with a small sable brush. Masking tape has to be put onto an unpainted surface

or thoroughly dry paint, but a ruler can be angled to prevent it smudging the paint, and held in place with the non-painting hand for as long as you need it. It may sound like cheating, but in fact such artificial aids allow you to paint much more freely because you are not having to worry about paint going over the edges and spoiling a clean line.

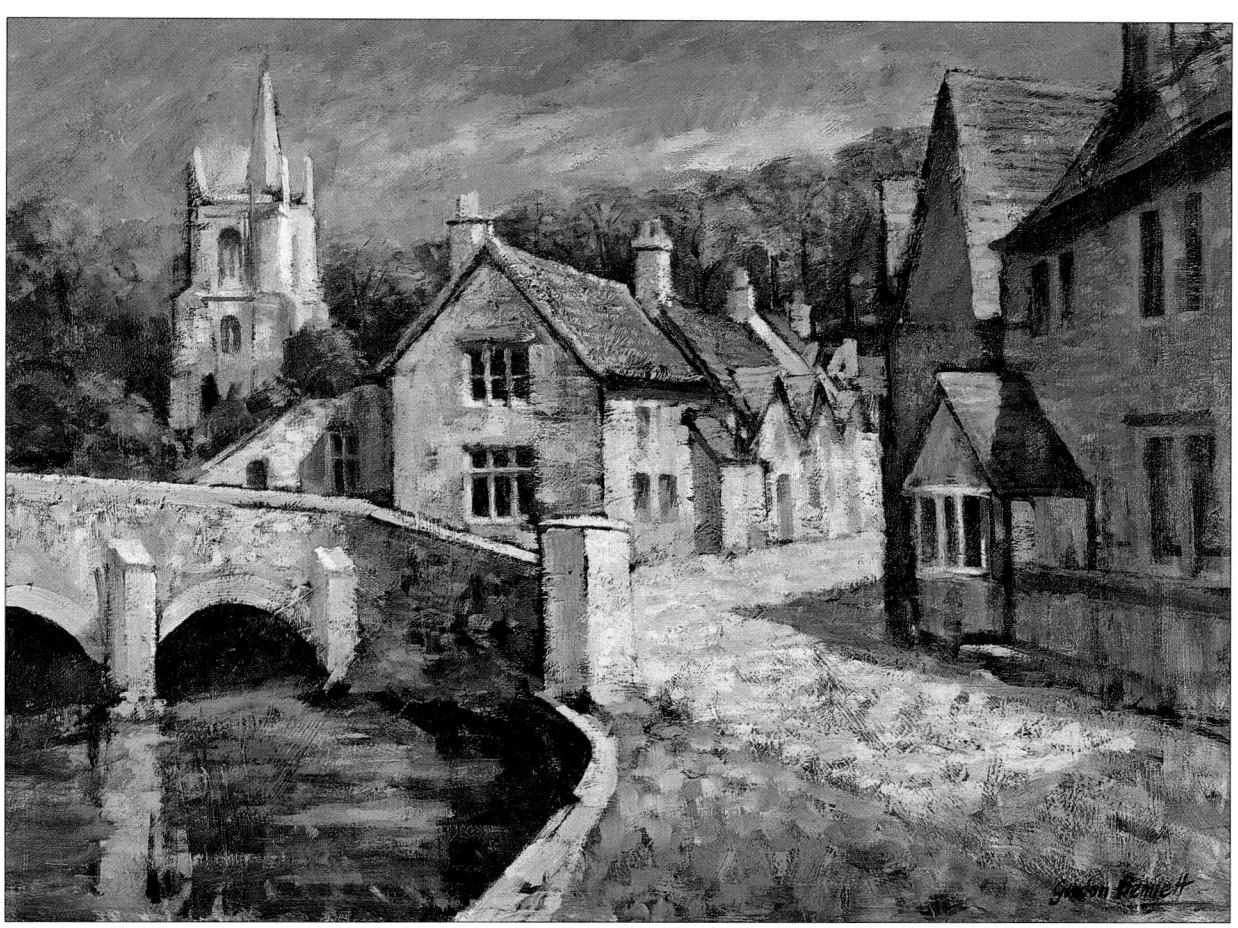

Castle Combe, Wiltshire by Gordon Bennett. $24 \times 36 \text{ in}/61 \times 91.5 \text{cm}$

■This artist does most of his paintings in the studio, but not before he has made a series of detailed on-the-spot drawings and color notes. These provide him with visual reference for the structural details that give buildings a solid, convincing look.

strokes, using long ones for the lines of tiles on the roofs and shorter, more rounded ones for the cobbled street.

■ Drawing aids Only very experienced draftsmen can accurately assess the precise angle of a rooftop or window frame, but a small pocket ruler carried as part of your sketching kit makes the task much simpler. This can be held up at arm's length to check out angles, horizontals and verticals, and can also be used for measuring proportions, such as the height or

width of a door or window in relation to the wall. The golden rule for painting buildings is to take your time in the early stages. Start with a careful drawing, measuring and checking every angle and the way each shape joins or intersects the adjacent one, and don't start painting until you are happy with the proportions and perspective. It doesn't matter if the drawing looks mechanical and uninspired; you can be as free as you like with the paint once you have the security of a good foundation.

 $Santa\ Maria\ Formosa$ by Bernard Dunstan R.A. $18\times20\ in/45.7\times50.8cm$

In this painting, unlike *Town Hall*, *Hartlepool*(opposite) the buildings are very broadly treated, with the minimum of detail. And yet they are completely realistic because the artist has painted them many times and understands

their shapes and characters. Starting with a good drawing, or at least a thorough understanding of the subject, enables you to be as free and bold as you like once you start painting, because you are working on a firm foundation.

- Sometimes buildings are no more than an incidental part of a landscape, as in this painting, but unless they look right, with the vertical lines straight and the doors and windows a believable size and shape, they will form a distracting element in a picture that might otherwise be quite satisfactory.
- ▼ For a painting like this one, perspective really matters, because the effect is largely created by the lovely, sweeping, receding curves of the wall and cobbled road. But walls and houses are really no harder to draw than anything else, so if you are attracted to architecture, don't give up too easily. Careful observation and hard work are part of being an artist.

From the Studio, Stroud by Geoff Humphreys $48 \times 36 \text{ in}/121.9 \times 91.5 \text{cm}$

 $Town\ Hall, Hartlepool\$ by Stephen Crowther. 18 imes 24 in/45.7 imes 61cm

I found the reflections very difficult. How can I make them look convincing?

- THE PROBLEM

When you look in a mirror you see a perfect, but reversed, replica of yourself, because a mirror is a flat surface specially made to reflect all the light that falls on it. A metal object, even when highly polished, absorbs only some of the light. so that it retains its own local (real) color in places, and the reflections are distorted by the object's shape. The student has failed to grasp either of these basic principles: we only know that the copper pot is round because of the curved line around the rim - the confused muddle of reflections tells us nothing about its shape or what kind of metal it is. Most of the light passes through plain, uncolored glass but it does reflect in places, producing very bright highlights which help to define the form. In the problem painting, these have been "grayed" down so much that they are neither meaningful nor visually interesting.

- THE SOLUTION -

Reflections are so beguiling that you have to take a firm stand and resist the temptation to put in too much detail. Look for the most important shapes and patches of color and try to simplify, or you could find yourself painting the reflections at the expense of the object. In the painting opposite, you'll notice that the reflections of the strawberries in the copper pot are only hinted at, so that the "mirror" image does not detract from the real thing or distort the shape of

the pot. In the student's painting it does both. Half-closing your eyes will help you to cut out extraneous details and to see the reflections as a pattern of abstract shapes and colors. Looking at the glass opposite you can see how the artist has observed the reflections very carefully. The student felt obliged to fill in the whole of this area with paint, but as glass is transparent, it sometimes cannot be seen. So with one deft brushstroke, the artist adds a patch of white where the light strikes the rim, leaving the eye to complete the shape.

■ Value contrasts Shiny convex surfaces give very pronounced contrasts, particularly when there are dark colors in the background or foreground, because the curves concentrate the light in some parts and the shadows in others. Don't be afraid of using pure white for the highlights, contrasted with bold darks. Look at the deep blues and greens at the bottom of the glass in the painting opposite.

almost no color of their own, so the reflections will be slightly muted versions of whatever is being reflected. But copper has a good deal of local color, a lovely pinkish brown, and anything reflected in it will take on some of its warmth and glow. Pamela Kay has used a range of reds, pinks, and golden browns, working wet- into-wet to give a realistic soft blurring where the light colors meet the dark ones.

Strawberries in a Copper Pot by Pamela Kay. $12\frac{1}{2} \times 10$ in/ 31.7×25.4 cm

The highlights are applied wet-in-wet so that the white is softened and modified by the color beneath.

The brushstrokes are broad and free, giving an overall impression of the reflections rather than a precise description.

Page numbers in *italic* refer to the illustrations and captions

acrylic paints 13	color:	TheRiverBed, Staithes56, 57
aerial perspective 82, 83, 84	black 38, <i>39</i>	Scalasaig Pier, Colonsay 73
$Alla\ prima\ 24,25$	blue 122, <i>123</i>	$Sheltered\ Moorings, Port$
	broken 26–8	Mulgrave 17
backgrounds 88	choosing 34–5	,-
Baker, Christopher: Bridge over	clouds 126	Darbyshire, Stephen: Summer's
the River Dordogne 132, 133	complementary $49, 52, 53$	Morning 37
Fenland Landscape 80, 81	echoes 56	drama 80, <i>81</i>
	flowers 50, 51, 104	drawing 12, 24, 105, 110, 111,
The River Nene,		118, 138
Northamptonshire 63	foregrounds 70	
SouthDowns, HalnackerHill	glazing 28, 29	drawing aids 138
70, 71	green 40–2, 41–3	Dunstan, Bernard: Santa Maria
$View\ from\ the\ Folly, 82, 83$	grays and browns 26, 27	Formosa 138
Bennett, Brian: Burnt Cornfields	harmony 56, <i>57–9</i>	
85	mood 60, <i>61–3</i>	edges 116–17, 117
ChilternLandscape20,21	neutrals 46, <i>47–9</i>	Ernst, Max 32
Farm Track 65	optical mixing 28, 29	
Floods on the Ouse 126	partial mixing 30	figure painting 68, 69, 78, 79,
Pancake Wood, Winter 105	perspective 82, 83–5	118, 119
Willow Trees 108	reflections 140	flowers 50, 51, 104, 110–12,
Bennett, Gordon: The Bridge at	scumbling 30–2, 32	111–13
Baslow 26, 27	shadows 52	focal points 68, 69
Castle Combe, Wiltshire 136,	skin tones $44, 45$	foliage 105, 106, 107–9
	staining 32	foregrounds 70, 71–3
137	0	
black 38, 39	values and 54, 55, 60, 70	$frottage\ 32,33$
blues 122, <i>123</i>	white 36, 37, 42	C C Will C I D I
boards 12, 13	complementary colors 49, 52, 53	Garfit, William: Camisky Pools
Bowyer, Jason: Flowers and Vase	Composition 64–5	and Ben Nevis 84
113	creating interest 76, 77–9	The Crives, River Beauly 135
Bowyer, William: Falling Blossom	drama 80, <i>81</i>	River Cerne 72
108	focal point 68, 69	River Test at Leckford 86, 87
$Reflections\ at\ Kew\ 134$	foregrounds $70,71–3$	Trees by the River Test 106, 107
$Sunken\ Tree\ 102$	horizon 74, 75, 136	glass, reflections 140
$The\ Terrace, Richmond\ 52, 53$	landscapes 65, 66, 67, 86, 87	glazing 28, 29
broken color 26–8	portraits 64, <i>64</i> , 92, <i>93–5</i>	Gore, Frederick: Flowers and a
browns 26	space and recession 82, 83–5	Staple Gun 62
brushes 13, 16, 17, 115	still life 65, 88, 89–91	Terraces, Forna Lutx 58
brushwork 16, 17–19, 30, 76, 106,	viewpoints 98, 99	Gowing, Sir Lawrence: Trees over
112, 132, 133, 135, 136–8	Constable, John 28	a Stream 109
buildings 136–8, <i>137–9</i>	Corsellis, Jane: Winter Light 36,	Within the Wood 79
Burnam, Peter: North Norfolk	46, 47	Graham, David: Mount Zion 34
Beach 18	Crowther, Stephen: Town Hall	Green, Margaret: Anne Draws a
Beach 18	Hartlepool 139	Horse 95
canvases $12, 13$	Curtis, David: Boy on a Jetty 94	The Beach with Sunbreaks 122,
Cézanne, Paul 16	A Corner of Sandbeck 109	123
The House of the Hanged Man 7	$A\ Derbyshire\ Landscape\ 120,$	The Black Dog 103
Self-portrait 8	121	Bonfire $54, 55$
Chamberlain, Trevor: Anchored	$The\ Gin\ Race, Old\ Edington\ 31$	Evening Walk, Walberswick 68,
$off Bradwell, Essex\ 127$	$Interior\ with\ Sian-Colonsay\ 63$	69
$Beach\ at\ Sidmouth\ 78$	TheLunchBreak78	$Lyons\ Corner\ House\ 60,61$
South Devon Coast 18	$The \ Old \ Village, Dron field,$	Primulas 91
Summertime, Budleigh	$Derbyshire\ 115$	Southwold Harbour 74,75
Salterton 127	A Pine Wood in Derbyshire 24,	Greenham, Peter: Lake Annecy 59
Welsh Cockle Gatherers 104	25	greens 40–2, 41–3
charcoal 12	Portrait of Jeanette 14, 15	grays 26
clouds 80, 87, 124-6, 125-7	Puerto de Soller, Majorca 117	
Coates, Tom: Portrait of Patti 10,	$Redmires\ Reservoir, Peak$	Haddon, Joyce: Still Life with
11	District 67	Pomegranates 35
		1 omegranates oo

hardboard 12, 13 Hayes, Colin: Chian Fishing Boats, Greece 100, 101 Herrick, Roy: Low Tide 102 Still Life with Garlic 90 Summer by the Windrush 41 Heston, Joan: Closed Mondays 29 horizons 74, 75, 136 Humphreys, Geoff 42 Beside the Lamp 79 By the Window 118, 119 Ennuie 93 From the Studio, Stroud 139 High Water, Cleethorpes 76, 77 Reading by Lamplight 98, 99 Towards the Severn 73

 $\begin{array}{c} \text{impasto } 20-2, 21-3, 28, 32 \\ \text{Impressionists } 9, 16, 24, 28, 38, \\ 54, 64 \end{array}$

Jameson, Norma: Sunflower Corner 105

112 Nasturtiums and Peaches in a Basket 65 Oranges and Gold Box 90 Oriental Poppies in a Garden No. 248Poppies, Roses and Daisies 50, 51 Portrait of Emma 44, 45 Still Life with Apricots and Buttercups 88, 89 Strawberries in a Copper Pot 140.141 Summer Flowers in a Blue and White Jug 110, 111, 112 knife painting 20-2, 21-3, 108

Kay, Pamela: Hellebores in a Vase

landscapes: composition 65, 66, 67, 86, 87 foregrounds, 70 71-3 horizon 74, 75 mist 120, 121 skies 74, 75, 80, 81, 86, 87, 104-5, 105, 122, 123, 124-6, 125-7 space and recession 82, 83-5 trees 105, 106, 107-9, 128, 129 Leech, Raymond: Black Shore near Southworld – Dusk 134 light: painting outdoors 24 sunlight 105, 114, 115 linear perspective 83, 85

lines 115, 116–17, 117, 137

linseed oil 10, 28

Maderson, Arthur: Picnic in Wales Welsh Valley, September Evening 124, 125 Winter Dawn 130, 131 mahlsticks 117 masking tape 137 mediums, impasto 22 metal, reflections 140 Millar, Jack: Trehiquir, Brittany 58 Ullswater 28 Millichip, Paul: Beach Taverna, Winter 72 Chorio Houses, Symi 39 mist 105, 120, 121 mistakes, correcting 12-13 Monet, Claude 16, 64 mood 60, 61-3 movement 76 Mynott, Derek: Hammersmith Gardens 59 Vineyard, Northern Italy 19

negative shapes 118, 119 neutral colors 46, 47–9

optical mixing 28,29 outdoor painting 24,25,40,114 outlines 116–17,117

 $\begin{array}{l} \text{paint: controlling 10-13} \\ \text{keeping 84} \\ \text{palette knives 20-2, $21-3, 108$} \\ \text{pattern 98, 99} \\ \text{perspective 82, $83-5, 105, 126, } \\ 136, 139 \\ \text{photographs, as reference 66, 67, } \\ 87, 91, 96, 97 \\ \text{portraits, composition 64, $64, 92, } \\ 93-5 \\ \text{proportion, building 136, 138} \end{array}$

rags, painting with 32
references, photographic 66, 67,
87, 91, 96, 97
reflections 105, 132, 133, 134–5,
140, 141
Rembrandt 16, 20, 28
Renoir, Pierre Auguste 38
Rubens, Peter Paul 32
Portrait of Susannah Fourment
9
rulers 138
Ryder, Susan: Alice Baker
Wilbraham at Rhode 94

Chantal Brotherton Ratcliffe 85 Neva Missiriam 64

scumbling 28, 30-2, 32 sgraffito 32, 33, 115 shadows 38, 39, 52, 70, 73, 90, 114 shapes 54, 80, 128 Sidaway, Ian: In the Garden, Richmond 96, 97 size of painting 14, 15 sketches 40, 54, 66, 92, 96, 111 sketching paper 14 skies 74, 75, 80, 81, 86, 87, 104-5, 105, 122, 123, 124-6, 125-7 skin tones 44, 45 snow 105, 105, 130, 131 space and recession 82, 83-5 staining 32 still life, composition 65, 88, 89 - 91stippling 106, 124 sunlight 105, 114, 115 supports 12, 13

Tarrant, Owen: Skiathos 103
texture 16, 30–2, 31–3, 136–8
Titian 16
"tonking" 13
trees 105, 106, 107–9, 128, 129
Turner, Joseph Mallord William
40
turpentine 10, 13, 28, 116

underpainting 12, 13, 24

value 54, 55, 60, 70 Van Gogh, Vincent 20, 22 Dr Gachet 9 viewing frames 86 viewpoints 98, 99

Warman, Oliver: Near the Taunton Canal 129 water 104–5, 132, 133–5 wet into wet 106, 107, 124–6, 133 Whistler, James McNeill 121 white 36, 37, 42 Williams, Kyffin: Dafydd Williams on the Mountain 22 Willis, Lucy: Afternoon Light 35

CREDITS

p3 Trevor Chamberlain. p7 Hubert Josse, Paris. p8 Bridgeman Art Library, London. p9 Hubert Josse, Paris. p11 Tom Coates. pp15 & 17 David Curtis. p18 (top) Peter Burman, courtesy of the New Academy and Business Art Galleries, London (bottom) Trevor Chamberlain. p19 Derek Mynott, courtesy of the New Academy and Business Art Galleries, London. p21 Brian Bennett. p22 Kyffin Williams, courtesy of the Royal Academy, London. p25 David Curtis. p27 Gordon Bennett. p28 Jack Millar, courtesy of Metrographic Arts, London, **p29** (top) Joan Heston (bottom) Arthur Maderson. p31 David Curtis. p34 David Graham, courtesy of the New Academy and Business Art Galleries, London. p35 (top) Joyce Haddon, courtesy of Metrographic Arts, London (bottom) Lucy Willis, courtesy of Chris Beetles Ltd, St James's, London. p37 Stephen Darbyshire, courtesy of the Federation of British Artists, London. p39 Paul Millichip. p41 Roy Herrick. p42 Geoff Humphreys, courtesy of Metrographic Arts, London. p45 Pamela Kay, courtesy of Chris Beetles Ltd, St James's, London. p47 Jane Corsellis, courtesy of the New Academy and Business Art Galleries, London. pp48 & 51 Pamela Kay, courtesy of Chris Beetles Ltd, St James's, London. p53 William Bowyer, courtesy of Metrographic Arts, London. p55 Margaret Green. p57 David Curtis. p58 (top) Jack Millar, courtesy of Metrographic Arts, London (bottom) Frederick Gore, courtesy of the Royal Academy of Arts, London. p59 (top) Peter Greenham, courtesy of the Royal Academy of Arts, London (bottom) Derek Mynott, courtesy of the New Academy and Business Art Galleries, London. p61 Margaret Green. p62 Frederick Gore, courtesy of the Royal Academy of Arts, London. **p63** (*top*) Christopher Baker (bottom) David Curtis. p64 Susan Ryder, courtesy of the Federation of British Artists, London. p66 (top) Pamela Kay, courtesy of Chris Beetles Ltd, St James's, London (bottom) Brian Bennett. p67 David Curtis. p69 Margaret Green. p71 Christopher Baker. p72 (top) William Garfit (bottom) Paul Millichip. p73 (top) David Curtis (bottom) Geoff Humphreys, courtesy of Metrographic Arts, London. p75 Margaret Green. p77 Geoff Humphreys, courtesy of Metrographic Arts, London. p78 (top) David Curtis (bottom) Trevor Chamberlain. p79 (top)

Sir Lawrence Gowing, courtesy of the Royal Academy of Arts, London (bottom) Humphreys, courtesy of Metrographic Arts, London. pp81 & 83 Christopher Baker. p84 William Garfit. p85 (top) Brian Bennett (bottom) Susan Ryder, courtesy of the Federation of British Artists, London. p87 William Garfit. p89 Pamela Kay, courtesy of Chris Beetles Ltd. St James's, London. p90 (top) Pamela Kay, courtesy of Chris Beetles Ltd, St James's, London (bottom) Roy Herrick. p91 Margaret Green. p93 Geoff Humphreys, courtesy of Metrographic Arts, London. p94 (top) Susan Ryder, courtesy of the Federation of British Artists, London (bottom) David Curtis. p95 Margaret Green. p97 Ian Sidaway, p99 Geoff Humphreys, courtesy of Metrographic Arts, London. p101 Colin Hayes, courtesy of the Royal Academy of Arts, London. p102 (top) Roy Herrick (bottom) William Bowyer, courtesy of Metrographic Arts, London. p103 (top) Margaret Green (bottom) Olwen Tarrant, courtesy of the Federation of British Artists, London. p104 Trevor Chamberlain. p105 (top) Norma Jameson (bottom) Brian Bennett. p107 William Garfit. p108 (top) William Bowyer, courtesy of Metrographic Arts, London (bottom) Brian Bennett. **p109** (top) David Curtis (bottom) Sir Lawrence Gowing, courtesy of the Royal Academy of Arts, London. pp111 & 112 Pamela Kay, courtesy of Chris Beetles Ltd, St James's, London. p113 Jason Bowyer, courtesy of Metrographic Arts, London. pp115 & 117 David Curtis. p119 Geoff Humphreys, courtesy of Metrographic Arts, London. p121 David Curtis. p123 Margaret Green. p125 Arthur Maderson. p126 Brian Bennett. **p127** (top & bottom) Trevor Chamberlain. p129 Oliver Warman, courtesy of the Federation of British Artists, London. p131 Arthur Maderson. p133 Christopher Baker. p134 (top) William Bowyer, courtesy of Metrographic Arts, London (bottom) Raymond Leech, courtesy of the Federation of British Artists, London. p135 William Garfit. p137 Gordon Bennett. p138 Bernard Dunstan, courtesy of the Royal Academy of Arts, London. p139 (top) Geoff Humphreys, courtesy of Metrographic Arts, London (bottom) Stephen Crowther, courtesy of the Federation of British Artists, London. p141 Pamela Kay, courtesy of Chris Beetles Ltd, London.